THE
WINDRUSH
VALLEY

A guide to the river, towns and villages

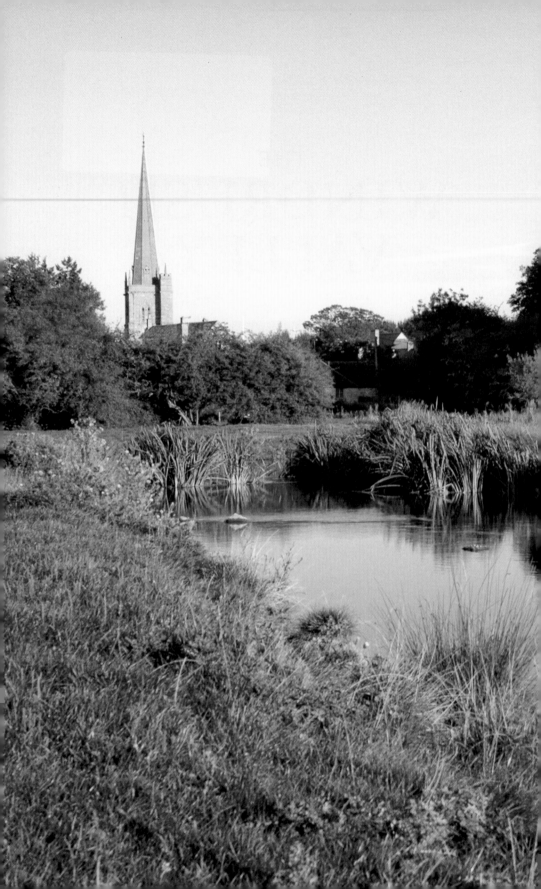

THE
WINDRUSH
VALLEY

A guide to the river, towns and villages

MARK CHILD

AMBERLEY

First published 2010

Amberley Publishing Plc
Cirencester Road, Chalford,
Stroud, Gloucestershire, GL6 8PE

www.amberley-books.com

British Library Cataloguing in Publication Data.
A catalogue record for this book is available from the British Library.

ISBN 978 1 4456 0008 6

Typesetting and Origination by Amberley Publishing.
Printed in Great Britain.

Contents

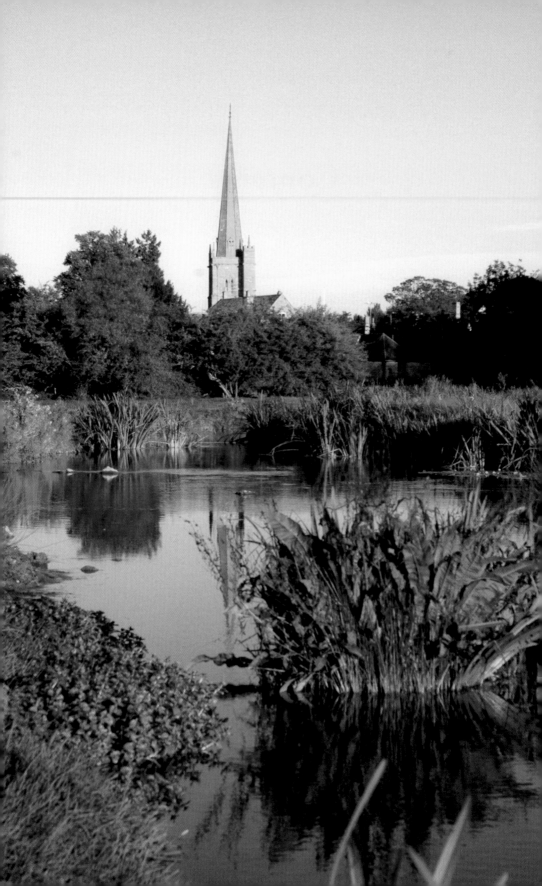

The Course of the River

The name Windrush comes from two Anglo-Saxon words, *wen* meaning wind or meander, and *risc* meaning rush or reed. Both are still evident in the forty-mile course taken by this, the longest of the Cotswold rivers. Yet just how those two words should be translated is lost in obscurity; are they derived from the way in which the waterway wanders through the rushes, or the way in which it hurries or rushes like the wind? It was called *Wenrisc* in the eighth century, *Wenris* or *Waenric* in the tenth. Sometimes it runs through flood meadows in open countryside; often it is contained within steep-sided banks in wooded areas. Occasionally, it washes past some of the most delightful stone-built residential and historic agricultural buildings in the Cotswolds. Communities were established close to where the river was shallow enough to be forded, and gradually grew away into the villages and hamlets that are now typical along the course of the Windrush. In most cases, the fords have been replaced, first by wooden bridges and later by those built of stone. Some of these are of considerable age.

The River Windrush is a cold and mostly clear waterway. It typically presents in the landscape as a ribbon of sparkling light that mirrors the seasons with pastoral clarity, and seems now to be detached from the demands of trade. That was not always the case. Historically, its course has been changed to facilitate social, economic, and business needs, notably at Naunton where it has been straightened, and Bourton-on-the-Water, where it was redirected to run through the village. Sometimes, it is still possible to see the course that it once naturally developed through the meadows, but which it no longer follows. Occasionally, it has also been manipulated into little lakes by landowners through whose estates it ran. It has driven innumerable mill wheels, and its waters have been used to wash and cleanse people and animals, and to facilitate the products of human labour.

In medieval times, its Oxfordshire course was associated with the Forest of Wychwood, then one of the four great hunting forests of England, but now reduced to a few small woods and copses, only a handful of which are in sight

of the river. If you draw a four-sided figure on a map of Oxfordshire, joining Taynton, Enstone, Kidlington and Stanton Harcourt, that is roughly the area of the medieval forest. It covered some 160 square miles and the Windrush ran along its southern extremity, where both the waterway and villages such as Swinbrook and Minster Lovell were engulfed by the forest. In this way, both forest and river provided protection for the settlements. Night poachers in the Forest of Wychwood, wherein commoners were banned from hunting except on one day each year, would find that the Windrush was an essential means of escape when they might otherwise have been cornered in the forest. Otherwise it was, as rivers have always been, a means of travel and trade between the villages.

Half a century ago, the course of the Windrush was still largely untrammelled, and the dedicated walker might then wander its length more closely, if rather more hazardously, than is now possible. Today, it occasionally provides the loudest chatter in some of the sleepiest villages in the Cotswolds. As it passes through parts of Gloucestershire and Oxfordshire, it is sometimes the focal point of leisure activities: at Bourton-on-the-Water, for example, Bourton Rovers' footballers contrive annually to play a match in it, to the great delight of visitors who crowd the waterside. Elsewhere, it may be the facilitator of quiet days with rod and line; or a compelling attraction for family days out. Occasionally, in high season, it is almost a holiday resort. In its time, the Windrush has been many things to many people, and along its banks now are many people doing many things. Artists, anglers, walkers, wardens, people on and in the river, and people living adjacent to it, all interact with each other and all have stories to tell. It is a very agreeable river to explore.

From its source, the Windrush winds and loops gently until, having passed through Bourton-on-the-Water, it goes into a long series of s-bends, double s-bends and – in one or two instances, particularly around Burford – is so tightly knotted that it practically creates small islands. Its largest loops are close to Minster Lovell and Witney, south of which it effectively becomes two rivers as it passes Ducklington and Standlake before reuniting for a comparatively straight stretch into the Thames.

It was the shallow limestone quarries along the Windrush valley north of Burford that provided the stone that was used to build practically all of these villages. The material comes from the band of sedimentary oolite that formed some 400 million years ago, creating the limestone belt that runs between the Dorset coast and Yorkshire. Along its length, there were famous quarries such as those at Doulting, Chilmark, Barnack, Clipsham, and Ancaster. Cotswold stone was quarried from Bath to north-east Oxfordshire, and that provided by quarries such as those at Burford and Taynton in the Windrush valley was particularly good. Of course, Cotswold stone is not just seen in the domestic build fabric of the area; a response to the Enclosure

Acts of the eighteenth and nineteenth centuries was to put up the miles of dry stone walls, made out of the material, which give character and shape to the Cotswold landscape. Followers of the Windrush will frequently see where these formed land boundaries with the river.

Cotswold stone differs in colour and building quality over very short distances. Around the start of the river, the old buildings have weathered to a shade of honey gold; by the time the Windrush has left the area, the old Cotswold stone buildings are a light buff-grey, perhaps with a touch of silver. The presence of good building stone along parts of the area accounts for the way in which old stone-built properties and farm buildings seem to meld together, forming villages into a homogeneous and visually satisfying whole. For this reason, visitors often say that particular villages 'seem to grow out of the landscape'. This is primarily cottage country, each settlement relying on its nearby quarry to provide blocks of stone for the walls and stone slates for the roofs. Whole villages are built of materials from the quarries closest to hand. The subtle differences now seen in the colours of the fabric, as one travels between the villages, represents the particular characteristics of each quarry, the ways in which the stone was dealt with during the building process, and the ways in which it has mellowed and changed colour in the face of the prevailing elements over the centuries. The result gives each village its unique visual characteristic.

Cotswold roofers had a selection of names for different sizes and shapes of stone tiles, and these differed quite considerably from one area to the next. For example, some twenty-one names were commonly used for the tiles that were put on roofs around Bourton-on-the-Water, but *short cocks* and *long cocks* there were *short days* and *long days* a little further south in the valley. When you look at a Cotswold roof, you are seeing stone slates that might be a *back* or a *beck* depending where you are. *Wivets* and *cuttings* were fairly universally used; you might also come across *maverday*, *moreday* and *muffity*; there are *lye-byes* and *bottomers*, *bachelors*, *cocks*, *nines* and *elevens*, and a great many more in a considerable vocabulary that was never properly standardised. Roofing slates came from numerous quarries in the area, those around the Slaughters notably supplying Bicester priory in 1440 and New College, Oxford in 1452.

The Cotswold building tradition was established by the monasteries, which, before the Dissolution, were the principal landowners. Their method of building barns and granges in medieval times transferred itself to cottages and houses that were put up or altered. By the time the monasteries had been suppressed, and wealth from the woollen industry hereabouts was in the hands of private merchants, the Cotswold style was well established. It came into its own, and was at its vernacular best, for about one hundred years from the end of the sixteenth century. Much of the old cottage and agricultural fabric

extant in the Windrush valley dates from this time. From the valley, too, finest quality Cotswold stone was exported to the greater centres of population, notably London and Oxford. Along the valley, families grew up steeped in the old customs and traditions of stone cutting and stone masonry that, as an industry, was only rivalled in the Cotswolds by the production of wool.

As riverside dwellers know, the Windrush is not always the calm waterway that it presents to visitors, as it sparkles invitingly through long summer days. Nevertheless, it has frequently inspired mostly amateur verses of a pastoral nature, questionable value, but undeniable passion. These usually extol its benign virtues in contrast to what the writers perceive as being the rapid pace of modern living. Of all the crystal-clear waterways that hurry through the region, often babbling noisily and at other times spreading sleepily and almost imperceptibly across shallow fords, it is the Windrush that turns up more frequently in the major tourist venues. Bourton-on-the-Water, in particular, derives visitor potential out of the Windrush, and Witney has used it as the focus for meadowland, ecology and country walks. It touches Burford, then hurries away across the fields largely unnoticed, leaving a mill stream – which visitors often mistake for the Windrush – to curl around the town.

Elsewhere, it runs, often above obvious gravel beds, through some of the area's most attractive corners. It accounts too, for an incredible amount of wildlife and a considerable diversity of freshwater fish – barbel, brown trout, chub, dace, gudgeon, perch, rainbow trout and roach being the fishermen's favourites that are found variously along it – and English freshwater crayfish. Historically, it has been a good river for trout, with sizeable examples being caught, particularly around Burford. Mayflies, dragonflies and damsel flies abound. Otters, for a while absent from the Windrush, have been successfully reintroduced. Swans, ducks and other waterfowl accompany its progress. All manner of bank-side dwellers, from shrews to water rats, will easily be spotted by riverside walkers; and in the adjacent fields, rabbits abound and deer and foxes are frequently to be seen. The Windrush was once a habitat of the water vole, a species said to have been depleted nationwide by some ninety-six per cent in the last couple of decades. Since 1998, when the creature became legally protected, the river has been a focus of the Water Vole Recovery Project. This is a joint initiative by the Berks, Bucks and Oxon Wildlife Trusts, the Environment Agency, British Waterways, and Thames Water. At a time when the imported American mink has become the greatest threat to the water vole, the Wildlife Trust volunteers carry out surveys along Oxfordshire stretches of the river, recording a good many species of mammals to be found there.

Much of the grassland in the Windrush's flood plain is now being managed to improve its environmental quality. This is a policy that, in recent years, has seen the return of otters, which are happy to live and breed on this river. There are plenty of creatures like water voles. Whilst adjacent areas have been

subjected to extensive gravel extraction, the Windrush itself, being largely undeveloped in any commercial sense, continues to support an amazing diversity of fauna and flora.

The hamlets that mark the river's early course are pretty, but unexceptional. They are linked by country roads that were not made with the motor car in mind, and by high-sided, narrow lanes that kept sheep in line when they were driven off the hillsides. Even today, after more than eighty years of leisure motoring in the Cotswolds, so many of its roads remain unfriendly to the motor car. This is particularly true of those country roads in the Windrush valley, which must still be negotiated with great care. Often, particularly in the Gloucestershire section, motorists seeking a pretty spot on the Windrush must park in the centre of the nearest village from where they will be directed along a footpath or bridle path. The way is often narrow and steep-banked, with a long descent into the distance. Wheel ruts along the lane will suggest that there may be more at the end than just a stretch of river, which is often the case.

Many of the Windrush villages are archetypal in their topographical make-up, in that they are moulded into a landscape wherein a tree-lined rise forms a backdrop on one side and a patchwork of fields stretches luxuriously on the other. Others virtually hug the river, seemingly squeezed into the bottom of a valley whose sides rise in soft folds on either side. These villages have no space in which to grow around a centre, but must straggle alongside the waterway, developing by means of a series of compartments. Within themselves, Windrush villages have village greens, of sorts; there may be a pond, and there is almost certain to be a large house that is still attached to part, if not all, of its landscaped parkland. Of course, those instances in which things have changed are obvious: parkland that has been annexed; manor houses that are now apartments; farmsteads that have become the focus for commerce and light industry; and agricultural buildings that have been converted to residential, which is better by far than agricultural buildings that are decaying.

The course of the river was once punctuated by working mills. One-time mill buildings and outhouses, farmhouses, clusters of former farm workers' cottages and other agricultural buildings – now made residential – are often to be found adjacent to the river, at the ends of long lanes. Here too, there are little bridges and shallow weirs, nearly always overhung by lush vegetation, and the sound of the water is at its loudest.

The village communities that grew up close to the Windrush were glued together by shop, public house, and church. Their economic and, to some degree, their social activities were dependent on the manorial estates, against whose walls their cottages were built, but at a respectful distance from the house itself. Many of these manor houses remain in the Windrush villages, often medieval at their core, usually sixteenth or seventeenth century in their gabled elevations, and sometimes now enjoying a renascence as hotels.

If you look at the records for even the smallest of these hamlets a century or so ago, you will find that many of them had a couple of shops, plus a baker. Most of the villages had post offices and schools, although very few remain as such. There are still the old farmsteads with their large, attractive dwellings and outbuildings; the occasional dovecote; but, for the most part, only the churches continue to fulfil their historic purpose.

Windrush villages are characterised now by the silence of absenteeism that hangs about many of them: the old order of community spirit crushed on the anvil of commuter living. That is not to say there is a decline in the build fabric. There has been much restoring, rebuilding and internal remodelling over several decades; change of use has seen many a building of industrial heritage converted to residential; and new developments have been designed in sympathy with the vernacular of the past. There is hardly a sadder sight, in an area where agriculture was always the principal activity, than that of a derelict farmstead. Even more desolate are those historic agricultural buildings being used to store rusty farm implements and very little else. An empty farm complex is such an uncompromisingly dead place because it was for so long so full of life and activity. There are many of these in the Windrush valley. Conversion to residential, as at Taynton, is infinitely preferable to such lifelessness.

Typically, new owners come to their 'little Cotswold bolt-hole' only at weekends, and their neighbours may turn up but once a month. The couple who own a cottage across the road live elsewhere, possibly abroad, and let out the property by the week. And so on; dwelling after dwelling is run either as an investment by absentee owners, or is lived in only part-time by people who have no need of village facilities, little interest in preserving them, and who frequently eschew the traditional ways of village life.

That said, the trend towards converted 'celebrity' homes, and country properties for the absentee affluent businessperson, has provided a solution to one longstanding problem in the Windrush valley. Writers at the beginning of the twentieth century were making it quite plain that in village after village more old cottages were crumbling than were not. Many manor houses were no longer lived in, and were succumbing to the elements. Without the degree of inward investment that has occurred latterly, the more rural areas of the Cotswolds, and that includes most of the Windrush valley, would be very down at heel. Much of the historic build fabric would have been lost. The area would certainly not be the attraction it currently is for visitors and tourists.

What you will find in the old fabric of the Windrush valley's villages is the whole panoply of the Cotswold vernacular. In its cottage architecture are the elements that exemplify the style: dormer gables raised above eaves level to accommodate an extra storey at roof level; square-headed mullioned windows with hood mouldings and plainly moulded labels; windows with diminishing

lights as the storeys ascend; and roof tiles that become smaller in area as they rise from eaves to roof ridge.

The area's comparative isolation is due in part to being little troubled by the railway. When the line was developed, linking Oxford with the Midlands, it progressed to the east of the Windrush, along the valley of the River Evenlode. Only Bourton-on-the-Water and Witney had railway stations. Bourton was on a line that was opened by 1881, linking Cheltenham with Kingham through a region from which horse-drawn carriages were already bringing visitors to this focal point on the river. The station closed in 1962. Witney's station was all to do with facilitating the local blanket industry and was part of a private venture by the Witney Railway Company to link the town with Yarnton. It opened in 1861 and was removed in 1873 to an adjacent new station built by the East Gloucester Railway. This closed to passengers in 1962, the original site being maintained for freight for a further eight years.

Writers describing the Windrush valley in the middle of the twentieth century were still able to say that its rural existence continued in a way that it had for centuries, unbroken by time and hostilities. They wrote with pride of something that was not then lost; the villages were full of country people who understood nature and the land on which their families had worked for generations. There was a bustle about them, and they would give a warm welcome to the stranger. Now, there is rarely a village shop, although a succession of public houses seem to manage, whetting the whistles of a straggle of locals, and benefiting – at least, those near the larger settlements – from the fringe of the lunchtime trade.

The Windrush runs through a part of the Cotswolds that is living vicariously through whatever of the tourist trade it can get. Even the smallest cottages are too highly priced to be starter homes, so extant members of many of the old families, whose surnames have been recorded for centuries in the parish registers, have been forced to decamp and to leave their heritage to the more financially able immigrants.

In its more rural stretches, the Windrush valley is a quiet place where warm welcomes are still to be had in its wayside public houses, pub restaurants and hotels. There are friendly aspects in its villages that, although deficient now in the industries which made them, are nonetheless places in which to idle about and engage in conversation with such residents as may be found. The course of the Windrush is also one of the prettiest motoring routes in the Cotswolds. It begins close to Gloucestershire's north-west boundary with Worcestershire, and ends in Oxfordshire, in the Thames Valley.

The origin of the river is an isolated spot on the map, although one that is readily accessible by road. The place lies in the lower third of an imaginary triangle, drawn to connect Broadway, Winchcombe, Stow-on-the-Wold, Moreton in Marsh, and Chipping Campden. This is not an arbitrary choice.

None of these are actually Windrush valley places, but are the closest small Cotswold towns (Broadway is actually a village, but is in appearance much the same as many a town in the area) where hotel accommodation can be had. They are all historic places with plenty of shops, and are worth visiting for their own sakes. From any of these, the Windrush explorer can strike out on foot or by car.

The source of the River Windrush is about four and a half miles south of Broadway; it is seven miles north-east of Winchcombe, nine miles north-west of Stow-on-the-Wold, seven and a half miles south-west of Moreton in Marsh and as many south-west of Chipping Campden. If you wish to explore from the confluence with the Thames northwards, the closest town is Witney, some seven miles distant. However, our journey begins high in the Cotswolds, on the hills above the valley wherein runs the river.

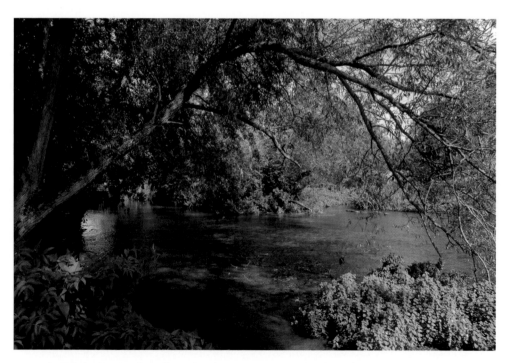

The Windrush, typically shallow, clear, fast-moving, and overshadowed by trees.

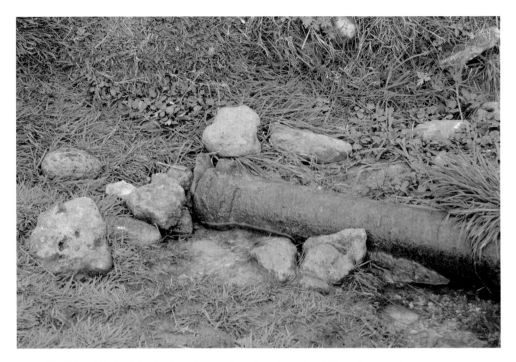

The River Windrush begins by dribbling through an iron pipe, laid on the ground.

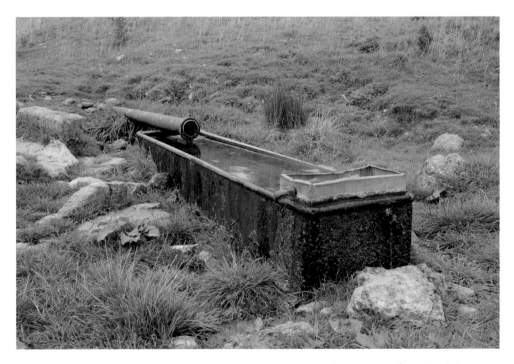

At its source, the Windrush drips through a trough that provides drinking water for the local sheep.

Snowshill

Hardly more than a mile to the north of the river's source, embedded in the wooded slopes of the escarpment and overlooking the Windrush valley, lies the straggling and secluded village of Snowshill. It has a small green that, together with a nearby cottage, was used in the year 2000 in the making of the film *Bridget Jones's Diary*. It was here that the eponymous heroine's parents lived, where a party sequence took place, and the storyline required a part of the village to be covered in fake snow. Attractive cottages cluster about the green, and many of them have partially hidden gardens wherein a riot of ornamental planting is beautifully displayed against a backdrop of mellowed fabric, old stone steps and stonework garden ornaments. There is a fine view of much of the village from the hillside to the south, and the long distance footpath that rides the ridge.

Here, you are over 900 feet above sea level, so the name derivation from the old English, *snaw* for snow and *hyll* for hill seems quite apposite. At the start of the ninth century, Kenulph of Mercia gave it to the abbey at Winchcombe, in whose possession it remained until the Dissolution, apart from a short time after 1319 when it became the property of the abbey at St Ebrulf in Normandy. At Domesday, the place was called *Snawesille*, and mid-thirteenth-century charters named it as *Snoweshull*.

Snowshill presents itself as a series of high-banked tiers, with the village grouped variously along each. One has the impression always of looking down onto the next level or up to the previous one; gardens are rarely on the same plane as the houses, and many of the buildings are – at least in part – below the level of the road. Some of the lower windows are almost at present-day ground level. The village has narrow, sloping and curved roadways that are bordered by gabled stone cottages with pretty dormers, and high, narrow chimneystacks. Green Close is particularly attractive, its cottage roofs and dormers being fine examples of the Cotswold craft of tiling.

There are comparatively few dwellings in the centre of little Snowshill, and most of the cottages press hard against the roadside. Almost all of the older ones were built of stone from local quarries, and the comparative isolation of

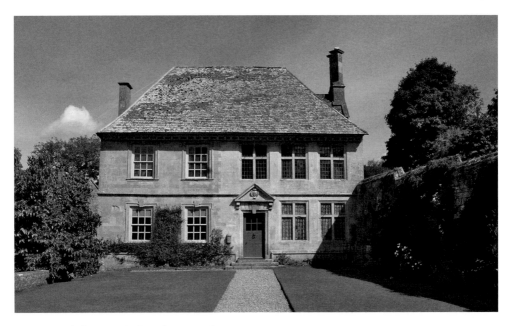

Snowshill Manor, built in the sixteenth century.

the village means that changes in architectural design were slow in coming. For these reasons, old Snowshill properties are hardly distinguishable from those that are very old; externally the fabric has melded and weathered over the centuries to such a uniformity that only internal investigation now reveals true individual age. The smallest and prettiest cottages line the road opposite Snowshill Manor. Here, many a golden stone façade is enlivened by a brightly coloured front door, some of which are obviously very old and reward inspection. Ivies and creepers climb the cottage walls, and plants squeezed in between the cottages and the roadside are the only barriers between the casual passers-by and ancient interiors that can be glimpsed through the windows.

The village hostelry is the Snowshill Arms. This gabled building apparently dates from the thirteenth century, may have had associations with the monks of Winchcombe Abbey, and once had a brewhouse attached to it. A hooded ghost, possibly the lingering shade of a Winchcombe monk, sometimes appears in an upstairs room.

Snowshill Manor, is a typical sixteenth-century Cotswold country house, reached now by a long pathway that runs alongside orchards from below the village. Built early in the sixteenth century as a manor house, the property was once in the possession of Henry VIII's queen, Katherine Parr, and the core of the house dates from about 1500. The entrance front is the result of classical re-facing early in the eighteenth century, and the low medieval building on the west side is a gem.

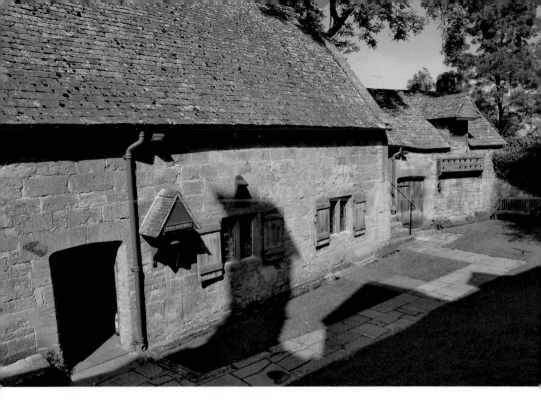

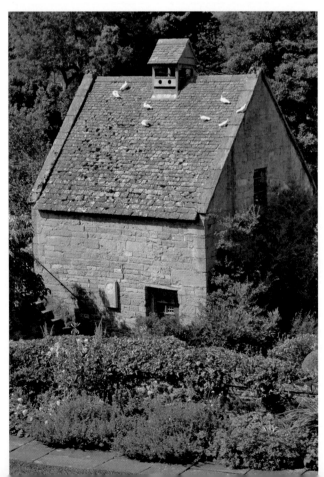

Above: Cottages adjacent to Snowshill Manor, in one of which lived the eccentric Charles Paget Wade.

Left: The dovecote in the landscaped gardens at Snowshill Manor.

Opposite: The gardens of Snowshill Manor.

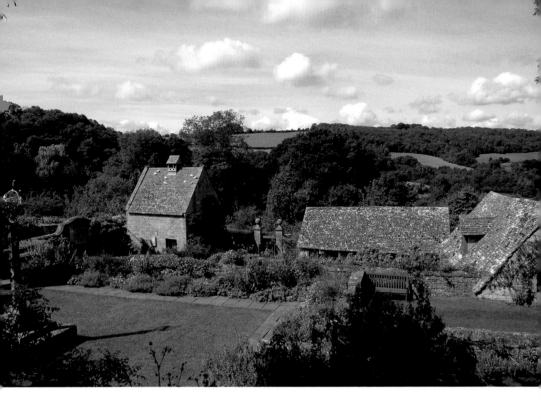

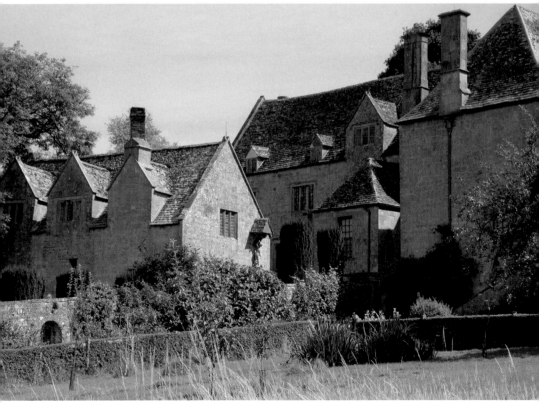

The manor was virtually derelict and its garden in need of reconstruction when it was acquired, in 1919, by fervent collector, architect and craftsman Charles Paget Wade (1883-1956). Paget could afford to indulge himself because he had inherited large family sugar estates in the West Indies. He was an eccentric, who delighted in a mixture of the weird and the macabre, and had a sense of humour that bordered on practical jokes of a most unsettling kind. Wade bought the manor as a home for his huge collections, and actually lived in an adjacent cottage. It has all the essential features of local medieval vernacular, and the seventeenth- and eighteenth-century additions just add to its charm. The garden was designed in the early 1920s by Mackay Hugh Baillie Scott (1865-1945), the architect and designer of furniture, interiors and gardens. He worked in the spirit of the Arts & Craft Movement and was responsible for numerous Art Nouveau creations. Wade gave the manor to the National Trust in 1951, but died whilst on a visit there five years later.

Allegedly, there are a number of ghosts at Snowshill Manor, including a guardian monk, and another of a young girl who, in 1604, was forced against her will to contract marriage in one of the upstairs rooms. Wade used to tell the story of workmen who were shaken by spectral presences there, and of those artisans who refused to stay because of the hauntings. There are even those who say that the spirit of Wade has not left the place, and his own shade may yet be encountered there.

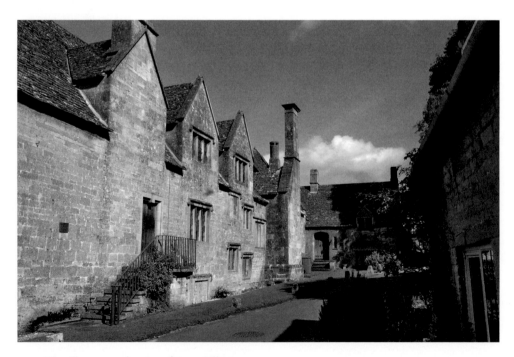

The village street elevation of Snowshill Manor.

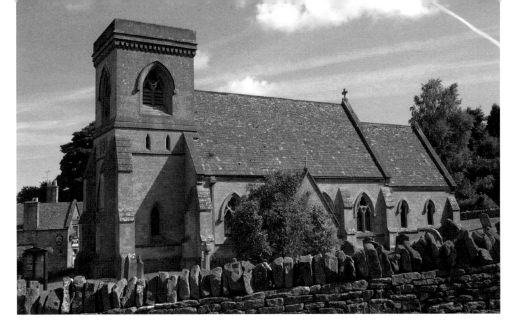

The church of St Barnabas, in the centre of the village, is mostly thirteenth-century and was rebuilt in 1864.

Your visit to the river's source might begin at Snowshill Manor, investigating the planted terraces and cottage gardens of this historic house, and enjoying the rich interiors and eclectic collections of furniture, fixtures, fittings and the artefacts that pay homage to craftsmanship, design and a compulsion for collecting. There are said to be more than 22,000 objects on view, in twenty-two rooms that are open to the public. In the garden is a seventeenth-century, stone-built, square, gabled dovecote with a tiled roof, containing some 380 wedge-shaped nesting boxes.

The solid and chunky church of St Barnabas dominates a village centre, and its churchyard contains some of the lost of the First World War, who are remembered by means of a stepped memorial cross on a chamfered base. The church was rebuilt in 1864, in a singularly uninspiring way, and is visually more attractive and promising from outside than it is within. It has a low tower with a flat, moulded parapet, a plain interior, and is in Early English style. The best feature is the octagonal Perpendicular font, decorated with quatrefoils and with trefoil-headed arches on the plinth. Charles Paget Wade is buried in the churchyard.

Close by the village, at some thousand feet above sea level, is Snowshill Lavender, established in 2000 by Charlie Byrd, an arable farmer who needed to diversify. It now comprises fifty-three acres of the gloriously aromatic plants, in some forty varieties. There is a distillery for the pure essential oil, and an on-site shop in an old Cotswold stone barn, where lavender plants, lavender products and the products of local crafts can be bought.

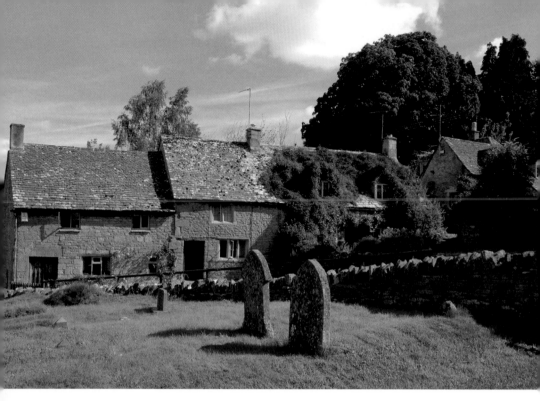

The old cottages, built in Cotswold vernacular, form a pretty backdrop to the church.

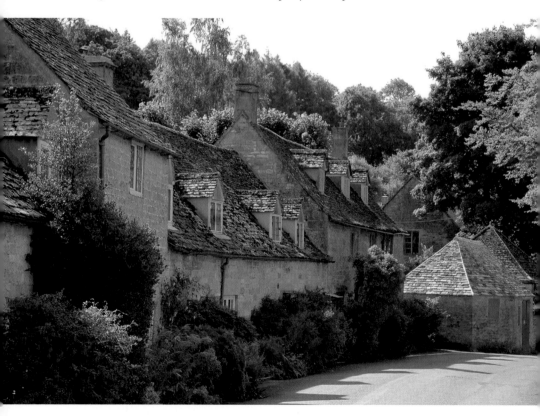

Cottages built into the side of the hill.

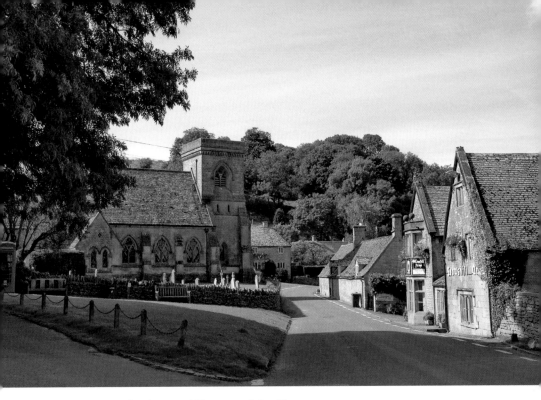

St Barnabas church, The Snowshill Arms, and the village green.

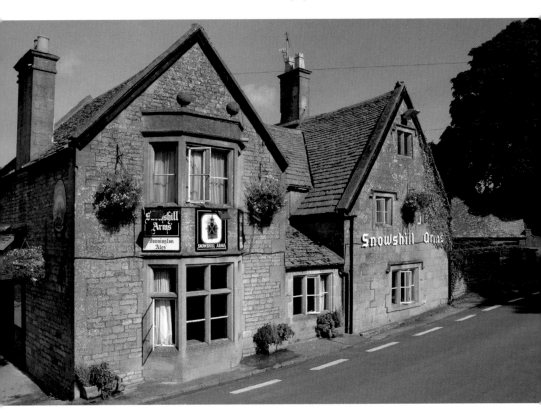

The Snowshill Arms, an ancient and attractive, allegedly haunted, village inn.

Taddington

The birth of a river is rarely a matter of note, except by contrast to what it may become as it gradually develops. Indeed, the great River Thames begins its course in rarely more than a puddle, only about twenty-one miles as the crow flies from the source of the Windrush, which will eventually flow into it, and in the same county. The nascent River Windrush begins high in the Wolds, about 750 feet above sea level, less than three miles from where Gloucestershire and Worcestershire meet near Broadway. Its source is an almost secret hollow in a landscape of sheep-trodden and enriched downland folds, adjacent to arable fields, just east of the hamlet of Taddington. Here, water bubbles out of the ground into a short length of iron pipe, from which it emerges at either end. On one side it dribbles directly onto the ground; on the other, the water fills a drinking trough, then trickles from its overflow. Following wet weather, a pond may appear about this place, and the slight grassy indentation that snakes away in the ground to the south may acquire a watery veneer. At other times, the trickle seems to disappear almost immediately, with no discernible evidence that this point is in any way connected to a rivulet that emerges across the meadows. But it is; and thereafter the waterway proceeds south-east through the heart of Gloucestershire and into Oxfordshire.

The most interesting building beside the source of the Windrush is a former tithe barn, with queen post roof, inscribed with 1632 on the porch. This houses the family-run Architectural Heritage, established in 1976, on property leased from Lord Neidpath of nearby Stanway. It displays and supplies reclaimed artefacts for gardens, homes and landscapes: from finials, urns and staddlestones to gazebos, statuary and summerhouses. Other than this, there is very little to Taddington, except a farm and some attractive stone cottages with pretty dormers and gabled-out central sections, built behind dry stone walls and fronted by cottage gardens. This is sheep country still, where sheep pens line the road through, and a footpath leads down to a rudimentary stone crossing of the just-born river.

Typical cottages and cottage gardens.

The Taddington 'village shop', open every day of the week for fresh vegetables, fruit and preserves.

From its source below Taddington's seventeenth-century manor house, having yet to learn the skittishness that will characterise its gathering maturity beyond Bourton-on-the-Water, the Windrush progresses in fits and starts about the hillside settlements of Cutsdean, Ford, Temple Guiting, Kineton, Barton, Guiting Power, and Naunton. These villages hide themselves well, either by folds in the valley or by foliage, and the roads within them rise and fall, twist, and disappear. It is possible to walk alongside much of the line of the Windrush, across the fields from its source to Cutsdean, past where a little wooden bridge spans the surface wetness. Occasionally, a spring will break out on the surface of the field, around which marsh plants, with their roots just about in the water, grow and bloom in their seasons.

The business end of the village, superior reclamation and antiques in historic buildings close to the source of the River Windrush.

The tiny Windrush trickling away from its source at Taddington.

Cutsdean

Historically, this little escarpment village was a chapelry of Bredon, whose monastery acquired it in the eighth century as the gift of Offa of Mercia, although it passed into the hands of the priory at Worcester before the Conquest. Thereafter it remained an anomalous adjunct to Worcestershire until 1931 when it was transferred to Gloucestershire. It is the highest settlement on the river, and it has all but buried itself in the soft and wooded undulations of the Cotswolds. It seems to be isolated in the landscape, and to wear an air of introspection.

St James's church, a medieval foundation rebuilt 1863-4 by Henry Day of Worcester.

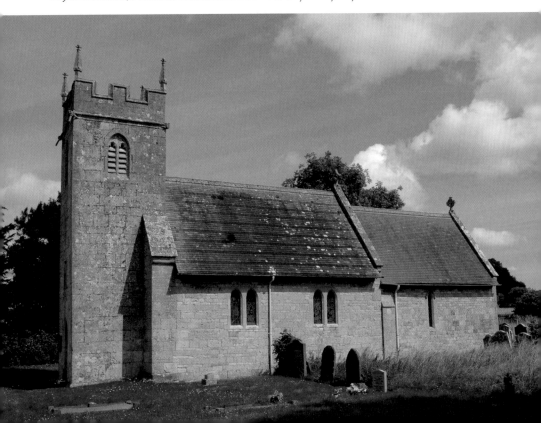

The tall pinnacles add height to this single-stage, fourteenth-century tower.

Several springs hereabouts seem to be associated with the Windrush. From the nearby slopes, there are satisfying views of pastoral England clustered about the historic fabric of its faith, and nestling as one into its surroundings. The notion persists that, in Anglo-Saxon times, a man named Cod was the possessor of an estate hereabouts. His name was maintained in the *Codestun* of Domesday, and thereafter, by derivation, *cod* became replaced by *cut*, and *dun* – via *downe* – arrived at *dean*. The area of Cod's original landholding around Cutsdean may well be the topographical source for the name of *Cotswolds*. In the early thirteenth century, tracts of land in the area were described as *Coddeswaud* and similar derivatives. This puts present-day Cutsdean firmly in the cradle of the Cotswolds nomenclature.

Today, the village is an arrangement of stone cottages around a green, and two working farms, where the North Cotswold Hunt Hounds sometimes gather. Cereal crops and root vegetables were for so long the staple fare to be found growing in the fields hereabouts, on a loamy soil that gave way to rich and stony clay. This is horse country, and many fields are studded with the glorious chestnut tones of the noble creatures. The Victorian schoolhouse, an old bakery, and the former Methodist chapel, are all residential now, and the little community lives in hope that one day its post office will open again. The Baptists were also active here, a chapel being opened in a former private

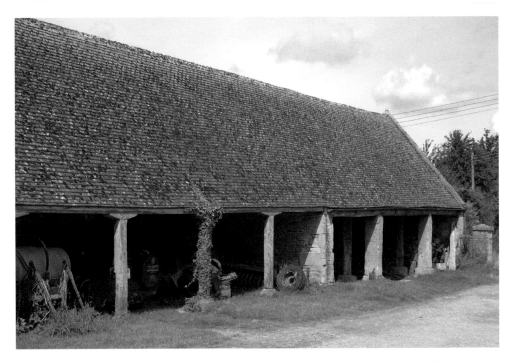

Old farm buildings remain as silent testimonies to the old farmsteads and agricultural life of the area.

residence in 1839. One of its great treasures is a rare, stone-built, banjo-shaped sheepwash that has been dated to *c.* 1810. This reminder of Cutsdean's past amidst the springy pastureland was rediscovered by local resident Jack Turner in 1978, and has since been variously refurbished and restored.

Here, in 1863/64 came Henry Day of Worcester to rebuild St James's church in the Early English style, although he left alone the slim, fourteenth-century battlemented tower with its gargoyles and pinnacles. The font is a slender chalice type, made in the seventeenth century. The church is reached through a farmyard, full of old agricultural buildings, some of which form boundaries of the churchyard.

A little to the east, Cutsdean Hill rises to more than 1,000 feet above sea level, and there is an old quarry that has notable limestone flora. The Windrush progresses from its source towards the hamlet of Ford, in racing stable country, where it is crossed by the main road from Stow-on-the-Wold. As it glides past the Guitings, anchored first beneath the eastward slope of the valley, and then to the western side, the Windrush runs through the first of its prettier stretches, here occasionally tree-lined, with the sides of the valley dipping towards it in a series of small fields.

Ford

By the time the waterway crosses beneath the road at Ford, it has acquired width and permanence and become a stream. This was a ford before the bridge was erected that now carries the B4077 between Broadway and Stow-on-the-Wold. The roadway rises quite dramatically, then dips and dives through Ford. It takes you around unsuspected corners and along a road lined by ashlar-built cottages and larger houses that all seem to have stone features beyond their status.

The village mill was possessed of the monks at Gloucester, following their acquisition in 1120, and it is recorded that a chapel of ease was once to be found here. There is a clear distinction at Ford between the old cottages that were built in Cotswold vernacular for agricultural workers, and were ever residential, and the agricultural buildings that have been converted, and both are attractive. Ford has always been a small farming community, although, even into the twentieth century, it had its blacksmith, wheelwright, and a shop, and there was some commodity selling at the public house.

The village's sixteenth-century Plough Inn, situated opposite gallops, is a favoured historic hostelry. It has long welcomed visitors with the rhyme:

Ye weary travellers that pafs by
With dust and fcorching funbeams dry
Or be he numb'd with fnow & frost
With having these bleak Cotswolds crofst
Step in and quaff my nut brown ale
Bright as rubys mild and ftale.
Twill make your lagging trotters dance
As nimble as the funs of france.
Then ye will own ye men of fense,
That neare was better fpent fixpece.

It is all very strange, since 'mild' does not quite accord with 'stale', which, when these lines were allegedly written in the seventeenth century, meant

matured or strong. However, a copy is affixed to the outside of the building, and there is another within.

According to tradition, the verse was written by William Shakespeare, who stayed overnight at the Plough and where he also stabled his horse. It is odd to think that this alleged deer poacher might have found himself at an inn that doubled, in its less benign moments, as a gaol and courthouse. This was still sheep country, and the unhappy felons incarcerated in the cellar beneath the present bar were mainly sheep stealers, taken up and stored away to await the magistrate. On court days, a bar was placed across the door, and the prisoners were brought up from the cellar to be perfunctorily tried and sentenced.

A detour west from Ford or Temple Guiting, by track or minor road, might lead to Guiting Wood. This is an ancient oak woodland, historically the natural habitat of rare and endangered species of plants, where deer are to be seen; it is now planted with beech, birch, larch, pine and conifers. The Warden's Way long-distance footpath runs through the eastern side of the wood, and the Windrush Way through the western part.

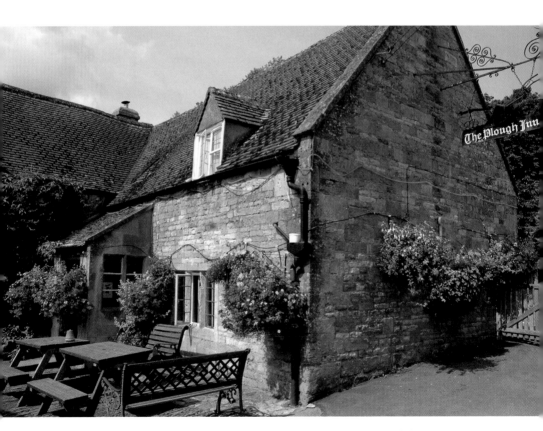

The Plough Inn, a sixteenth-century hostelry where, according to tradition, Shakespeare wrote a verse that has given it lasting fame.

Temple Guiting

Here the river fills out, but it is almost enfolded in tight undulations, tall trees and grassy slopes that prohibit most views as it progresses through private properties and past the church. The strange village name recalls its inclusion in lands and properties held by the Order of the Knights Templar from the twelfth century, the gift of Gilbert de Lacy. These were the famed landowning religious and military crusaders whose lives were tied up with those of pilgrims visiting the holy lands. The Knights Templars were suppressed in 1312 amidst a flurry of accusations, and, also in the fourteenth century, Edward II reallocated the land and property rights to the Knights Hospitallers.

Here were working farmsteads amidst rich farmland, whose products were literally carted off for sale in the markets of Gloucester and Hereford. The 'guiting' part is thought to have derived from *gute*, meaning 'flood', thereby relating to the state of the river. By about the middle of the fourteenth century, the village economy was also based on the cloth industry, where the river was fundamental to working a fulling mill, and on the local quarries. The old manor farm, a one-time hall house built early in the 1500s, is said to have been a summer residence for the Bishop of Oxford. Nikolaus Pevsner wrote that 'it has for a long time been considered one of the finest, if not the very best, of the small Cotswold Tudor houses'. The stone mullioned windows, with mostly pairs of four-centred arched lights, and square labels, are a joy.

It is a triple-gabled gem, with two dovecotes. At the Dissolution of the Monasteries, lands here passed into the hands of Christ Church. Long-dead occupants of the house variously and successively turned the waters of the Windrush into lakes for their own use. The manor is thought to date from the fourteenth century, to have been in the occupancy of the Beale family between 1469 and 1774, and to have been remodelled in 1580 when it became 'a summer residence for the bishops of Oxford'. In 2002, the garden designer Jinny Blom and the conservation architect Ptolemy Dean began to lay out the grounds, and Ptolemy's work is also evident in the nearby old granary, now residential.

The little bow-windowed village shop, a rare survival, run by volunteers.

Temple Guiting house was built for Reverend Dr Talbot. This two-storey mansion has a Tuscan porch at the entrance, and, on the three-bay garden elevation, there is a pedimented central section with a Venetian window to the first floor.

St Mary's church originated as a Knights Templars foundation, *c.* 1170, and is basically in Early English style; its chancel and some decoration are Norman work and there is much more of the fourteenth century. Some fifteenth-century stained glass depicts the Virgin Mary, Mary Magdalene, and St James the Less. The Georgian windows and splendid pulpit are said to have been given in the early 1740s by the vicar, the Reverend Dr. George Talbot; so too, the royal arms of George II and the ornate Decalogue. In 1745, he restored St Mary's church and decorated the interior using, it is said, £1,000 of his own money. He is also supposed to have refused a bishopric, and his other virtues are recorded in the church. Parts of the church, however, are of a Classical style, done in 1772.

There is an interesting Venetian window. The church was restored in the 1870s. The Decalogue was restored by conservators Hugh Harrison and Madeleine Katkov – who specialise in working with polychrome and gilded wood – set up in its present position, and rededicated in 2005.

A most attractive part of the village is about its little bow-windowed shop and post office, which is run by volunteers. The village school was built in 1873. If you are inclined, there are several leafy trails to follow through Leigh Woods, which are just south of Temple Guiting. The river hereabouts was particularly noted for its trout.

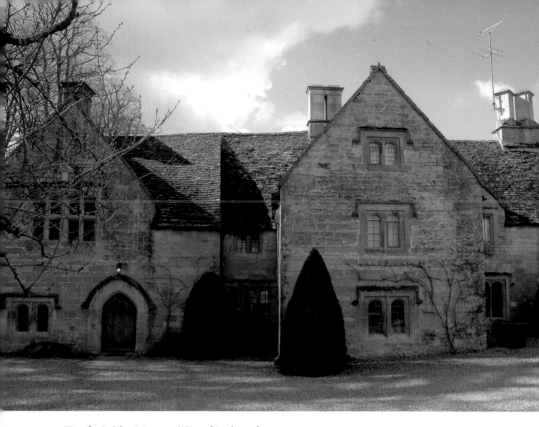

Temple Guiting Manor originated in the early 1700s.

St Mary's church, a Norman foundation but now mostly the result of a rebuild in Classical style in 1772, and restoration a century later.

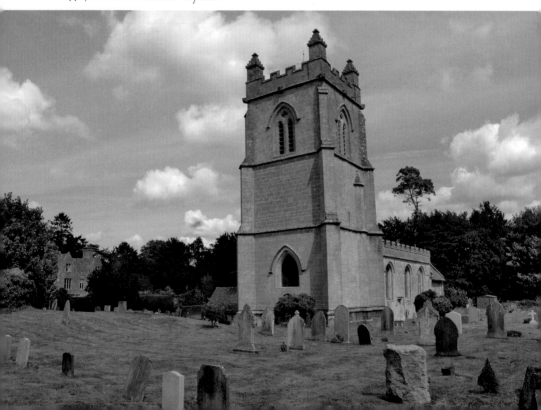

Kineton

Hardly a mile south of Temple Guiting are the damp rush beds and fords at Kineton, the willow-lined watercourse, and a tree-enclosed footbridge across the river at the end of a steep incline where the stream trickles into a pool and then presses on beneath the stones. The village is close to an area of ancient broadleaved woodland, and there are horse-racing gallops in the vicinity.

There are a number of pretty seventeenth-century cottages and larger farmhouses here; stone-built with stone tiled roofs. The village pub is the seventeenth-century Half Way House, which is halfway between the two

The Half Way House, a seventeenth-century hostelry that gave shelter to travellers on the exposed road between Temple Guiting and Guiting Power.

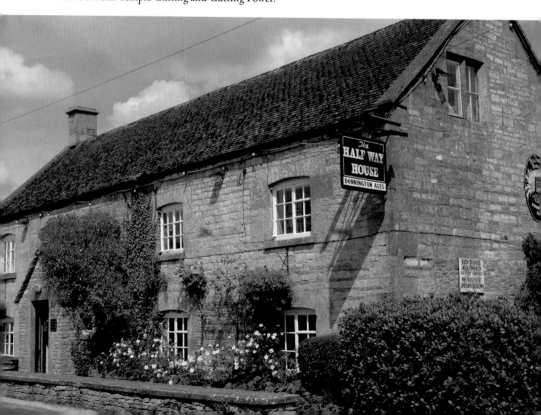

Guitings, and, until 1975, was owned by Corpus Christi College, Oxford. You will have to exert considerable pressure on the latch to gain entry. It has no resident ghost, but there is an eyewitness account of one evening at the beginning of the twentieth century, on a foul night when the surrounding countryside was deep with snow and a gale raging outside was whipping up great drifts against the front of the building. The door suddenly flew open, admitting the shade of a highwayman, which disappeared before the frightened eyes of the assembly in the bar.

The Windrush runs to the east of the village, and there are two ways down to it. The darkest and prettiest, beginning close to the Half Way House, leads to a ford and a little stone footbridge. The river has arrived here through reed beds and much vegetation, and, before disappearing into wooded countryside, spreads out into the ford beneath a canopy of sheltering trees through which shafts of sunlight break in showers of dappled gold. It is almost a secret place, with a clapper bridge, and one that promises hidden delights where the fanciful might come for spectral pleasure or just to sit and think. That is, until some van driver who knows the gradient of the steep approach and can finely judge the point at which the little ford can be taken, does so at a speed that sends as great a wash over fanciful notions as it does over the clapper bridge.

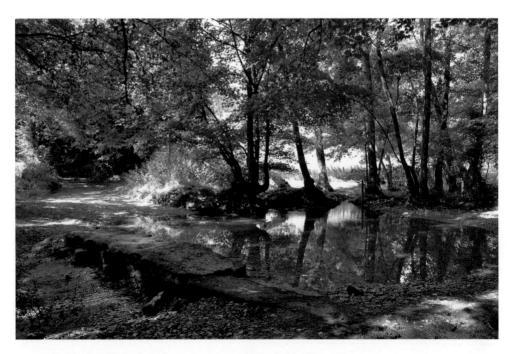

A ford in the Windrush, and stepping stones, almost hidden by trees.

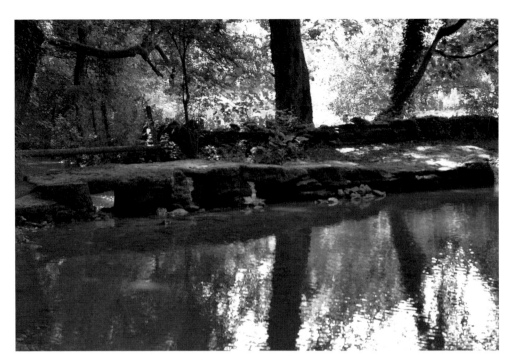

The river glides past Kineton.

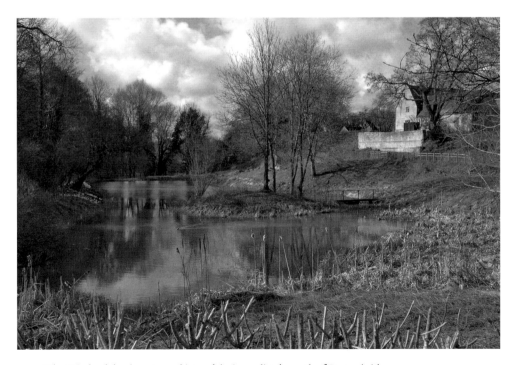

The Windrush has been turned into a lake immediately south of Barton bridge.

Barton

Another mile brings the stream to Barton, where the road suddenly descends through the trees, crosses the Windrush on the ancient Barton bridge, which has a number of small arches, and keeps to its east bank for about a mile further. Here, a brook that emanated from two sources north of Guiting Wood enters the Windrush. Barton was one of the estates owned locally by the Knights Templars until their holdings were reallocated at their suppression, and then passed, at the Dissolution, to Christ Church, Oxford.

A fulling mill was recorded in the village by 1185; there is now a notable seventeenth-century farmhouse, and the seven-bay Barton House has a hipped roof, tall chimneys and stone mullioned and transomed windows. Historically, the hamlet's employers were farmers, and its cottagers were farm employees. Footpaths and bridle ways run along the valley, accompanying the River Windrush from Barton to south of Bourton-on-the-Water.

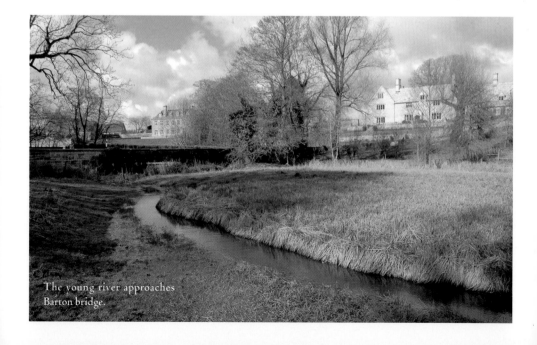

The young river approaches Barton bridge.

Guiting Power

Two small streams run into the Windrush near Guiting Power, also known as Lower Guiting, and formerly as Nether Guiting. The first of these begins as two separate trickles: one of them approaches from above the northern reaches of Guiting Wood, and the other equally slim thread of wetness advances from a hill to the west of the village. They combine, and the result slides into the Windrush a couple of hundred yards to the east of Guiting Power. The other stream, again a two-pronged affair originating in the Naunton Downs, combines a mile or so to the east, and meets the Windrush a few hundred yards south of the village, just before it takes a sudden turn to the east, away from the road, and across the fields to Naunton. Between Guiting Power and Tally Ho there is a 17-acre wetland nature reserve; on the hill to the south-west of the village there is a small round barrow, and another round barrow and ditch was built in what became the grounds of the old manor.

Guiting Power, the larger of the Guitings, is built on sloping ground around a picturesque village green, which is still the most pleasant focal point of the place. The village takes part of its name from the Anglo-Saxon word *gute*, meaning a flood, and the rest derives from that of the Le Poer family who held the manor by the thirteenth century. Before that, it was one of the areas given by William I to William Goizenboded. It was granted market rights in 1330, which effectively created the village square. Stones from the market cross that were associated with it are now embedded in the green. There were two mills at Guiting Power. Once, it was a profitable trading place; pilgrims passed this way to and from Hailes Abbey wherein a shrine lay some of the blood of Christ as authenticated by Pope Urban IV, and Guiting Power was on a salt way from the mines at Droitwich. The Warden's Way, a long-distance linear footpath, bisects the village and can be followed through Guiting Wood. The sixty-mile circular Diamond Way, created in 1995 by members of the Ramblers' Association's North Cotswold Group to mark six decades of working for walkers since 1935, also runs through Guiting Power, as well as Temple Guiting.

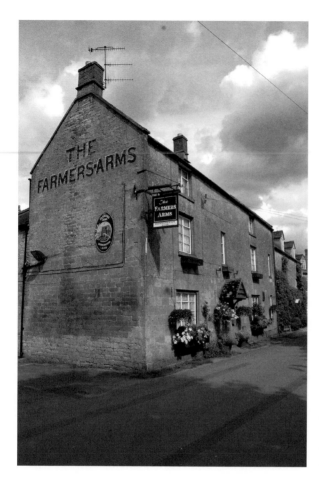

The Farmer's Arms
is a traditional village
pub, beloved of its local
clientele.

The original Guiting Grange was an ancient foundation that belonged to the Cistercian abbey of Bruern, and which was sold into private hands in 1543 at the Dissolution. A chapel in the grounds dedicated to the Holy Trinity allegedly became the family burial place, and seems later to have been demolished. The two-storey Grange was rebuilt in Italianate style, c. 1849, for John Waddingham senior, and is a much-remodelled property in which American troops were billeted during the Second World War.

The Old Bakehouse dates from 1603, and became a bakery in 1860; it is now residential. Old Hall House, in the square, dates from the fourteenth century. A Baptist chapel was built here in 1835, a village school was founded in 1872, the old vicarage was once a reading room, and the stone memorial cross was erected in 1920. It has an inhabited lantern head. The village still has its village shop, bakery, village hall, which was built in 1962 for community use, entertainments, and as a sports pavilion, and there is a post office that is also a café.

Guiting Power's modern history is inextricably linked with the life of Sally Latimer (1904-77). She was the actress, producer, theatrical manager and founder, in 1936, of the Playhouse repertory theatre that was created in Amersham, Buckinghamshire from a one-time restaurant. Her memorial plaque in the village says that she 'gave much to Guiting Power' and recalls her as 'The delight of her husband and of all sorts enchantingly beloved'.

Sally Latimer came to the Old Manor at Guiting Power in 1958 when her husband, Raymond Cochrane, acquired the manorial estate. At that time, this accounted for about half the dwellings in the village, many of which had become run down in the wake of agricultural depression. Some of these buildings were cottages that had been bought by Moya Davidson in the mid 1930s, specifically to make available to villagers and local families, and which were sold into the manor estate in 1945. Cochrane placed some thirty-six houses in the village into a charitable trust with a view to conserving them sympathetically whilst modernising their interiors, and renting them out at affordable prices. In 1971, the Cochranes moved out of the Old Manor to a farmhouse on the outskirts of the village. This delightful building was a sixteenth-century rebuild, later given a five-bay Georgian frontage, pedimented doorway, and a cupola on the roof; it looked every inch a manor house, so that was what the couple called it. The Guiting Manor Trust, continuing to work in the spirit and ethic of Raymond Cochrane's enterprise, was instrumental in gaining Conservation Area status for the village.

Many of the residential properties here are in good condition, thanks to restoration by the Guiting Manor Amenity Trust, the 1976 successor to Cochrane's original charitable venture, and the cottages continue to be let only to people with proven local connections. In 1996, the Trust bought the old village primary school building, and the following year a nursery school opened in it. There is an ancient packhorse bridge here. Its two public houses are the stone-built Farmer's Arms in the village centre: a basic, old-fashioned type village pub, and the seventeenth-century Hollow Bottom, at one time the Olde Inne. Its name derived from its geographical position: when it had no real name, villagers going there said they were on their way 'down to the bottom of the village' or 'going down to the hollow'.

Guiting Power has become well known since 1970 for its annual Guiting Festival of classical music and jazz. This is held at the end of July and the beginning of August, and regularly attracts outstanding musicians and performers. The organist, composer and choir director John Barnard, who favours British villages in his titles, named a hymn tune *Guiting Power,* which is played as the music to 'Christ triumphant, ever reigning'. In the late 1990s, the village was used in the making of a film, *The Wyvern Mystery,* which was based on the story by J. Sheridan Le Fanu and starred Derek Jacobi and Naomi Watts.

There are fine views of the village and part of the Windrush valley from a

The village memorial cross, and old houses beside the green.

footpath leading from the back of the church, proceeding across the fields to a rise in the land. The church is surrounded by farmland with a fine collection of Cotswold barns in the adjacent fields. The well-kept churchyard is punctuated by large, spreading yews and conifers, and there is a substantial holly tree beside the tower.

St Michael's church is Norman within and much famed for its well-preserved doorways of the period. Visitors are momentarily disorientated, for the south door was relocated in the mid nineteenth century, so that the south transept is now the main entrance. It is one of two decorated Norman doorways here, and has a little hourglass carved into the lintel as a reminder of mortality. The chancel was built late in the twelfth century; the battlemented tower was put up in the fifteenth; 1820 saw the addition of the north transept, and that to the south was built in 1844. The church bells, unused for more than a century, were re-hung in 1869, and the church was restored in 1903, when work beneath the chancel disclosed a small Saxon coffin. Excavations nearby further proved that Guiting Power was a Saxon settlement and that there was a pre-Conquest church on the site.

The Cotswold Farm Park is at Bemborough Farm, Guiting Power, which has been the home of Rare Breed Conservation since 1971, and is the Rare Breeds Survival Trust centre. Then, Joe Henson set aside 25 of his 1,600 acres

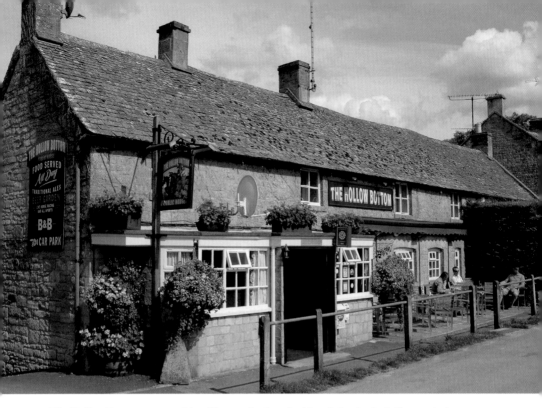

The Hollow Bottom, so named by villagers who described it as being in the hollow at the bottom of the place.

St Michael's is a Norman foundation on the site of a pre-Conquest church.

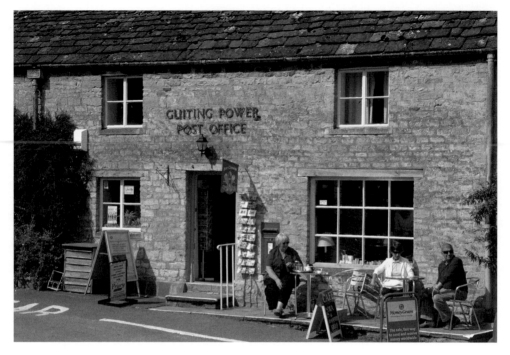

The village post office and shop, a rare survivor in the Cotswolds, where teas are also served.

for the project, and ran farm and centre together with his business partner, John Veave. Here is the living history of British livestock breeding, illustrated with examples of animals whose current level of survival is either critical, endangered, vulnerable, or at risk. Visitors can experience rare domestic breeds from ancient history to modern times. The printed material, setting the breeds in their historic context, is an education and an excellent souvenir for the visitor. There is a programme of seasonal events, a calendar of daily activities, a wide range of activities for children, a gift shop and a restaurant. A little to the east of Guiting Power is Roel Farm, where Olive Dingle Blackham (1899-2002) spent part of her life in a converted granary barn. She was a puppetry pioneer and writer, the author of *Puppets Into Actors*, who ran puppetry courses from there in the 1930s, during which decade she frequently appeared on early television with her life-size marionettes.

Naunton

Having left the Guitings, the Windrush winds across open meadowland towards Naunton, where the valley slopes are softer and, traditionally, arable farmland abounds. The river here was straightened to take its present course. A small stream, emitting at Aylworth, a tiny farming hamlet to the south-west, flows into the Windrush below Naunton, between Harford Bridge and the agricultural hamlet of Lower Harford. This is where it is thought the earliest settlement hereabouts was established, beside the ford that preceded the bridge. Naunton is about a mile long and built along a single road that dips and narrows. It is constructed of stone from the several quarries that operated in the immediate area, and topped with the products of the local slate pits.

The village folds into gentle hillside slopes to the north of the river, beneath the main road between Stow-on-the-Wold and Cheltenham. It is approached along narrow roadways bordered by trees and low drystone walls. From every aspect the village appears to be folded gently into a landscape that is crossed by stone walls, or into which stone walls intrude that cease abruptly, their ends seemingly crumbling back into the earth. According to legend, one of Satan's devils crash-landed hereabouts, irreparably broke his wing, and decided to build himself a cottage, thereby establishing Naunton.

It is thought more likely that the early settlement here was created by an Anglo-Saxon group who were displaced from nearby Harford when the Windrush flooded, causing a landslip that threatened their village. Its ancient name of *Niwstone*, or 'new town' is thought to be a reference to this. There is a shallow ford near Naunton, and the settlement seems to be more of an intrinsic part of its surrounding fields than most. The Windrush, now clear, fast-flowing and narrow, passes very close to Naunton's square, four-gabled, early seventeenth-century dovecote, which has 1,176 nest holes. The two bridges that here cross the river were built by Naunton's one-time rector, Revd John Hurd, who constructed that at the west end in 1819, and in 1851 added the crossing to the east. An earlier rector, the poet and divine Clement Barksdale (1609-87), was appointed rector of Naunton in 1660; he remained there until his death, and is buried in the

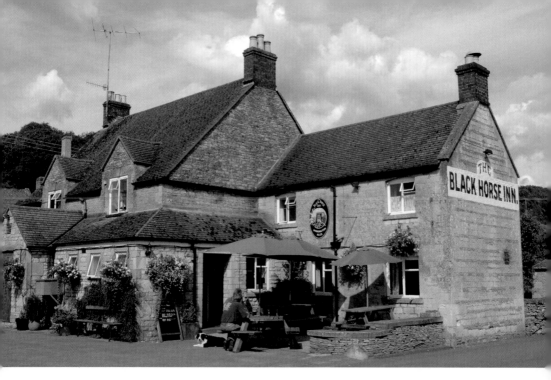

The Black Horse is a late nineteenth-century inn that has become a favourite with walkers.

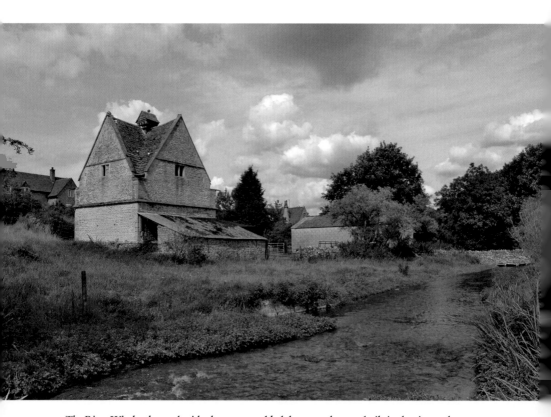

The River Windrush runs beside the square, gabled dovecote that was built in the sixteenth century.
Opposite: The water flows beneath a rudimentary bridge.

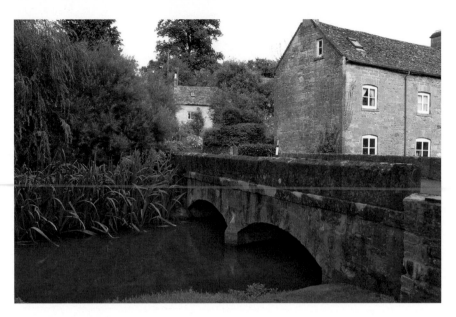

A bridge across the Windrush.

church. Barksdale was more widely known for his poem *Nympha Libethris or the Cotswold Muse*, published when he was at nearby Hawling in 1651.

The Windrush caresses the footings of Cotswold stone dwellings at Naunton, historically an isolated settlement that depended on agriculture and working the nearby quarries. It runs alongside many very attractive private gardens, into which it has occasionally spread to the extent of confining residents to their upstairs rooms. At one end of the village, where the Windrush laps at the grounds, is an extremely engaging series of buildings associated with a sixteenth-century corn mill. The buildings have all been integrated by the present owner of thirty years, and beautifully converted to residential. Nearby, old barns and outbuildings have also been sympathetically remodelled.

The Black Horse Inn was made from a cluster of seventeenth-century roadside cottages, and still proclaims its business in large letters across the roadside gable end. The hostelry opened in 1870 and is much favoured by walkers hereabouts. As late as the 1970s there were no beer pumps here, each glass of beer being fetched to order from the cellar. It has rooms to let within, and also at other properties in the village; the front bar has a lot of old oak, a flagstoned floor and much beamwork. There is a footpath, running from across the road, which accompanies the river past pretty cottages and gardens. Naunton is a place of dry-stone walls, one of which neatly surrounds the village pump.

Along the main village street, there are fine historic houses and many attractive cottages, including the rectory of 1694. The gabled Cromwell House was built in the mid 1600s and once belonged to the Aylworth family, who were staunch Parliamentarians at the time of the English Civil War.

The Windrush in full flow in front of the former mill, now residential.

Richard Aylworth fought against the Royalist army at Stow-on-the-Wold, shutting up his prisoners in the town's parish church. Cromwell House is now rendered and lime-washed. Dale House is of *c.* 1700; and Longford House is of 1800. The Baptist Chapel was erected *c.* 1850, and has a magnificent pair of wrought-iron gates. The village school was built in 1864.

St Andrew's church lies on a leaf-sheltered knoll, also near the river, where it has been since the thirteenth century. It is predominantly built in Early English and Perpendicular styles. The fifteenth-century battlemented and pinnacled three-stage tower has two sundials by Thomas Baghott: one is square and dated 1748, the other is circular and inscribed *Lux Umbra Dei* – 'light is the shadow of God'. Both have Roman numerals. Most of the church was rebuilt in the sixteenth century, but two of its nicest features – the pulpit and the font – were made in the fifteenth. The stone pulpit of *c.* 1400 is richly carved with panels, tracery and buttresses, and the octagonal font bowl has quatrefoils in circles, four-leafed flowers, shields, and stands on a pillar with trefoil-headed niches. The church has an Anglo-Saxon cross that has been relocated into the north wall of the nave, and some reset Norman masonry. Essential repairs were made in 1878, and a complete restoration that took place in 1899 included underpinning of the walls, and new pinnacles for the tower.

For walkers, the Windrush Way is about a mile to the south, and the Warden's Way passes through the village. If you wish to follow the course of the river's upper reaches, you may do so along a parallel country road. The waterway may be temporarily lost in Leigh Wood, and it will suddenly head off across the meadows south of Naunton. You, meanwhile, may take a scenic route through the Slaughters.

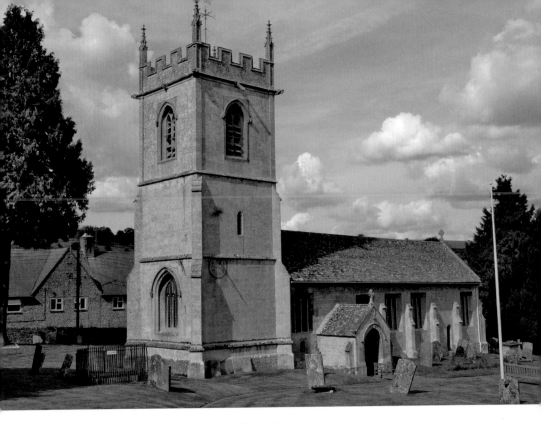

St Andrew's church lies on a leaf-sheltered knoll near the river.

A footbridge across the Windrush.

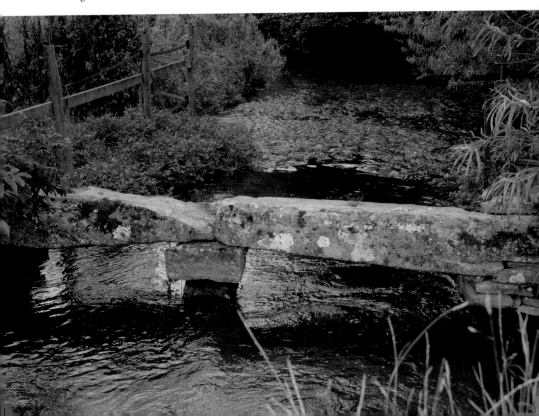

Upper Slaughter

The word 'slaughter', in this regard, is thought to derive from the Anglo-Saxon word *slohtre* – meaning 'muddy place'. A tenth-century charter calls it *Slohtranford*, and, at Domesday, it was *Sclostre*. Another version suggests that a Norman landowner hereabouts, Philip de Sloitre, may have consolidated the name as it is today. The Slaughter family lived at the old manor house, possessor of a forest of chimneys and a dozen gables. It was built on a sloping site that was inhabited in the fourteenth century, was possessed by the Abbey of Evesham, and which came into private hands at the Dissolution. Primarily Elizabethan, the house was famed for its stone-vaulted basement, and the semi-circular pediment with Doric and Ionic pilasters with which all-comers were faced after it was extended in the seventeenth century.

The church of St Peter, a Norman foundation, restored 1877.

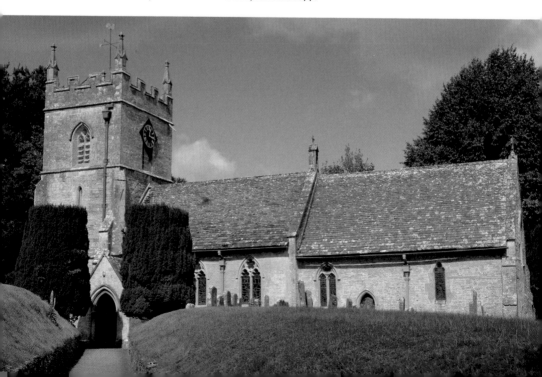

An old footbridge across the river.

There is a shallow ford across the road at Upper Slaughter, with a footbridge by its side. Here, it is the River Eye or Eyford, colloquially known as Slaughter Brook, which rises amidst ancient earthworks on higher ground about one-and-a-half miles due north of Upper Slaughter. Its waters make their way towards the Dikler and thence into the Windrush near Bourton-on-the-Water.

The river meanders through Upper Slaughter, bubbling and dancing beneath the stone slabs of the little footbridges beside a cluster of farm buildings. It quietens down within a few yards of the road ford then filters through lush vegetation, and escapes across the fields – pure, clear and inviting as it curves around the site of a one-time motte and bailey castle. Just as there was no 'slaughter' here, neither was this the case for any its residents through two world wars. This is one of the so-called 'thankful villages'; it sent twenty-five of its sons to the Front in 1914-18, and thirty-six went to fight 1939-45. All sixty-one came back safely, and everything that the wars threw at Upper Slaughter was also dealt with without loss.

Close by, is the former Methodist chapel, dated 1865. In 1906, the architect Sir Edwin Lutyens bought Upper Slaughter and set about remodelling many of its cottages, including the medieval almshouses on the square. Everything is

built of local limestone, roofed in Cotswold stone tiles, and huddled together around the church for comfort. Some of them are gloriously misshapen, have stepped chimneystacks, or strangely shaped stone-built extensions that invite closer inspection. Many have either long cottage gardens at the front or considerable vegetable gardens at the rear. From a vantage point in the square, one can see most of the village. Like its near neighbour, Lower Slaughter, the village has become a honeypot for tourists in pursuit of the picturesque, and film companies anxious to capture the Cotswold idyll. Despite these intrusions and the gradual decline of the old farms and the takeover of former agricultural workers' cottages by outsiders, both villages have kept their character. Farm buildings, if now residential, are still much in evidence hereabouts.

There are also a handful of larger residences, mostly built in the seventeenth and eighteenth centuries, and a village hall. It was at Upper Slaughter where Francis Edward Witts (1783-1854) wrote the diaries that record village life between 1820 and 1850, and which were published more than 120 years later as *The Diary of a Cotswold Parson*. Revd Witts, who was rector from 1808 until his death, inherited the manor estate from an uncle, and purchased the title to Lord of the Manor. Although he lived at the rectory – which can still be seen – his inherited home was also what is now the Lords of the Manor Hotel. The Witts family created the hotel in 1972, relinquishing their interest thirteen years later. The fabric of the hotel dates from *c.* 1649, although it may be on the site of a fifteenth-century building. The porch is Jacobean. There are eight acres attached, with parkland and lake.

Upper Slaughter is such a small place, yet those who are buried around St Peter's church are in subterranean layers, for the churchyard is at least six feet above the floor of the church. The original church, dated *c.* 1160, is a homely affair with two fonts – one thirteenth-century, and the other a retrospective piece of the thirteenth – yet it struggles to present its Norman origins coherently. It is largely Early English and Decorated. Subsequent re-builders found such other uses for the ancient fabric that, until what amounted to a wholesale interior remodelling in 1877, St Peter's bore little likeness to what it is today.

The church consists of chancel; three-bay nave; north aisle with a north chapel of 1854 separated from it by a stone screen; south porch; and an embattled western tower, which was rebuilt in the fifteenth-century, with pinnacles. Before the Restoration, there was no south porch; if one previously existed, it had been removed in favour of an entrance through the tower, and the south door blocked up. Inside, is a cinquefoiled, cusped piscina, and an arched and gabled sedilia with consecration crosses. The mortuary chapel, built in 1854, contains the altar tomb of the Revd F. E. Witts. The fifteenth-century chancel is attractive enough; so is the chapel – said to be by Benjamin Ferry – if you are a lover of competent, mid-nineteenth-century Decorated.

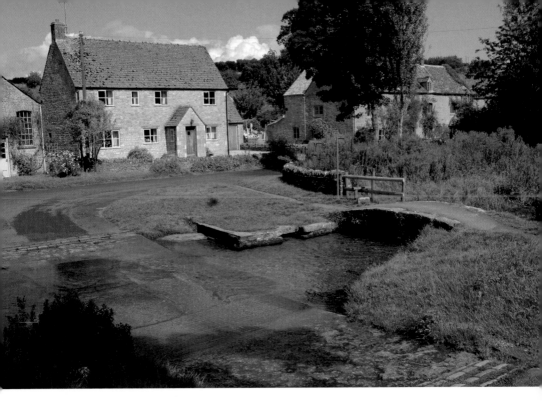

A ford in the river.

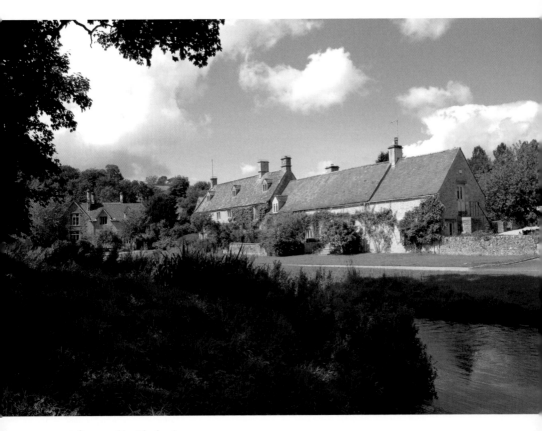

A farmstead beside the river.

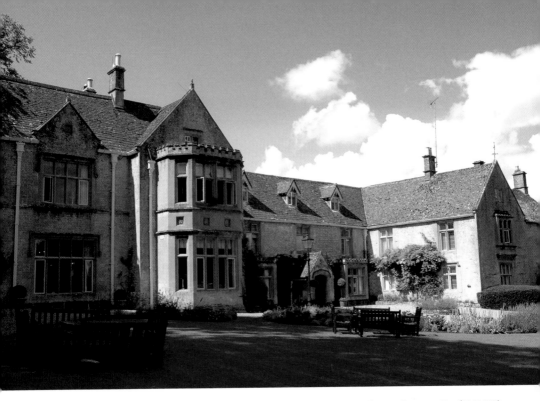

The Lords of the Manor Hotel, a seventeenth-century one-time rectory that was home to Revd F. E. Witts.

Typical cottages and cottage gardens at Upper Slaughter.

Lower Slaughter

Lower Slaughter is what Bourton-on-the-Water would be without commerce, retail, or the summer crowds; how it is now, its more gregarious neighbour used to be. There are several parallels, and Lower Slaughter has more to offer than just the River Eye, whose way through the village en route to the Windrush south of Bourton is the subject of countless thousands of photographs. Here, the gravel-bedded Eye has a wide collar of grass on either side, and it ripples a generous course through the centre of the village, beneath a succession of low, weathered bridges. Some of these are made of timber; others are just stone slabs; and one occasionally comes across a bridge of similar design to those at Bourton-on-the-Water. You can walk the course of the waterway between Upper Slaughter and Lower Slaughter.

The Eye passes beside the village green, upon which the village well still stands beneath its little buttressed gable. It is often dressed, as is the custom hereabouts (there are similar wells in the Rissingtons). Here, the scene is completed by a gentle curve of sixteenth- and seventeenth-century stone-built, former farmworkers' cottages, larger houses, and a cluster of background roofs. From the moment the Eye enters the village, to the moment it exits the place, it frames and links several picturesque aspects. What could be more appealing than the pond beside the old mill wherein two or three horses stand drinking whilst their riders chat casually in the sun?

Lower Slaughter's old cottages are so endemically of the Cotswold vernacular that relatively modern building projects have been carefully done to maintain an illusion that the whole place is of a piece. The village was given a school building in 1871, financed by the lord of the manor; after sixty years, it was converted to cottages for residential use. The village hall was built beside the river in 1887, and continues to be well used.

The one-time manor house dates to before the Norman Conquest, and was, in the fifteenth century, a convent for nuns from the contemplative Order of Syon, the mother abbey having been established in 1415. In the walled garden, a two-storey, double-gabled dovecote, with twin columbaria and square-

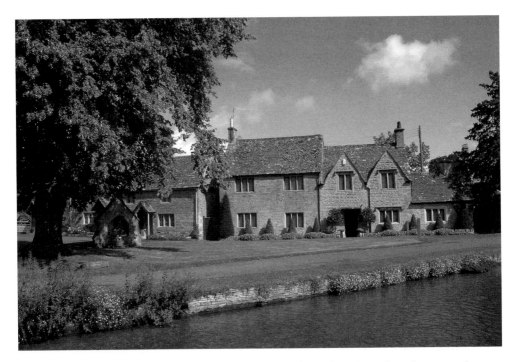

The river winds through the village against a backdrop of appealing sixteenth- and seventeenth-century cottages.

headed windows with mullions and dripstones, dates from the fifteenth century. It is a beautiful building per se, and one of the best of its kind to be found anywhere. The nuns probably remained until the Dissolution, when the convent became crown property and was eventually disposed of in 1603 to Sir George Whitmore, sometime High Sheriff of Gloucestershire. Much of the house was rebuilt in 1658 – the date on a stone fireplace there – by Valentine Strong, albeit not in the Cotswold gabled tradition. There are steps up from ground level, in order to clear the high basement, and the entrance porch into which they lead is set sideways on. Purists may dislike the resulting visual impact of this intersection with the new wing that was added in 1891; others will find that it adds character. The house remained in the possession of the Whitmore family until 1964, and is now the Lower Slaughter Manor Hotel. This exudes classical elegance and architectural detail on every level, including some highly decorated seventeenth-century ceilings. There is an attractive coach house and stable block dated 1770 in the grounds; its symmetrical façade has doorways and arched coach entrances with keystones, round and square-headed windows, and is topped by an octagonal wooden cupola. The stone gate pillars here were strongly attributed locally to Inigo Jones, but without a shred of evidence.

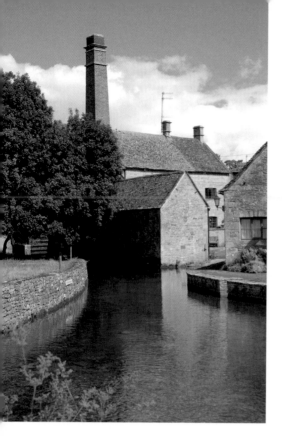
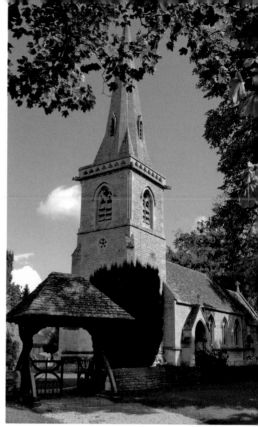

Above left: The early nineteenth-century corn mill and water wheel in an attractive setting beside the pond.
Above right: St Mary's church, rebuilt by Ferry in 1867.
Below: Old stone footbridge across the river.

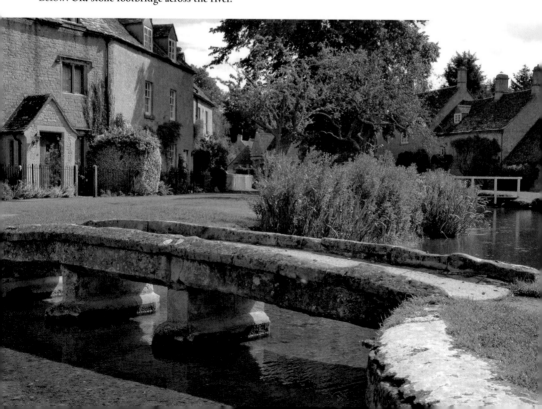

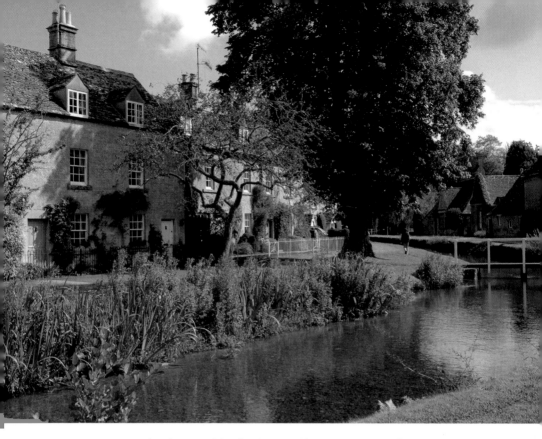

A pretty waterway, here known as 'the Slaughter brook', runs through the village.

The former stable block at Lower Slaughter Manor.

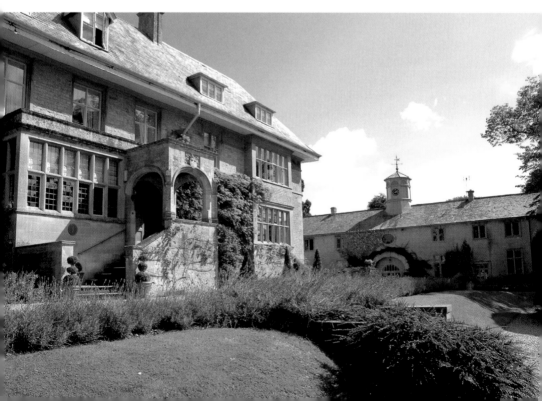

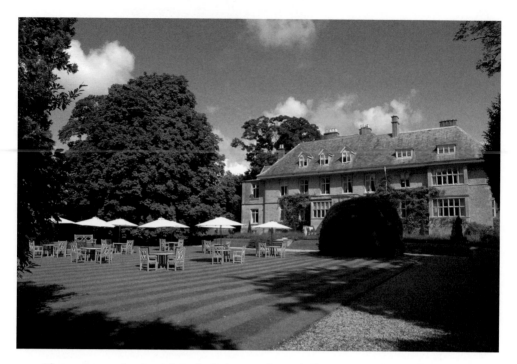

The manor, now a hotel, pre-dates the Conquest and was rebuilt in 1658 by Valentine Strong.

Just around a bend in the road, where the River Eye laps against its garden wall, is Washbourne Court, which became a hotel in 1988. Parts of this building date to the seventeenth century, and it was once used as a residential cramming school for Eton. The complex that surrounds it is effectively a village of mews cottages in Cotswold stone, built to incorporate three farmworkers' cottages, a barn and a stable block that have medieval origins. The complex here was formerly called Washbourne's Place, allegedly taking the name of the land-owning family in the fifteenth century. The main building was remodelled into a private residence in the 1920s, and the relatively new build is seamless.

In Lower Slaughter, you will also find the Old Mill in a very attractive spot on the river. This early nineteenth-century corn mill, with a water wheel and a distinguishing red brick chimney, was a working mill until the 1960s. Since 1995, it has been partly an agricultural museum, which includes one of only three unused millstones in the country. There is also an antiques shop, craft shop, and tearoom, well known for its handmade organic ice cream. You can tap away to the music of the 1920s and '30s, for the owner and founder, Gerald Harris, is also a jazz singer who fronts the Alex Steele Trio of piano, bass, and drums. He is often to be seen performing at the nearby Washbourne Court Hotel.

The pigeon house at Lower Slaughter Manor.

There is a sixteenth-century dovecote next to the churchyard. St Mary's is predominantly a Benjamin Ferry creation of 1867, paid for by Charles Shapland Whitmore, QC, recorder of Gloucester, who was then Lord of the Manor. The work was done in Early English and Decorated style, although the church retained an authentic Transitional Norman nave arcade. This is of four bays; the capitals are scalloped, and the arches pointed, and of two orders chamfered. Its plan is similar to several others in the area, consisting of chancel, nave, north aisle, south porch, and a western tower – here with a spire.

If you choose to drive through the Slaughters, you will pick up the Windrush again at Bourton. The road across Harford Bridge is your alternative. Here, sheep once packed the wide meadows, the sides of the green valley are steeper, and it is accentuated by the height of the hills on either side and the particular flatness of the approach through meadowland. If you want to stretch your legs, a footpath accompanies the Windrush between Harford Bridge and Bourton. Beyond the bridge, the Windrush flows south-east into an ever-enclosing valley brushed by an area of woodland, and for much of the way is accompanied by the line of a disused railway embankment. It emerges just in time to encounter the Fosse Way and the stone bridge beside the road into Bourton-on-the-Water.

Above left: The courtyard at Washbourne Court Hotel in summer.
Above right: A footbridge across the river.
Below: Washbourne Court, a group of part-medieval buildings, remodelled into a private house in
the 1920s, and turned into a hotel in 1988.

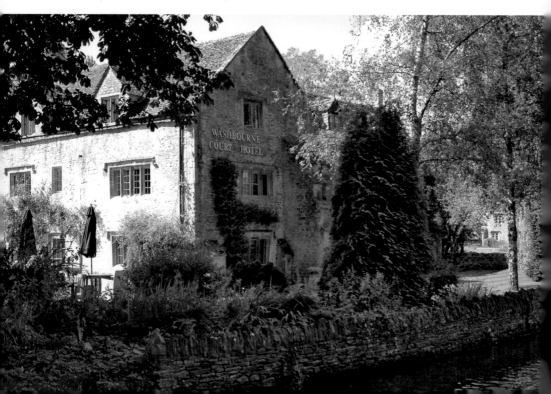

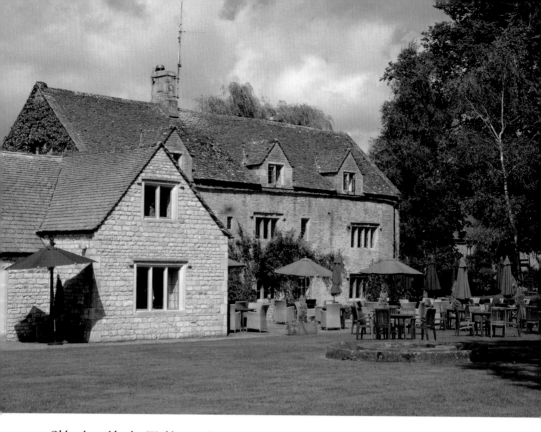

Old and new blend at Washbourne Court.

The village well.

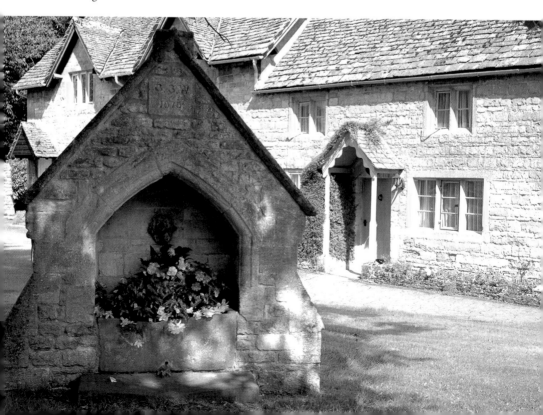

Bourton-on-the-Water

Bourton-on-the-Water is about ten miles from the source of the Windrush. Its name is derived of *burgh*, meaning camp or fortification – in this case that of the Iron Age settlement at nearby Salmonsbury, the highest point in the vale hereabouts – and *ton*, meaning estate or village. Thus, one arrives at the village next to the camp.

The river reaches the outskirts of Bourton beneath the Fosseway Bridge or Bourton Bridge, and over a modern little weir. This bridge was rebuilt in 1806, and was widened in 1959. Once it has escaped the weir, the river widens, running clear and strong beside the roadway into the village, accompanied by sentinel trees, diverging only to take account of some attractive private dwellings. Then it tumbles into Bourton beside the old mill, and thereafter gathers credibility, width, and a sense of purpose. The former mill and a run of mill workers' cottages stand where the village's first little road bridge straddles the course of the incoming Windrush. The river may seem to appear from nowhere in front of the mill, but there is no missing its steady course down the high street. Here it really earns its keep. The collection of little bridges is both a necessity and an identifying feature, and the wide greens that accompany the river are the pleasure grounds of the village. No one would deny that, particularly during the summer, the waterway has sufficient influence to enable a range of visitor-oriented commercial enterprises to flourish around the village. In the 1890s, the young Gustav Holst, then organist and choirmaster at nearby Wyck Rissington, was appointed conductor of Bourton's amateur choral society. His compositions *A Festival Chime* and *Turn Back O Man* were written at this time for just such an ensemble of singers and orchestra.

It is here that tourism and the Windrush really combine. The Windrush Way, a trek of thirteen miles or so, follows part of the Windrush Valley and is sometimes associated with the Warden's Way of similar length. Together, these give a circular walk between Winchcombe and Bourton-on-the-Water.

The Windrush runs through the centre of the village, hardly above ankle height, beneath little low, arched bridges. The wide green that now so neatly

The Cotswold Perfumery in Victoria Street.

sets it off, where on summer days tourists, picnickers, and family groups turn the waterside into as densely packed an area as any popular beach, were once private gardens that formerly ran down to the river on either side.

Here are the bridges in sequence. Bourton Bridge is to the west of the village centre, where there was a ford in Anglo-Saxon times at the Fosse Way. Next is the eighteenth-century Lansdown Bridge. Mill Bridge (aka Big Bridge or Broad Bridge) of 1654 follows; then comes Narrow Bridge (aka High Bridge) footbridge of 1756; Victoria Street road bridge that was built for G. F. Moore in 1911; Paynes footbridge of 1756 is next; and the final crossing is by Coronation Bridge, which replaced a wooden footbridge in 1953. Bourton has been referred to as 'the Venice of the Cotswolds', not because it is in any way similar to that city, but by reason only of the number of bridges so close together.

In high summer, thousands of people disport themselves alongside the Windrush at Bourton; children play in the river, and organized activities take place in its shallow waters on high days and holidays. For more than a century, games of five-a-side football have taken place in the water, for here its depth averages less than a foot. At Christmas, it provides the setting for the village's Christmas tree. Bourton-on-the-Water is the Cotswolds' day out for all the family, and it markets itself as such with a wide range of attractions.

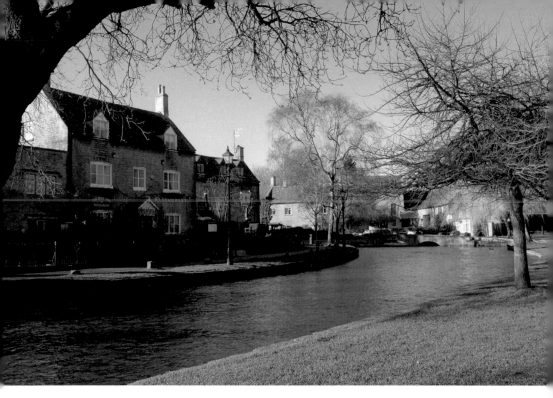

The river is a tranquil focal point, running through the village centre.

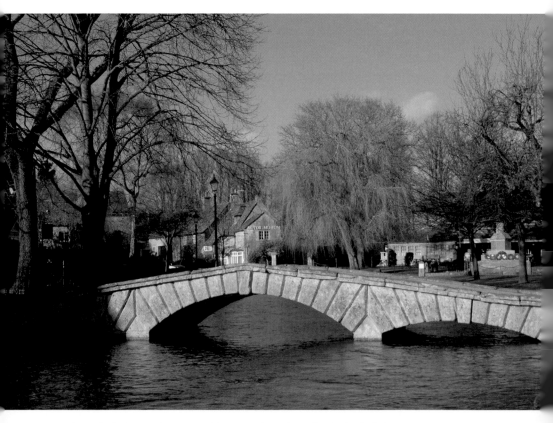

The quaintly designed Narrow Bridge or High Bridge, a footbridge built in 1756.

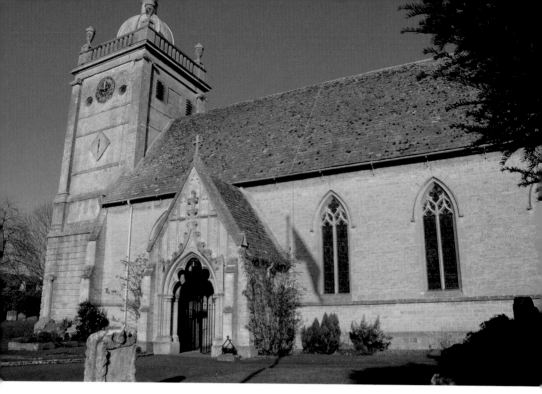

The church of St Lawrence is a Georgian and Victorian rebuild on the medieval site.

The church of St Lawrence; and the former rectory, now Glebe House.

The village is packed with historic places where you can stay, and where you can eat, all centred on the Windrush. You can sit in cottage-style gardens, eating homemade food whilst listening to the splashing, and watch the crowds go by. As if there were not enough major visitor attractions here, the village's gift shops, galleries and visitor-oriented specialists also flex their blandishments with consummate skill. In the season, Bourton-on-the-Water is the painted face of the Cotswolds. It is a place where the beast of twenty-first-century marketing has made the beauty of history and nature into a seductive siren. All about are attractive cottages and terraces, mostly dating from the seventeenth century, and a number of larger dwellings and public buildings that were built during the eighteenth. One of the best of these is Glebe House, next to the church, the one-time rectory with its beautifully symmetrical five-bay, three-storey front. When there are fewer visitors, these lovely cottages, golden-walled, dormered and bow-windowed, quietly re-assert themselves; the river seems to slow down and the main street perceptibly widens. Then, Bourton is even more beautiful than you might imagine.

The parish church of St Lawrence was built on a pagan site. Pevsner called the building 'this exceptionally beautiful nineteenth-century church'. It has a twelfth-century crypt that was once joined by a tunnel to the manor house – on the site of which was formerly one of the Abbot of Evesham's residences. Most of the early Christian building was pulled down in 1784. The rebuild was entrusted to a local architect, William Marshall, and he kept the chancel of 1328 – the oldest part of the church extant above ground. The Classical-style Georgian tower, of 1784, was also by Marshall. Ionic pilasters climb the corners, and within the balustraded parapet, with its fine urn finials, the love-it-or-hate-it lead-covered dome is something of a surprise. It is not liked by purists, but is an attraction for tourists.

During rebuilding in the nineteenth century, the chancel was given a ceiling of square panels. In 1928, these were painted by F. E. Howard with heraldry associated with the church, its benefactors, patrons, and certain dioceses. The church has a nineteenth-century king post roof in the nave, and inside there are some nice Classical and Baroque monuments. The place was rearranged in 1810, and in 1875 was extended by Sir Thomas Graham Jackson – well known for his work on Oxford colleges – who added a new north aisle and south porch. The latter, with its ogee-arched foliated and cusped opening that pretends to be Decorated, is his piece of nineteenth-century whimsy. However, it does reflect the true fourteenth-century work within; the tracery in the chancel and elsewhere, the priest's door, and the piscina are all of this date.

The overall appearance is not of Georgian Gothic, but of Gothic bolted on to Georgian. There are some nice headstones and table tombs in the churchyard; the decorative stonework is varied and nicely done, and there is

The Dial House, built by architect Andrew Paxford as a private residence in 1698.

much headstone symbolism and some fine calligraphy to enjoy. This a calming place to potter, away from the crowds by the river.

Since the 1960s, John Stephen's family business has been here, next to the Windrush, manufacturing and selling perfumes. The premises of The Cotswold Perfumery in Victoria Street were formerly the village garage, although far more pleasant odours now bring tourists (in season) and local residents (mostly out of season) to test their olfactory memories and take with them some fragrance of their visit. Whilst you can sniff in the fragrant garden outside, John does so indoors, creating blends and manufacturing perfumes in his laboratory from more than 600 essential oils and absolutes. His creations, and a range of accessories, can be purchased in the perfumery's shop. You can tour virtually all areas of the operation, and the establishment is also an education centre for anyone who is interested in the sources, history and psychology of fragrances.

The oldest of Bourton's visitor attractions is the model village, constructed behind a one-time lodging house said to have been built in 1714 out of cottages and agricultural buildings. Cecil Arthur Morris, engineer, and his wife Winifred came to the New Inn in 1930. In their care, a covering of plaster was removed from the inn's façade, revealing the original Cotswold stone, and the place was renamed the Old New Inn. Cecil had grandiose and fanciful ideas

Independent traders in the centre of the village.

Central streetscape features the classical-style bank building, erected as a private house in the eighteenth century.

The Windrush Garden Café beside the green.

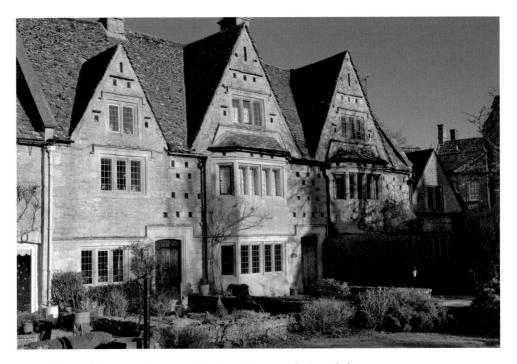

Gabled, mid-seventeenth-century Sherborne Terrace, with pigeon holes.

for a woodland glen with a waterfall, in what was once the hostelry's vegetable garden. In 1936, he modelled a bridge on Bourton's Victoria Street Bridge, then added a model of the Victoria Hall. Thereafter, the couple painstakingly measured all the old buildings in the village centre, adding them one by one to the model. Six local craftsmen worked on this accurate reconstruction, with its own River Windrush, built out of specially selected and collected Cotswold stone from local quarries.

Finances dwindled within a year, so what was intended as a hobby was opened to the public in 1937, and a small entrance fee was charged to enable further work on the model. The project was finished in 1940, and a gardener, a stonemason, and a carpenter now maintain it. Its owners call it 'the one-ninth wonder of the world', for that is the scale in which the village is presented behind the Old New Inn in Rissington Road. The model of Bourton remains the only construction of its type in the country to represent a real settlement.

The Cotswold Motoring Museum is in the mill buildings on Sherborne Street, hard by the Windrush. It was established as a tourist attraction in 1978. The mill forms a group with the adjacent former mill workers cottages, just beyond the quaint little historic road bridge. Their courtyard approach is littered with staddlestones, millstones and cartwheels, and inside the old mill there is an explosion of historic bicycles, motor bikes, motor vehicles, motoring artefacts and ephemera. This is a wonderful place, displaying tens of thousands of items associated with the history of motoring, through the golden age of leisure, and into the late twentieth century. It is not only a museum of the hardware involved in motoring, but also of the traditional accompaniments – old cameras, gramophones, picnic baskets and the like – of those who took to the road by pedal- or engine-power.

Here are displays in the likeness of just about every country garage you might have come across during the first half of the twentieth century. It could take you just one visit to enjoy the cars; another to read the walls on which there are more than 800 period advertising signs; and goodness knows how long to go through the tens of thousands of artefacts that link just about every moment of the age of leisure motoring up to the 1960s.

Birdland, Rissington Road, opened in 1957 and has been on its present site since 1989. It was built by Len 'the birdman' Hill – widely known as 'the penguin millionaire' – in the garden of his home at the Elizabethan manor house. Len, who died in 1981, was as notable for his charity work as he was for the great visitor attraction that grew out of a boyhood interest in horticulture and aviculture. Essentially, Birdland is an island beside the Windrush, supporting mature gardens – wherein you will find numerous habitats, more than fifty aviaries and over five hundred birds – overhung by an extensive woodland canopy. Living here are numerous tropical and exotic birds from

across the globe, and a good selection of native species of waterfowl. The park carries out an active breeding programme.

In 1995, Kit Williams created the labyrinth and rebus puzzle that is the Dragonfly Maze, between Birdland and the model village. Participants can just go round it as they might any other maze, searching for the centre. However, for those who really want to enter into the spirit of the puzzle, there are numbered flagstones, flanked by yew hedges, which gradually reveal the means of reaching the bejewelled dragonfly. It is all good fun.

Bourton craftspeople John and Jude Jelfs run The Cotswold Pottery in Clapton Row. The couple have run their creative studio pottery in the village since 1973, and supply some of the country's most prestigious galleries and museums. Here is a combination of potter and sculptor specialising in one-off, individual pieces, made entirely from local materials using traditional methods. Also more than three decades old is the model railway exhibition in High Street: some 500 square feet of landscaped OO/HO and N gauge layouts.

Several of Bourton's more interesting historic buildings are now hotels. The Old New Inn, mentioned above, was made out of a couple of cottages and a barn that were remodelled in the seventeenth century. The Dial House Hotel, High Street, was built in 1698 for an architect named Andrew Paxford, when it was called Vine House. It has been a dairy, home to various doctors, and treatment rooms. The dining room has Tudor windows, a large inglenook fireplace that has wooden seats and several recesses including a salt cupboard, and a spice cupboard on the wall. The Old Manse Hotel, Sherborne Street, was built as a residence for the village's Baptist minister in 1748, and was financed by wool merchants in the congregation. It has a splendid frontage, beside the Windrush. There have been Baptists at Bourton since the mid seventeenth century, and their present church, of 1876, is in Station Road. Close by the western road bridge over the river is Chester House Hotel; this was an old inn with a courtyard, made by converting a number of old farm buildings.

In 2007, some 167 homes and business premises in the centre of the village were affected when five inches of rain fell in just fourteen hours and the Windrush spread uncharacteristically about the place. In the immediate aftermath, the number of visitors plummeted by nearly one-third, and they continued to stay away even though most affected businesses were up and running within a few days. Bourton, and indeed much of the Cotswolds, had great difficulty in assuring people that it was open for business. The flooding highlighted just how much Bourton-on-the-Water relies on the visitor trade, and how vulnerable is a place of small, independent retailers – the very factors that give Bourton its visitor appeal – which do not have the backing of lucrative and powerful high street names. Here, the Windrush may have begat tourism, but tourism has become the behemoth of Bourton.

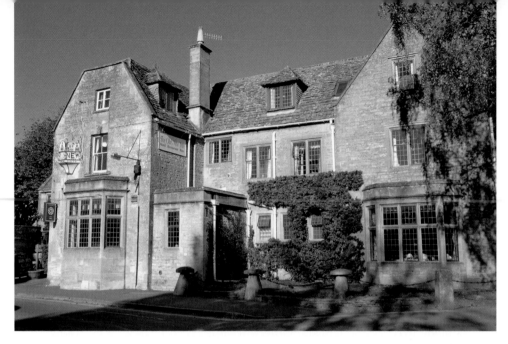

The Old New Inn, a hostelry in the seventeenth century, coaching inn, and now the site of the model village.

Just south of Bourton, the river is joined by the River Dikler, and thereafter it wobbles in the landscape all the way to Burford. Close by the spot where the two waterways combine, there is a series of quite beautiful lakes, full of waterfowl and wetlands fauna and flora, created when gravel extraction ceased there in the 1960s. You can follow the Windrush closely by the minor road that progresses through Upper Rissington and Little Barrington. A little to the east of Bourton is Greystones Farm Nature Reserve and the wildlife- and wildflower-rich Salmonsbury Meadows, bisected by the Oxfordshire Way. They both lie between, and on the flood plains of, the Windrush and the rivers Eye and Dikler that eventually feed into it. Salmonsbury is an 85-acre Site of Special Scientific Interest, and the wet meadows are an absolutely stunning diversity of flora and wildlife. It is managed by the Gloucestershire Wildlife Trust. The adjacent site of the Salmonsbury Iron Age hill-fort means that the area around the farm is of archaeological significance. There is an archaeological walk, and walks around the adjacent meadows.

Hereabouts was great sheep country; the flocks belonged, in medieval times, to the land-owning monasteries, and a lot of the wool was exported. At the Dissolution of the Monasteries, the estates passed into private hands and were run by rich families, who built the fine country houses for themselves that dominated the villages. The first three of these settlements, to the south of Bourton-on-the-Water, are not strictly in the Windrush valley, being built in each case into the hillside about a mile from the river. However, they face into the valley, and must be considered to be of it.

Wyck Rissington

Just north-east of Bourton-on-the-Water, between the rivers Dikler and Evenlode, and on the Oxfordshire Way, lies this village, where the road that runs through is so narrow, and the grass verges – punctuated by large horse chestnut trees – so wide on either side, that the place seems to be arranged around a long, continuous village green. In fact, the relatively few seventeenth-, eighteenth, and nineteenth-century cottages and houses that comprise Wyck Rissington, with their occasional stone mullions and pretty dormer gables, are mostly set back on one side of the roadway. The village school, opened in 1848, closed ninety years later. A lady of the manor provided a reading room in 1900, which continued until after the Second World War. A pond, a fine farmhouse adjacent to it, and the little stone, Victorian gabled fountain add character. There are several old farmhouses scattered about, and a few farm complexes are still working in some manner of trade.

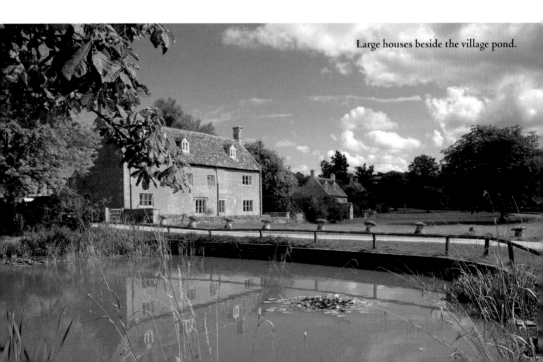

Large houses beside the village pond.

The pretty village well.

The Rissingtons derive their name from *hrisen,* which might describe a covering of brushwood thickets, and a hill, *dun.* The distinguishing *wick* would have been a small farm or collection of buildings.

It is all about St Lawrence's church, a Norman and Early English building that was enlarged in 1833 and restored with the addition of a north aisle in 1879. The nave has a catslide roof; and the thirteenth-century chancel is remarkable for its windows. There are two pairs of slender lancets with diamonds in the heads, as plate tracery, at the east end; smaller lancets with ancient stained glass, including a depiction of the Crucifixion, in the north and south walls of the chancel; and decorated and Perpendicular windows. The stone font is Norman.

The little village church is where Gustav Holst was appointed organist and choirmaster aged seventeen, and played there 1892-3 on the organ that was brought there in the 1870s. The church is also associated with Canon Harry Cheales who, following a dream, constructed a liturgical maze in the rectory garden in the 1950s. Within the maze were fifteen way-marked pilgrim stations, each containing a wooden carving, for prayer and contemplation. Following the canon's death in 1980, the rectory was sold and the maze dismantled, although a mosaic of it was placed in the church.

Just outside the village is Wyck Hill House. It was built early in the eighteenth century as a wedding present for a member of the Corbett family, and enlarged about forty years later, when it was given the double-height bow window that distinguishes it today. The house was associated with a number of the local landed families during the eighteenth, nineteenth and early twentieth centuries, but became a succession of schools from the 1940s. The earliest part was gutted by fire in 1958; it was restored to residential in the early 1960s, and, since 1989, has been a hotel of the same name. This is set in one hundred acres, from where there are stunning views across the Windrush valley.

The road through Wyck Rissington, never wide, narrows still further as it leaves the village in the general direction of Upper Rissington, and in places only admits single-file traffic. On either side, the banks and the hedges are high, and one has a great sense here of how the old tracks must have been, as made by wandering cows. In places, the bends are sharp, the gradient undulates, and the sides are so broken away and rutted that the motorist can only hope for the sake of his tyres and suspension that no other vehicles will be coming in the opposite direction.

Pretty cottages beside the wide greens at Wyck Rissington.

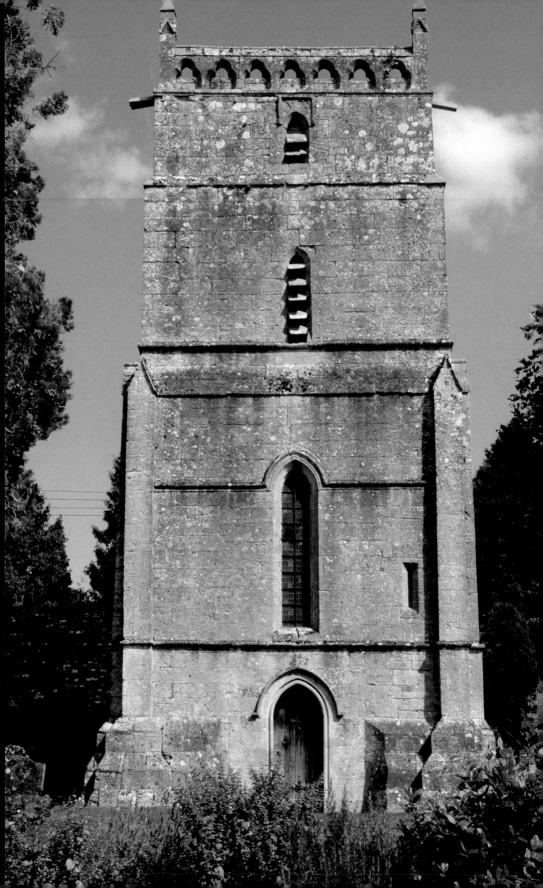

Upper Rissington

Until the 1990s, this area was simply the site and environs of RAF Little Rissington. It lies to the east of the minor road between Wyck Rissington and Little Rissington, and one that will eventually take you across the Windrush at the Barringtons. Built by the Ministry of Defence as an RAF aerodrome and service station that was opened in 1938, RAF Little Rissington was, 1946-76, the home of the Central Flying School. Here too, were the Red Pelicans aerobatic display team, formed 1964 and disbanded in 1973. They were one of a number of RAF display teams that operated locally throughout the country at the time, but were almost immediately succeeded by the Red Arrows who took over the RAF's aerobatics in 1965. Although the Red Arrows were actually stationed at Kemble, they first displayed at RAF Little Rissington; they were also in the charge of the Central Flying School that was stationed there. For this reason, Little Rissington was considered to be their proper home.

The Red Arrows relocated in 1983. In 1996, the Ministry of Defence began to sell housing around the airfield, much of which had been put up as officers' married quarters, for private development. Speculative building firms took over, and created the village of Upper Rissington, with street names like Avro Road, Siskin Road, Sopwith Road, and Wellington Road that recall its airforce past. The military housing was modernised and sold into the private sector. The airfield is now used for cadet force training, gliding, hang gliding, and, occasionally, as a film set.

The new village lies behind a long Cotswold stone wall, adjacent to the road to the Barringtons, and this gives it the appearance of being set apart from the world. It has a general store, a tree-lined village green, a children's play area, and a community hall. Since 1994, the family-run Cotswold Reclamation Company has been at Upper Rissington, where there is also a business park.

Opposite: The church of St Lawrence originated in the twelfth century.

Little Rissington

A brook to the south of the village, and another to the east, connect just north of Great Rissington and thereafter wander into the Windrush. Little Rissington is small, and is mostly an arrangement of narrow roadways about the thoroughfare to Bourton-on-the-Water. History has moved it about; it has no discernible centre but describes a kind of nucleus based on the way its houses and cottages are grouped on the curving site that slopes towards the river. Much of the place was built of stone from the nearby quarries in the seventeenth century, and there is evidence of expansion during the nineteenth.

In the village are the remains of stone fountains, dated 1874 and 1875, like little seats set beneath round arches in stone walls. The school, of 1840, was closed in the 1960s and converted to residential; the shop and the post office were lost in the early 1970s. Notable, is the castellated rectory at the approach to the church, and much has been made of Porch Cottage, which once had a wooden porch said to have formerly protected the church door. Of interest too, a cottage made of a seventeenth-century, four-gabled dovecote.

The little Norman church, formerly belonging to Osney Abbey, is dedicated to St Peter and sits in isolation across the fields, on a hill from where there are fine views across the Windrush valley. There is a slope down to it, then a sudden incline between high banks, before a meticulously groomed churchyard is revealed behind its drystone wall. Around it are humps and indentations in the ground, thought to be evidence of a village that was abandoned as a result of the Black Death. At one time, there was a manor house nearby.

St Peter's has an Early English chancel with eight lancet windows, a piscina and aumbry; a two-bay nave separated from the north aisle by round Norman arches, whose cylindrical pillars have scalloped capitals; south porch with a round-headed Norman door; and an embattled north-western tower. The church was restored in 1850, and more widely in 1883 by London architect William Bassett-Smith, when the north aisle was widened. A stairway exists to the former rood loft. The windows in the nave are Decorated, and the octagonal font is Perpendicular. The stained glass was placed in the east

window in 1862 as a memorial to a former rector, Richard Wilbraham Ford.

An airfield was built at Little Rissington in the 1930s, and this became the home of the Service Flying Training School prior to, and during, the Second World War. At the same time, the Empire Central Flying School, based at Hullavington, Wiltshire, was formed in 1942 to continue instructing pilots in succession to the flying training courses that had been run since the inception of the Royal Flying Corps in 1912. This establishment was renamed the RAF Central Flying School when it relocated to Little Rissington in 1946, and it continued to operate on the site until 1976.

Some of the windows in the church are memorials to RAF personnel who were killed in the Second World War. The churchyard has many graves wherein lie people from all over the Commonwealth who were trained at the school and who died on active service. The churchyard cross is a memorial to them all, and the altar cross, presented by the RAF, commemorates those people and the time they spent at Little Rissington. The west window, dedicated in 1983, is a symbolic memorial to those of the RAF and Commonwealth Air Forces who were stationed at Little Rissington during the Second World War. It also commemorates members of the Red Arrows, the RAF aerobatics team.

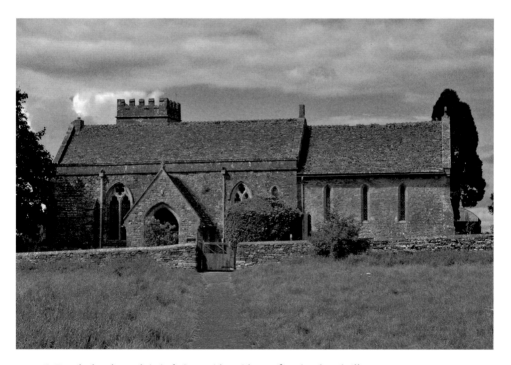

St Peter's church stands in isolation amidst evidence of an abandoned village.

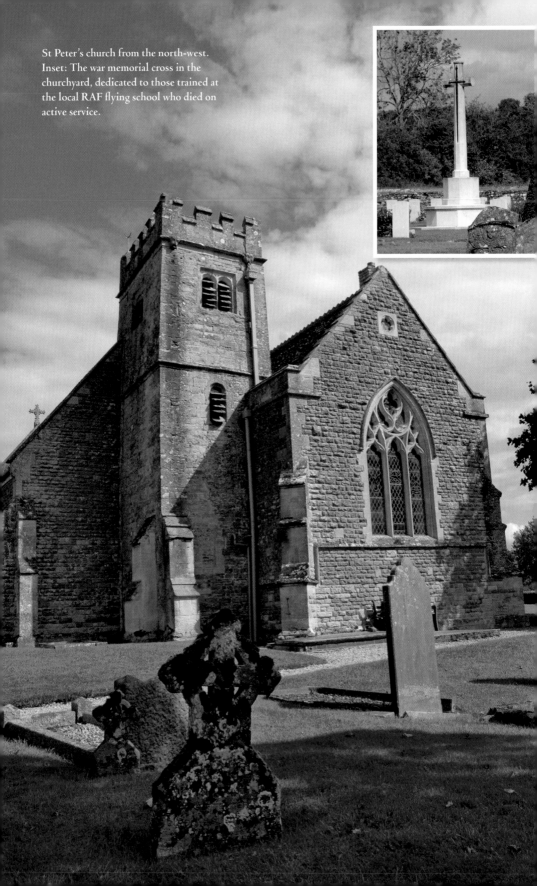

St Peter's church from the north-west. Inset: The war memorial cross in the churchyard, dedicated to those trained at the local RAF flying school who died on active service.

Great Rissington

Here, small cottages line the road and meet about the sloping, triangular village green. The seventeenth-century gabled and mullioned manor house, Georgian rectory, and church are of a cluster at one end of the village, amidst the larger old houses. The village school was built in 1842. Parts of the pretty Lamb Inn, a converted farmhouse that almost certainly brewed its own beer and slid inevitably into the trade, already existed in the eighteenth century. This gabled roadside hostelry begins below road level and wanders down the hillside.

The cruciform church of St John the Baptist, thirteenth to fifteenth centuries, is a catalogue of church building.

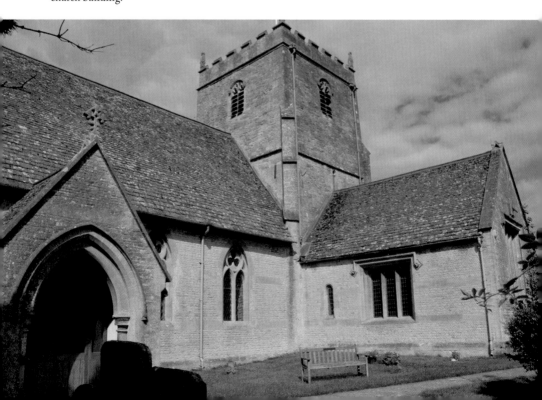

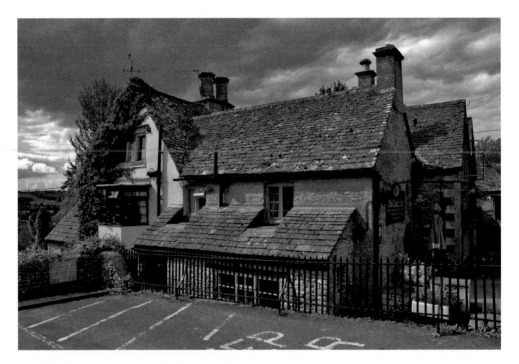

The Lamb Inn was once a farmhouse that brewed its own beer.

Some of the fabric in the cruciform church of St John the Baptist may be from an early post-Conquest church, but it presents an amalgamation of all periods up to the fifteenth century. The church comprises thirteenth-century chancel with a piscina of the same date and a three-light Early English window; rebuilt nave of *c.* 1200; thirteenth-century transepts – one with a chantry chapel; south porch, and an embattled fifteenth-century tower with pinnacles. The church has a pictorial memorial to the five Souls brothers – Albert, Alfred, Arthur, Frederick and Walter – who were all killed between 1916 and 1918 in the First World War. The stained glass in the east window is a memorial to Katherine Emily Lyle, the daughter of a rector here in the nineteenth century. A small monument in the south transept includes the kneeling figures in low relief of John Barnard and his wife, and is dated 1621.

Clapton-on-the-Hill

This little knot of a farming hamlet, once famed for its strawberry crops, is situated some seven hundred feet above sea level. There are extensive views over the surrounding countryside. The approach is by country roads, or on foot along several paths and bridle ways. Here runs the Dikler brook, beyond which there are fine views from the village. It is all seemingly in the middle of nowhere, to the south of Bourton-on-the-Water, and much of it hides away from the two approach roads. Clapton lies on the western side of the Windrush valley, overlooking the river from about a mile distant, and several small streams that rise close to the village almost immediately find their way into the Windrush. There is a narrow lane, which will not suit motor vehicles, between this and the village. The lane, steep at first, largely runs straight as an arrow between Clapton and Great Rissington, and is carried over the Windrush at New Bridge. The stone-built bridge has heavy, double-capped end pillars, and a pointed arch beneath which flows the river.

The hamlet has a small triangular green, a scattering of fairly plain Cotswold-style cottages with pretty dormers, barns, and larger farmhouses. The place was once included in the manor of Bourton-on-the-Water, owned by the monks of Evesham. Words such as 'old chapel', 'granary' and 'wharf' still appear in the names of properties, thereby suggesting brief moments in its history. There was also a school here, established late in the nineteenth century. The place has three main points of reference: physically, its church and Manor Farm, and, by way of a worthy, William Fox (1736-1826) who was a native of the place and who founded the Sunday School Society.

Clapton Manor is a small but impressive Grade II listed, three-storey, multi-gabled Tudor house that dates from 1550 and altered in the seventeenth and eighteenth centuries. It is set in beautiful gardens that were landscaped and replanted by James Bolton – a garden designer and garden history lecturer – and his wife Karin, who opened their home and their calm way of living to bed and breakfast guests in 1993.

The little church of St James, built in the late 1100s.

St James's church is said to be one of the smallest in the Cotswolds and has very thick walls. During the eighteenth century, it was unusable, and for a time a 'Clapton aisle' was added to the old church at Bourton-on-the-Water. Clapton's church comprises chancel, nave, south porch and a small, square bell turret that is capped, louvred, and tile-hung. The church was built in the twelfth century, and, although much of the fabric is Norman, the pointed chancel arch with its plain impost blocks, south porch and little lancet east window are thirteenth century. The latter is dedicated as a war memorial to the men of the place 'who served overseas in the Great War of 1914-1918'. The other windows in the church are square-headed, late Perpendicular, with hood mouldings and decorative label stops. There is an interesting indulgence of a thousand days, carved into the north respond of the chancel arch, and a Norman plain tub font that was chamfered on its lower edge to meet a later, octagonal base. The building was restored in 1670, enlarged and repaired in 1913, and re-roofed and again repaired in 1951. It is, however, old-fashioned and familiar, comfortable and comforting in its quietude.

The church is set within an undulating churchyard. Close to its stone-built wall is a loaf-shaped piece of local Cotswold stone bearing the legend 'Peace be with you', and a small pavement beneath. This is a twenty-first-century memorial to those who are buried nearby after cremation. The churchyard is further distinguished by having churchyard gates made from old horseshoes by Raymond Philips.

Sherborne

The Windrush, on its descent from Bourton-on-the-Water, runs to the east of the Sherborne Park estate. The land here once belonged to the abbey at Winchcombe, and the village, which is arranged alongside the minor road between Farmington and Windrush, straggles the line of the Sherborne Brook. This, which hereabouts can be as wide as an average Cotswold river, begins a little to the west, just north of Farmington. The village of Sherborne is built parallel to the brook as it runs past in the valley before debouching into the Windrush about a mile to the east. It is possible to walk alongside sections of either waterway on footpaths created on National Trust land through the water meadows and adjacent woodlands. These paths run across the fields from Northfield Barn, on the road towards Clapton-on-the-Hill, and connect with public footpaths, one of which runs to Windrush village. It is a good area for walkers.

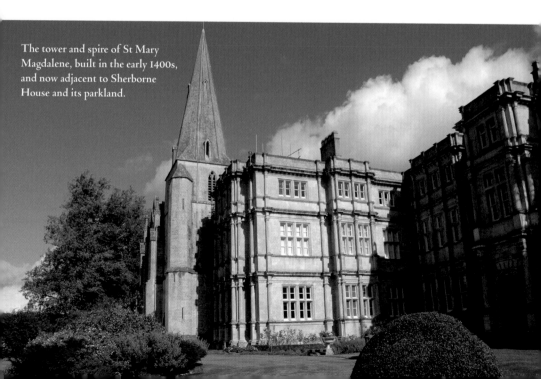

The tower and spire of St Mary Magdalene, built in the early 1400s, and now adjacent to Sherborne House and its parkland.

The coach house and stables, built in the eighteenth century, and now converted to residential accommodation and private gardens.

Effectively, there are three sections to Sherborne. To the west, and at the east, the village begins or ends in groups of cottages built on the north side of the road; in between them, built on the south side of the road, is the Sherborne House complex, the Sherborne Park Estate and the church of St Mary Magdalene. The National Trust owns the village and the Sherborne Park Estate, the latter having been bequested to the Trust in 1983 by Charles Dutton, 7th Lord Sherborne. It consists of 4,000 acres to the west of the river, comprising woodland, parkland, and the village of Sherborne, and includes a wildlife-rich, working estate on which there are six tenanted farms. The Trust has also created several walks centred on its property at Ewe Pen Buildings, one of which connects with public footpaths that lead into the Trust's Northfield Barn walks. Another will eventually take you along the whole of the village street.

Farmhouses and old farmyard complexes punctuate the outlier roads, and some come into the village. The properties at Sherborne have stone-tiled roofs; square-headed windows with stone mullions and dripstones, and some of the doorways have stone hoods. The group of cottages at the west end, built between the 1600s and 1800s, have different characters but all are traditional. To the east are groups of pretty nineteenth-century terraced properties with little gabled windows. One of these properties is now the Sherborne Club, run on a part-time basis by a handful of villagers, wherein beer is served at

weekends. Another was the village post office, until it was closed in 2008. Front cottage gardens are still a feature of Sherborne; there is a war memorial in the model village, and a drinking fountain. At the east end of the village is a residential property sometimes referred to as 'the old church'. It includes two Norman doorways of the twelfth century, a thirteenth-century window, and quatrefoil lights. One doorway is plain; the other has chevron ornamentation, roundels carved in a tympanum, and attached shafts. The presence of two doorways suggests that this was once an ecclesiastical building.

Sherborne House is privately owned, and is now residential. In the sixteenth century, the lands here that formerly belonged to Winchcombe Abbey were bought by the wool merchant Thomas Dutton, who was a commissioner for the Dissolution of the Monasteries. The house he built was remodelled, *c.* 1651-3, for John Dutton by the Taynton architect builder Valentine Strong. Its 'rebuilding' and Classical façade of *c.* 1831 at the hand of Lewis Wyatt is thought to have been substantially in the likeness of that completed by Strong. Sherborne House is surrounded by its own parkland, which was laid out during the 1720s by Charles Bridgeman (1690-1738), sometime Royal gardener to Queen Anne. Transformation of the house into private flats was completed in 1982. The adjacent range of stables, coach house, and baths – once used as a school – were built for James Dutton in the mid eighteenth century, and have also been converted into a number of luxury apartments.

The Windrush runs below the rise on which Sherborne is built.

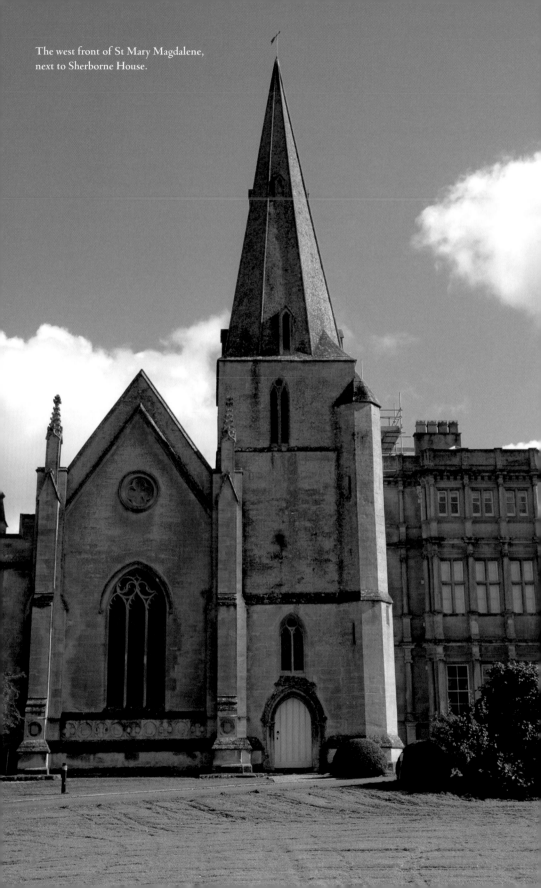

The west front of St Mary Magdalene,
next to Sherborne House.

Lodge Park, built for John Dutton in the mid eighteenth century, possibly by Valentine Strong, and used as a grandstand for viewing sport in the deer park.

Old cottages in the village.

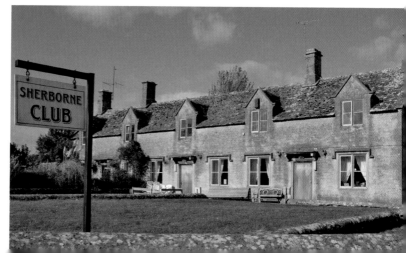

Sherborne Club is an example of co-operative enterprise in an otherwise dry village.

The stable yard is now their communal ornamental garden with a fountain. To the east is a stone octagonal dovecote with cupola; it is said to have been moved around over the years.

The church of St Mary Magdalene is adjacent to the house, and consists of chancel, nave, and late thirteenth-century western tower with a ribbed spire that has spire-lights. The church is the result of building in the thirteenth and fourteenth centuries, and later rebuilds in the style of those times. It was restored in the eighteenth century, and its rebuild of 1850 was financed by the second Lord Sherborne. The otherwise fairly plain interior is sectioned by a slender rood screen. This was very much an estate church, in which the Dutton family memorials date back to 1587, memorial tablets abound, and there are a number of interesting monuments. The most notable, because of its life-size subject matter, is possibly that of 1791 by Richard Westmacott the Elder to James Lennox Dutton and his wife Jane. It shows a grisly skeleton, representing death, being trampled by an angel who holds the triumphant inventory of the deceased individuals' lives in her hand. Another monument is J. M. Rysbrack's homage to the classically attired Sir John Dutton, dated 1749, who leans against an urn.

The National Trust has been restoring the water meadows since the early 1990s as a major conservation project under the Countryside Stewardship Scheme. The project has created a wetland habitat and a site for several species of birds. There are three main walks on the estate, one of which includes a sculpture trail; a public footpath will take you to Windrush village; a footpath through the water meadows; and there is a children's animal trail.

The latter is centred on Park Lodge, also now owned by the National Trust, which was first opened to the public in 1999. It is Parliamentarian John 'Crump' Dutton's classical, rusticated and fussy grandstand for viewing his mile-long, walled deer course from a balcony above the portico. Dutton inherited the estate in 1618, and within two years had laid out the park and the run, the latter for the sport of using dogs to course stags from the herd of deer in the park. The lodge was designed by John Webb and built, possibly by Valentine Strong, in the 1640s. This, and the parkland, was remodelled in the early eighteenth century, and the lodge has changed shape internally during the last three centuries to suit various types of residential needs. One of its most striking possessions is an ornate fireplace in Bath stone, a recent faithful recreation of an original. Throughout the year, musical, theatrical, leisure and naturalist events take place there.

Sherborne's most famous son is arguably Dr James Bradley (c. 1693-1762), although his birthplace has historically been contested by Hampnett, near Northleach, where he attended the grammar school. He was the Astronomer Royal of England from 1742 until his death. Bradley discovered the aberration of light, and Newton ascribed him 'the best astronomer in Europe'. He is buried in Minchinhampton, marked by a table tomb with a descriptive plate.

Great Barrington

The River Windrush separates the two Barringtons, the last of the Windrush villages before Oxfordshire, and is itself divided into several channels to facilitate the former mill to the south of the village. This complex is residential now, but a public right of way between Great Barrington and Little Barrington separates the front doors from the residents' gardens, before crossing the channels and the river proper. The road between these two villages crosses one of the millstreams that, in conjunction with the Windrush itself, make islands of fields close to the Fox Inn.

Thomas Strong's causeway is a feature, and he also built the bridge at Great Barrington in the seventeenth century. This is where the river, having dashed through Barrington Park, crosses the minor Stow road. There are still some high, old stone walls here, particularly those that effectively hide the church and help to maintain the privacy of Barrington Park. The main village street contains stone houses and cottages on both sides – with stone mullioned, square-headed windows – built from the seventeenth century onwards. In contrast to the dressed ashlar that is so commonplace hereabouts, some of the old buildings are of rough stone, giving the thoroughfare a pleasing character. The heavyweight war memorial cross stands on an octagonal base and plinth where all roads into the village meet, and from where the main street extends towards Burford. Here stands the attractive village hall, vaulted with exposed beams above a space that is occasionally used for regional arts and crafts exhibitions.

The Italian-style Barrington Park House, together with a decorated temple in the grounds, was built for Charles Talbot (1685-1737) who was the Lord Chancellor from 1733. He bought the then existing manor house at Great Barrington from Reginald Morgan Bray, after it survived a fire in 1734. There is a story that in 1682, when the old house was in the occupancy of Sir Edmund Bray, it was visited by Thomas Wharton (1648-1715), who would become Earl Wharton in 1706, and the 1st Marquess of Wharton in 1714. As a younger man, however, he was a party-loving carouser, and on this particular visit,

The Fox Inn, beside the Windrush, was a favoured stopping place for horse-drawn coaches.

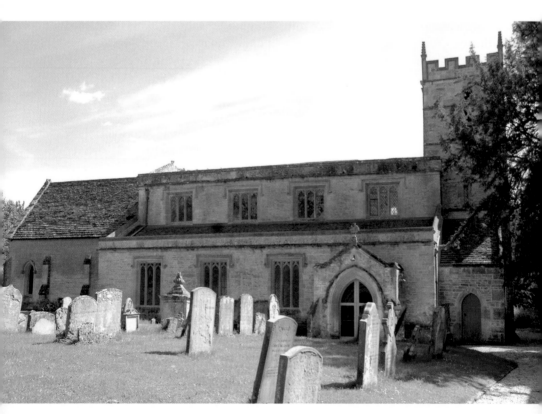

St Mary's church, next to Barrington Park House, is notable for its marble monuments.

All roads into the village meet at the war memorial cross.

he led a number of inebriates through the churchyard and into the church, wherein lay generations of his host's family. There, they proceeded to create a cacophony with the bells and generally vandalise the place. They then set out to raise the village, but its inhabitants – being seriously discomfited by all the noise – were already sufficiently raised and angered to take up arms and drive the revellers back to the manor. When the escapade reached the ears of Robert Frampton, Bishop of Gloucester, the perpetrators were threatened with excommunication, and given a stiff fine.

Mary, Countess Talbot (*d.* 1787) brought the house to its Palladian splendour, and it was enlarged by the addition of wings in 1873-74, the same date as the nearby church was restored. In the mid eighteenth century, the estate took advantage of the Windrush by diverting the waters into the grounds for its own use, and building a three-arched bridge over the river. In the grounds, there are several little gothic and classical-style buildings, by way of temples and follies, in the prevailing manner of the eighteenth century. The place is also identified with the Irish poet Tom Moore (1779-1852), who is said to have been a regular visitor at Barrington after he settled at Bromham, Wiltshire in 1817 and came under the patronage of the Marquis of Lansdowne at Bowood.

St Mary's churchyard has an eighteen-foot-long stone seat with elbow rests built into the wall. The grounds are packed with mossy, eroded tombstones on

the south side; on the north side, it is almost impossible to see what is there, for a wilderness of vegetation is several feet tall, and there appears to be no way through. The back of part of the Georgian stable range of the adjacent Barrington Park makes a nice backdrop to the churchyard.

The church has a fine Norman chancel arch with scalloped capitals, chevron, and double billet ornamentation. There is a late Early English four-bay nave arcade, and carved bosses and corbels; but it is otherwise late fifteenth-century Perpendicular and well lit by square-headed nave and clerestory windows with cinquefoiled lights. The old oak-braced roof is late fourteenth-century and has pierced quatrefoils, dagger motifs, and bosses, with posts resting on stone corbel heads.

There are several marble memorials, some with lengthy inscriptions, and monuments to the Bray family – notably, hard against the south wall, Captain Edmund Bray of 1620 – sometime owners of the estate. The Captain, who was apparently right-handed, has his sword on the right-hand side. According to legend, having been pardoned by Elizabeth I for killing a man, he swore never again to use his right hand. In the south aisle is the marble memorial to two children, Jane and Edward Bray, who died of smallpox early in the eighteenth century, and are shown being led away by an angel. Mary, Countess Talbot, is depicted in a fine, white marble memorial in the chancel, attributed to London sculptor Joseph Nollekins.

A memorial to Charles Rhys Wingfield, who clearly enjoyed sport in the Windrush, reads: *God grant that I may fish/Until my dying day/And when it comes to my last cast/I humbly pray/when in the Lord's safe landing-net/I'm peacefully asleep/That in his mercy I be judged/As good enough to keep.*

The village hostelry, The Fox Inn, hard by the way to Little Barrington, is built alongside the Windrush. It is a charming roadside pub, protected by tall trees opposite its entrance. Local artist Lara Cramsie's thirty-foot-long mural of the Windrush valley occupies one wall of the restaurant. At one time, it was called the Fox Wharf Inn, and although there is evidence of a nearby wharf, it is not clear in what commodities it may have traded. The suggestion that it might have been the point at which stone from some of the quarries hereabouts entered the watercourses has not been proven. It was a favoured stopping place for horse-drawn coaches, and still has the original coach house, although converted. The river skirts its terrace, runs alongside the car park and disappears down the valley. From here, there are fine views, and, over the next couple of miles or so, several very short streams run into the Windrush as it advances towards Burford.

Windrush

The little village whose name accords with that of the river, stands well above it and is gently spread about the hillside, where there is an Iron Age hill-fort. The river has so far been flowing south, and now turns towards the east. You can see this happening if you follow the narrow public right of way that disappears beside The Barn in the direction of the former Windrush corn mill. This is just one of several green pathways that connect various parts of the village, the river and the surroundings countryside. The stone-mullioned mill house and adjacent agricultural buildings, put up at the end of the long track in the seventeenth century, are still there. They are residential now, make a picturesque group with the outhouses, and the old mill workings are still in situ.

Here, the river is some forty or fifty feet wide; the peripheral vegetation is high; and its banks are overhung by trees. There is a wonderfully stress-relieving sound of running water here, as the Windrush changes its mind and strikes out for Burford. You can follow its course for a while in either direction, along public footpaths.

Windrush village is a mixture of ancient stone cottages, estate cottages, farms and larger Cotswold-style houses. It is centred on a triangular green with mature beech trees, at the confluence of four minor roads. Much of the architecture here is of the eighteenth century, and some of it includes fragments that are hundreds of years older. One of these, at one time called the Old Monastic House, later became the village post office, which it remained until about 1948, then the residential Pear Tree Cottage, as it is now beside the green. It is distinguished by its fourteenth-century, pointed-arch stone doorway.

St Peter's church, which stands adjacent to the green, has a Norman doorway with a rare double row of beakheads and other decorative motifs. Each beakhead is slightly different, but together they are the symbolic representation of nearly sixty demons, waiting to drag to a fiery fate those hypocritical souls whose apparent churchgoing belied their imperfect characters. The chancel arch and aisle arcades are of the same period as the doorway, and there are sheep's heads carved into the corbels of the south aisle arcade.

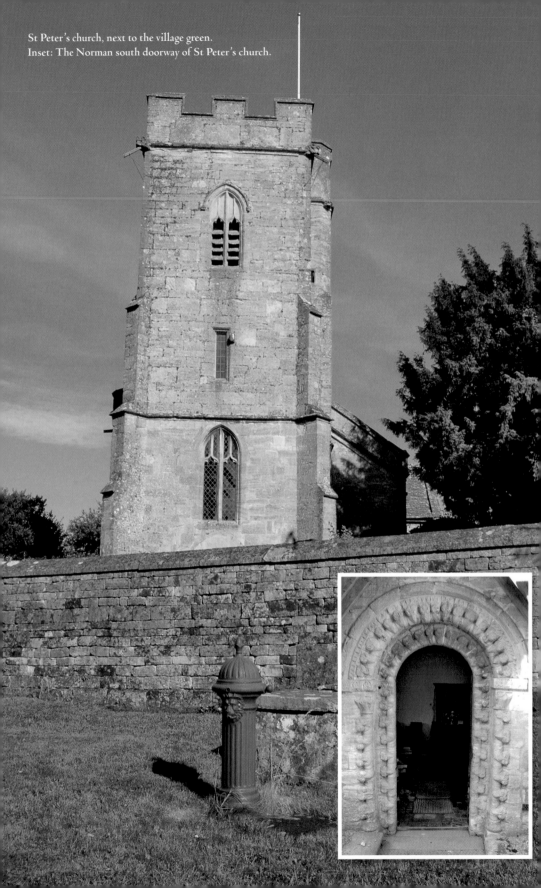

St Peter's church, next to the village green.
Inset: The Norman south doorway of St Peter's church.

Typical Cotswold-style tombs cluster around St Peter's church.

Eighteenth-century cottages, glimpsed through mature beeches on the triangular village green.

There is a mounting block for horseriders nearby, and the eighteenth-century table tombs and decorated roll-top tombs in the churchyard – some clearly belonging to persons in the wool trade – are a joy.

The Old Forge is a particularly attractive cottage opposite the church; the forge was adjacent, and the building was latterly used as the village post office. Its near neighbour is the equally interesting Malt House. A Gothic-style school building of *c.* 1840 is still here, and has a gabled porch, angle buttresses, and mullioned and transomed lights. The row of pretty cottages next door was put up at the same time, and one of them was the schoolmaster's house. There are old terraces of pretty cottages and some gabled new-build alongside the public footpath that passes Windrush Manor, which is set back from the village centre and has stone barns adjacent.

Revd Isaac Williams (1802-65), the religious poet and a member of the Oxford Movement, was curate at Windrush, 1829-31, at the time of agrarian riots in the village. William Hooper (1864-1955) was born in Windrush, and, although he achieved no fame in the village of his birth, he relocated to Swindon, Wiltshire in 1882 where he became the town's most famous photographer. Some of the best pictures ever taken in Swindon were composed in his camera.

The influence of the river amongst the trees.

Little Barrington

The village of sixteenth- and seventeenth-century cottages and farmhouses is on the north-facing side of the combe. Much of the old village of Little Barrington is arranged above what is left of a central quarry, said to have been the source of the stone that built it. This is now a grassy hollow, above which there were springs which provided water to the two late nineteenth-century village hand pumps. Thick vegetation encroaches into the former quarry, whose bed is now so well covered that the grass there can be mown as if it were a lawn. A small, clear brook runs across pebbles through an adjacent triangular green, fringed by pretty cottages, and onwards to the Windrush. All of this can be taken in from the seat, set above it all on the south-west side.

On this side too, there are old farms and former farm buildings, some converted to residential. Some of the buildings on the north-west side of the rise have made little terraces overlooking the quarry, planted them up, and given them seating from where their residents can enjoy the view. The properties here are all different, but were mostly built of ashlar in the seventeenth century. Characteristically, they are a mixture of flat fronts, gabled central sections, and roof dormers. The windows are stone-mullioned: groups of up to four in the lower stage and up to three above. The Smithy is particularly appealing, with its arch-headed lights and a porch with stone seats. Next door, is a stone-built former blacksmith's forge with roof gables, converted to residential in the 1960s. On the opposite side, there are longer farmhouses, one of which has a moulded fourteenth-century doorway in a building that may once have been associated with the church, and there are more low, sixteenth- and seventeenth- century cottages. The village shop, owned by Edward Hayward in the nineteenth century, has long gone and the immediate community of half a dozen or so farmsteads he served is now greatly reduced.

This village was the adopted home of Timothy Strong, who relocated there early in the 1600s and was associated with several stone quarries in the vicinity, including that around which is gathered the centre of the village. The Strong family owned a quarry here from early in the seventeenth century,

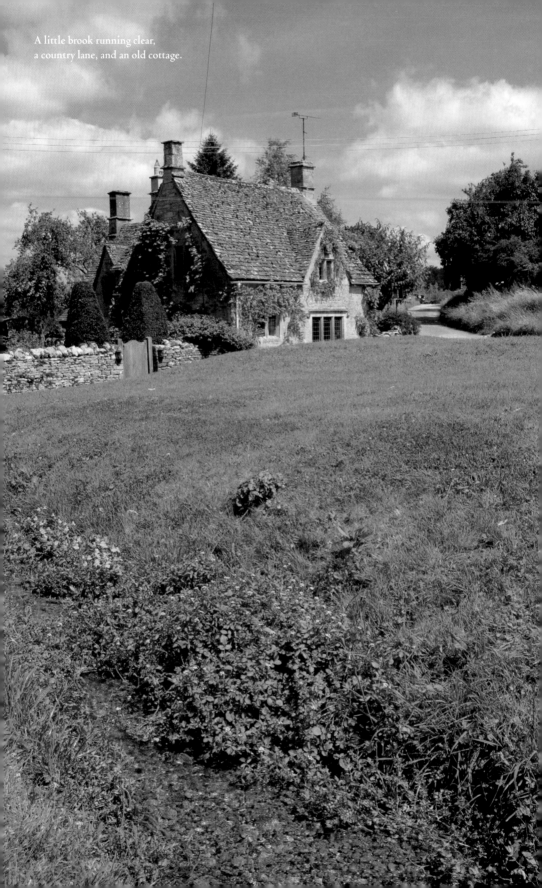

A little brook running clear,
a country lane, and an old cottage.

The one-time smith's cottage, next to the former forge, with its arch-headed lights and stone seats in the porch.

One of the village pumps overlooks the site of the village quarry.

Typical Cotswold cottages with gables and pretty dormers beside the quarry site.

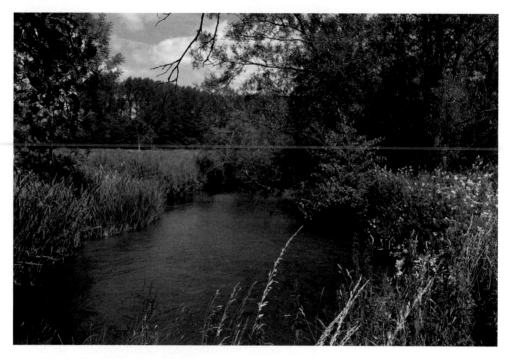

The Windrush as it passes the village.

and it is thought that the gatehouse at Stanway was Timothy's work, using stone from Little Barrington. The material was of particularly fine quality. Timothy's grandson, Thomas, worked on some of Wren's London churches and St Paul's Cathedral.

St Peter's church is a little way along an unmarked road leading from the telephone box. The land to the north sweeps down towards the river to such a degree that many of the cottage rooftops are below the roadway. Here you will find 'the reading room', a nineteenth-century building in red brick with stone dressings. The bricks were brought from Horsham Park, Sussex, at the instigation of Maria Mills, and the place was built, *c.* 1890, specifically as somewhere where letters sent back from the Front during the South African wars could be read out to the illiterate village wives of the time. Today, it serves as a function room for gatherings that are too small for the roomier village hall at Great Barrington, and is also the venue for art classes and other meetings.

It is beside this roadway that the landowners of Little Barrington built their estates, and where the Windrush runs along in parallel just beneath them. Church Farm, next to the church, is seventeenth-century and its cedar tree seems almost to be part of the churchyard. A little way past, is the four-square Grove House, built just above the river in 1779. Its extensive stable block is now garages.

St Peter's has stood just south of the river at Little Barrington from Norman times. It has a small, three-stage tower that hardly rises above the nave roof, and is built at the north-west end of the north aisle. The building was re-roofed in Cotswold stone tiles in 1986. The fifteenth-century tower has double ogee-headed lights to the bell stage, and there is a castellated thirteenth-century bellcote with a tiny spire above the intersection with the chancel. The church has an exceptional twelfth-century south doorway of three decorative orders, and a nave arcade of two round arches above scalloped Norman capitals. On the outside wall of the aisle is a tympanum showing Christ flanked by the wings of two kneeling angels. Visitors have to step down into the building. There is much fourteenth-century work, a Perpendicular font, and some illuminated panels painted on the walls. Notable is the Lord's Prayer, dated 1736. The Perpendicular window, a pair of double lights above the transom, and a pair of single lights below – ogee-arched and cinquefoiled – are interesting.

In the churchyard, beside the large yew tree, are several eighteenth-century headstones with winged angels, tea-caddy tombs – one with a pyramidal top – and a table tomb that has a scalloped upper edge. By the church door, lies the Venerable Francis Crosse, the first Archdeacon of Chesterfield, who died in 1941. A striking memorial to members of the Tayler family who died between 1699 and 1726 is carved into the outside of the porch, on the east side. This piece, wherein the figures are heavily robed, is ascribed to William Mury, carpenter.

A public footpath leads from Minnow Lane, close to St Peter's church, across the river by means of little wooden footbridges, through fields towards the former mill at Great Barrington. There, it connects with the eponymous walk named after ramblers' champion Colonel W. P. d'Arcy Dalton, which was created in 1986 by the Oxford Fieldpath Society, in association with the Campaign for Rural England, to commemorate the former's diamond jubilee.

Ironically, the river is a greater distance from the village of Windrush than it is from Little Barrington and Great Barrington, although all three can claim to be on it. Besides, the minor road that links them closely follows the river, from where there are rewarding views across a wide valley that can flood spectacularly in winter.

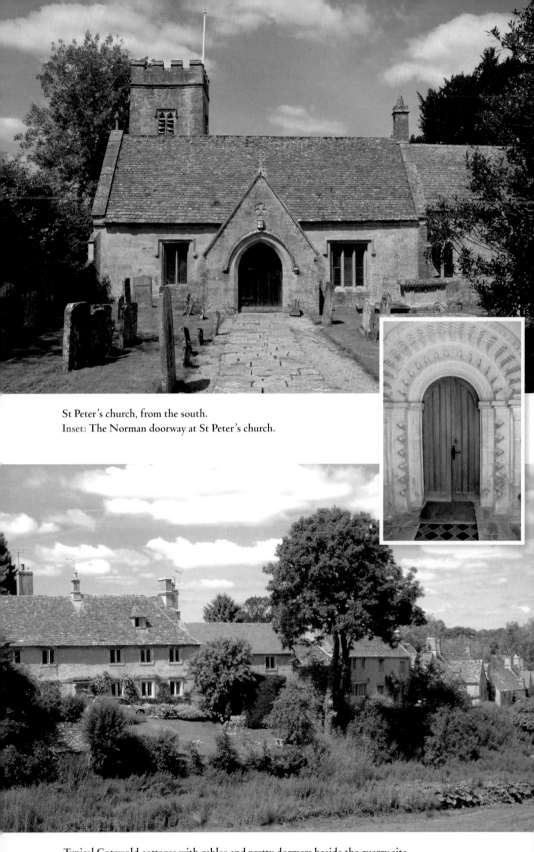

St Peter's church, from the south.
Inset: The Norman doorway at St Peter's church.

Typical Cotswold cottages with gables and pretty dormers beside the quarry site.

Taynton

Just before it reaches Burford, the Windrush passes through water meadows close to Taynton, where the Coombe Brook runs swiftly through the village. This brook straggles down for about six miles from its source near Little Rissington, running through the separated remnants of the ancient Forest of Wychwood, and on the way picking up its own trickling tributaries, before tumbling into the Windrush.

Edward the Confessor, whose allegiance to the Norman court resulted in his alleged promise of the crown of England to Duke William of Normandy, once gave Taynton to the abbey of St Denys in Paris, but it was not an arrangement that would survive hostilities between England and France. The manor passed to the monastery at Tewkesbury, and into private hands at the Dissolution.

At Domesday in 1086, *Teigtone* had two mills and a number of stone quarries that may already have been worked for centuries. The quarries here are close to the course of the Coombe Brook. Stone quarried at Taynton was carted overland, placed on barges at a wharf on the Windrush near the Fox Inn, and thence on to the Thames. In the seventeenth and eighteenth centuries, it was put directly onto the Thames at Radcot Bridge, where the waterway was sufficiently wide to admit much larger barges. Quarrying was an industry that hereabouts occupied pockets of stone-cutters and masons for generations.

Most of the churches within a radius of about twenty miles from the village were built of Taynton stone. It was used, apparently, in old St Paul's; in the thirteenth century to build Oxford Cathedral and St Mary's church, Oxford; at Windsor Castle, 1358-68; during the seventeenth-century re-building of St Paul's Cathedral; and over the first two decades of the eighteenth century at Blenheim Palace. It is in most Oxford city churches, and in some Oxford colleges – of which Merton Chapel, 1289-95, New College Bell Tower, 1380-6, and Magdalene College of 1474 are good examples. It went into the building of All Souls, 1735-41, and Corpus in 1748. It was used in the building of the Sheldonian Theatre and Magdalene Bridge; and the Radcliffe Camera, 1737-49. It also went into the Norman tower of nearby St John the Baptist's church at Burford.

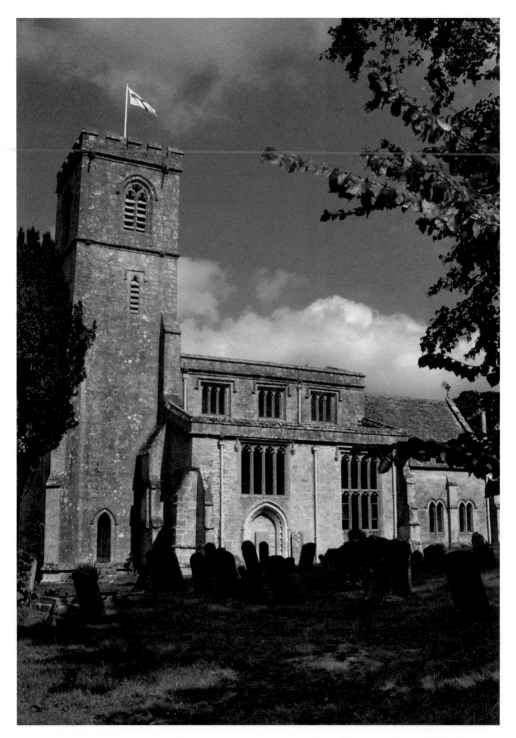

The church of St John the Evangelist is mostly Early English and Decorated, with a Perpendicular tower.

Agricultural buildings beautifully converted to residental are a feature of the Cotswold villages.

Inferior Milton stone was quarried, probably from the thirteenth century, at several places on the opposite side of the same limestone ridge, only a mile or so from the superior Taynton stone. There are suggestions that it was sometimes substituted for the better quality product. St George's Chapel, Windsor, of 1478-83, is said to include Milton stone, as is Christ Church College, Oxford of 1525. The local quarries received a boost from around the middle of the nineteenth century, on the crest of the Gothic Revival, and their stone can be seen at Basil Champney's former Indian Institute in Broad Street, Oxford.

The best-known lessee of the Taynton quarry is arguably Timothy Strong, a builder in the Classical and Renaissance modes, and his son Valentine, who is buried in the churchyard at Fairford. It was Timothy who was charged with the classical-style remodelling of Cornbury Park, completed 1633. Thomas and Edward Strong, two of Valentine Strong's sons, and grandchildren of Timothy, were famously associated with Sir Christopher Wren. Thomas met the architect when he was Doctor Wren, Professor of Astronomy at Oxford, and became involved in his project to design lodgings for Trinity College. After the Great Fire of London, in 1666, Thomas relocated to the capital, where he was delivering large amounts of Taynton stone needed for the rebuilding programme. Wren gave him the contract to re-build St Stephen's, Walbrook and he was famously one of a pair of contractors who laid the foundation stone of new St Paul's in 1675. Thomas Strong died in 1681; his brother Edward continued to work on St Paul's and was said to be the best of all Wren's mason contractors. He completed the cathedral's lantern in 1708 and also worked on Blenheim Palace, for which he provided some of the finest Taynton stone ever quarried. He died in 1723.

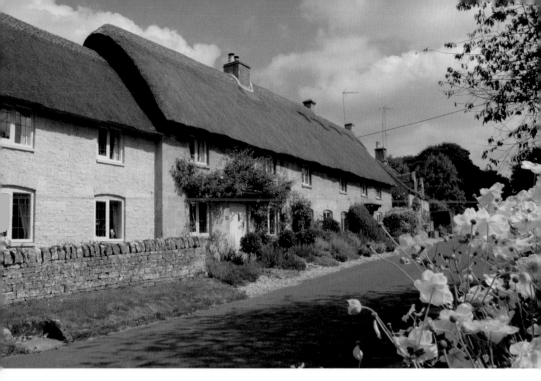

Cottages built of stone from the local quarry.

The Taynton quarries were still in regular use when the railway lines pushed through the Cotswolds. It was the means, 1846-52, of building bridges over rivers crossed by the Oxfordshire section of the Oxford, Worcester & Wolverhampton Railway. However, no railway line came to Taynton, so its quarries became uneconomic and the stone difficult to transport. The village became almost wholly dependent on agriculture. Comparatively little stone was quarried at Taynton from the end of the nineteenth century, and, although the quarry and some of the old lifting gear remains on private land, stone was last extracted – latterly by just one man, Philip Lee – in the 1980s.

Of course, local stone also built the village of Taynton, where the cottages are characteristically honey-gold in colour with lichen-encrusted stone tiles, although some are still thatched. Much of the work extant originates from the sixteenth and seventeenth centuries, but there is neither public house nor shop; nor does the school – erected in 1877 – still echo the sound of children. Taynton appears to be an undisciplined arrangement of a place, until one realises that it effectively comprises four large old farmsteads – no longer working farms – connected by a series of roadways and lanes with a more substantial thoroughfare winding through between Burford and the Barringtons. It is exceptionally satisfying and a joy to walk around. There are hardly above forty-five properties here, including four bungalows that were built by the local authority in the last century. They are completely in keeping with the rest of the village, and were later sold into private hands.

An old water pump stands beside a large and well-ordered churchyard that surrounds St John the Evangelist, and sheep graze in adjacent paddocks amidst mature willows that plot the course of the Coombe Brook through the village. The churchyard is notable for its variety of sculpted and moss-encrusted seventeenth- and eighteenth-century tombstones. These are mostly low, with classical-style shoulders and edging. Although the descriptions are generally indecipherable, enough remains to enjoy the lettering styles of the times, and the many winged angels and other decorative motifs that still stand out in sharp relief. There are also a number of Cotswold-style tea caddy tombs.

The church porch is, unusually, on the north side; the entrance from the south – enclosed in ballflower and now blocked up – was effectively the lord of the manor's private way in, before the manor house, which stood in an adjacent field, was destroyed by fire. The north side of the church is embattled, and ballflower is the prevalent decoration on the exterior, where it is unusually large and used as a cornice. There are Decorated windows, possibly reinserted from an earlier church when the present one was built *c.* 1450. Although Perpendicular was elsewhere then at its height, for some reason the re-builders at Taynton were unwilling to advance with the development. The nave is of two bays; its roof is

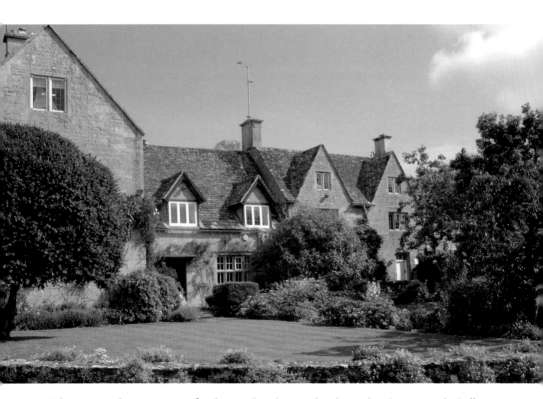

The seventeenth-century manor farmhouse, whose barns and outhouses have been sympathetically converted to residential.

The Windrush in its flood plain between Taynton and Burford.

supported by genuine fourteenth-century corbels in the likenesses of villagers
– some wearing headgear of the period. The embattled tower with its gargoyles,
south aisle and clerestory were all built in the sixteenth century. The chancel
was rebuilt in 1861 in the Early English style, with three lancet windows at the
east end. An opening in the wall of the nave admits stone steps towards a rood
loft that is no longer there; close by is a pretty niche with an ogee-arch head
and ballflower decoration, and the wooden church chest dated 1709. The royal
arms above the door were as used by the first three Georges.

The octagonal font is said to be fifteenth-century; this is arguably doubtful,
and it may be an excellent early nineteenth-century copy. Each face has a band
of tracery and one of Tudor flowers, divided at the corner by kneeling angels.
There is also figurework in the moulded underside of the bowl, sharply cut
horizontal mouldings throughout, and the stem is traceried.

Manor Farm, just east of the church, is a double-gabled building of
c. 1600, although it has been much added to over the centuries, and includes
a nineteenth-century extension. Within the old farmhouse, there is an
unusual vaulted cellar, constructed in Taynton stone. The historic adjacent
barn, the stables and cart sheds, and the nearby animal pens have all been
sympathetically converted to residential in comparatively recent years. Tucked
away along one of the village lanes that cross Coombe Brook is a two-gabled
house dated 1676, symmetrical, and of two bays with two- and three-light
stone-mullioned windows. The dripmoulds over the heads are continued as
string courses. It is possibly the most striking vernacular building in a village
where virtually all of the build fabric is a quiet representation of the sixteenth
to the eighteenth centuries.

Upton

Most of Upton lies immediately to the north of the B4425, linking the busy A40 with Sheep Street in Burford. It is unmarked, its presence is hardly felt along the leafy minor road, it has no obvious centre, and is mostly secreted about former farm tracks. It looks as if the landscape has been lightly sprinkled with buildings here, in a particularly haphazard manner. The approach from Little Barrington is particularly secretive, and there is nothing car-friendly about the lanes that wander past such cottages and houses that remain. In times past, there was more to Upton. The local limestone quarries provided the work that kept this little place alive from the medieval period, and several stonemasons made Upton their home. For centuries until the mid 1800s, a mill made use of the waters of the Windrush and was variously engaged in grinding corn, fulling, and paper-making. Only depressions and markings on the ground, close to the river, show where this once was.

The best known of the Upton quarries were those owned by the Kempster family, formerly farmers around the village. The builder, master mason and stone carver Christopher Kempster (1626-1715) is famed for his connection with Sir Christopher Wren, largely for his involvement in the rebuilding of St Paul's Cathedral after the Great Fire of London, and his association with other London churches, notably St Stephen's Walbrook, 1672-9, and, 1676-83, St James Garlickhythe. Wren probably met Kempster when the Upton man was on a marketing trip in the capital for the sale of stone from his quarries, and doubtless commended him to Thomas Strong from Taynton: an act that underlined Kempster's emergence as a London mason.

Other Upton-based and Taynton-based stonemasons, fathers and sons, were also in the Wren company, and stone was used from both quarries. Kempster's quarries at Upton supplied stone for the walls and the dome during the rebuilding of St Paul's Cathedral. This material was taken overland, often on farm carts, to the wharf close by old Radcot Bridge and thence conveyed along The Thames to the capital. Closer to home, Christopher Kempster was the builder (1678-82) of the market house and county assize court that is now

the town museum at Abingdon, and the alleged builder of several properties in Burford. Famously, upon the recommendation of Wren, he was also the builder, 1681-82, of the Wren-designed great Tom Tower that was added – with octagonal lantern and ogee dome – to Cardinal Wolsey's unfinished gatehouse at Christ Church, Oxford.

Upton has Kit's Quarry House, where Kempster died. This is a much older farmhouse that was remodelled by the master mason in 1698, and bears an inscription to that effect. It fronts his quarry and the mason's yard.

The church, and the almshouses of 1457 and 1726 make a nice group beside the green at Burford.

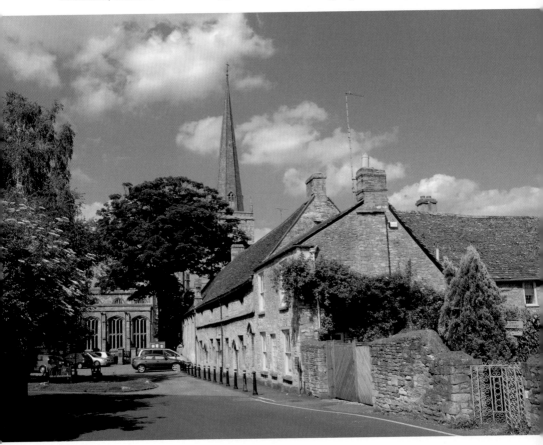

Burford

Burford's name is derived from *beorga feorda* – ford by the hill – which exactly describes its topography. It is the archetypal Cotswold town, but it has not developed its tourist industry in the same way as Bourton-on-the-Water. Instead, its attraction is based on the build fabric and a retail mix in which the Windrush is now an incidental passer-by. Yet Burford was established because of the river, and, although it was never involved in the woollen industries to quite the degree of other Cotswold towns, its cottagers were employed at the several nearby riverside factories and fulling mills that lined the purses of its wealthier merchants. Today, visitors come to walk about the water meadows, or to feed the ducks on the millstream, sitting with picnics beneath a canopy of tall trees.

Over time, the town became an important junction on roads that went in all directions, leading to its particular economic success during the coaching era. When the Oxford and London coaching routes were at their height, hotel expansion went into overdrive, and some fifty horse-drawn carriages left the town's hostelries for somewhere or other each day of the week. By the end of the nineteenth century, there were still more than sixty licensed premises in this tiny town.

The railway line did not come to Burford; it followed the valley of the Evenlode rather than that of the Windrush. Rail travel nonetheless put a stop to the town's coaching trade; and a succession of planning authorities have since made sure that it is kept within bounds. The town was effectively mothballed. No longer prosperous, it was unable to develop in a depressed rural economy, and slumbered untouched into the twentieth century. Then the motor car arrived, bringing middle-class tourists.

Rather more of a 'shop window' for the Cotswolds than its usual description of 'the gateway', Burford presents a microcosm of most of the elements of architecture, history, natural beauty and shopping that you will find throughout the region. In virtually one sweeping and much photographed hill, the town exudes atmosphere and architecture in a tumbling, undulating

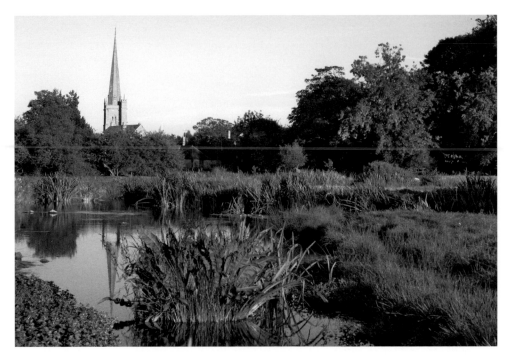

The spire of St John the Baptist greets the Windrush as it approaches through the water meadows.

cascade of Cotswold stone through the centuries. It presents an undiluted concentration of historic architectural pulchritude. Quaint doorways, stone-mullioned and bowed windows, old gables, and little dormers abound; former medieval hall houses, sixteenth-century cottages, and larger merchants' dwellings are all here, packed side by side. Alleys and courtyards run off with medieval fragments in situ, and reveal old outhouses that have been converted to residential or retail. This is a place where architectural stories are written on every façade, and every feature rewards inspection.

Christopher Kempster (see also Upton) lived at Burford. His nearby quarries were known as St Christopher's or Kitt's quarries. During the rebuilding of St Stephen's Walbrook, Kempster became Thomas Strong's chief assistant at the suggestion of Sir Christopher Wren. And like the Strong family of Little Barrington and Taynton, he and his son William also worked on parts of St Paul's Cathedral, as well as other city churches. In 1689, the firm relocated to St Paul's; what the Strongs had started with the foundation stone of this great building, the Kempsters finished with the dome some thirty-three years later. Christopher Kempster's house can be seen in Burford, date-marked 1698. He died in 1715, and the sculpted tablet on his grave in Burford church briefly records the details of the life of someone who was clearly a family man.

The town tumbles tipsily down its high street in an undiluted concentration of historic architectural pulchritude.

Burford had been troubled by the English Civil War from 1642. Parliamentarian and Royalist forces were variously in and out of the town; there was a steady toll of persons injured or killed in its streets; and both Cromwell and Charles were there. Skirmishes and battles took place in such close proximity to the town, that its inhabitants must have been sufficiently reconciled to it all to take little regard of the Levellers incident seven years later. It was here that a force of battle-weary Parliamentarians fetched up in 1649, having mutinied at Salisbury. Their anger, in that they had been ordered to Ireland without being paid for past service, underpinned a desire to end class distinctions. They wanted greater individual freedom, and less state interference.

Tricked into believing that they could put their case unmolested, they were nonetheless set upon at Burford by Cromwell and a force of two thousand. Three hundred and forty of their number were shut up in the church for four days, and Corporal Perkins, Private Church and Cornet Thompson were executed by gunfire in the churchyard. Burford has had a Levellers Day annually since 1975, during which political figures and human rights campaigners speak on aspects of democracy and international injustice; singers of folk songs and songs of protest, along with other musicians, entertain in a similar vein.

St John the Baptist is one of the best and most architecturally rewarding churches to visit in England.

Almshouses by Henry Bishop, 1457, and Dr John Castle, 1726.

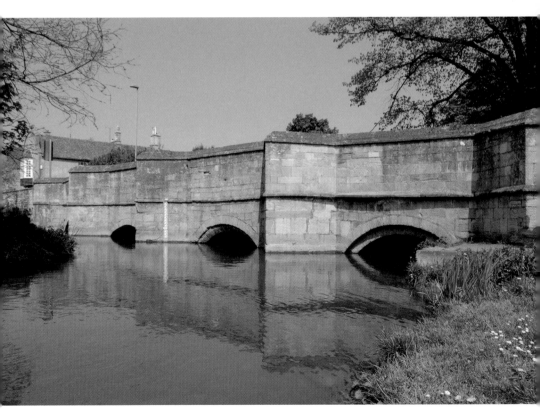

The town bridge was built across the Windrush in the fourteenth century.

The Methodist chapel, built as a private house *c.* 1715, was bought by the Methodists in 1849.

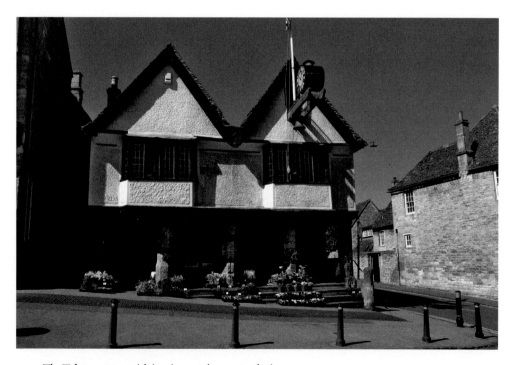

The Tolsey, *c.* 1500, with its nineteenth-century clock.

The cross on The Hill.

The River Windrush approaches the town in an open landscape across wide water meadows. It is easy to confuse its course beyond Burford Bridge with some associated waterways. The river skirts the north-east of the town, poses for a fine photograph near the low-arched, single carriageway bridge, and splits into two. It was the ford at this point that established the town in Saxon times and made it a convenient stopping place for travellers.

Burford Bridge was probably built in the fourteenth century, replacing a wooden bridge that stood near to the ford. Here, the river is shallow. Beside it, are little stone-built and gabled weavers' cottages. These were built in 1576, and were once the property of Simon Wisdom, Burford's great benefactor, who used the income to part-endow Burford School. There is a mill race, and a millstream that leaves the town beyond the church. Close to the bridge is The Old Vicarage. Its façade was built in 1672, and it is distinguished by three ornamental Dutch gables with enclosed blank medallions. Behind it is the result of a nineteenth-century remodelling; to the rear of that, it is medieval. Cobb Hall, a medieval courtyard house, stood adjacent until it was demolished – except for the arched entrance – in 1876.

The town's car park lies adjacent to the millstream. It was built on ancient meadowland, known as Bury Orchard, which bordered the flood plain of the River Windrush, and was extended in 2002. There are spaces for 151 vehicles,

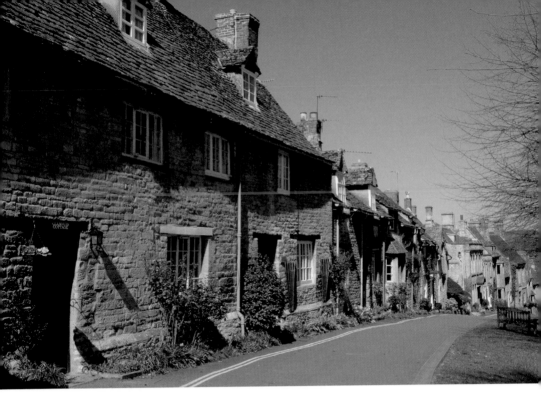

The old cottages on The Hill.

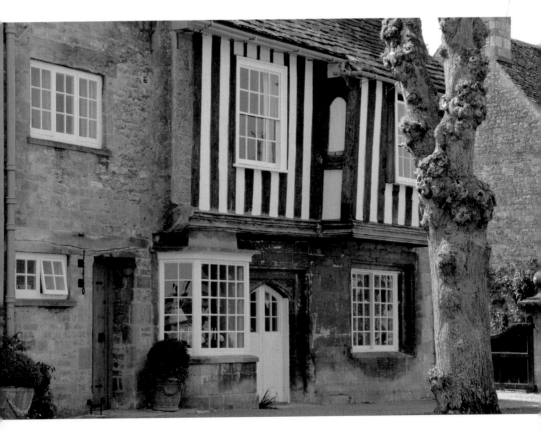

Calendars, Sheep Street, built in the fifteenth century, has a seventeenth-century doorway.

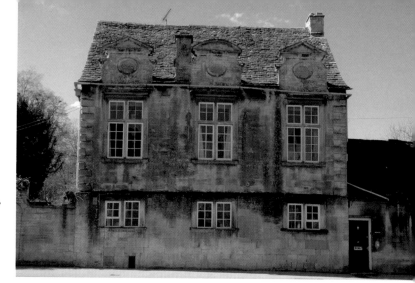

The old vicarage,
High Street, has
a façade of 1672
distinguished
by ornamental
Dutch gables.

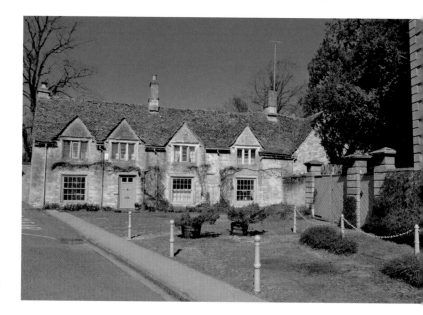

Weavers'
cottages, built
beside the town
bridge in 1576.

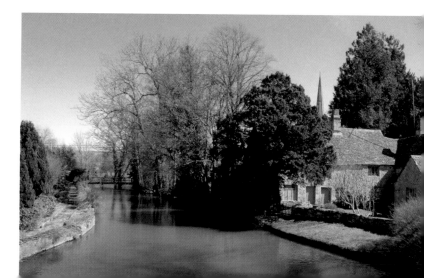

The River
Windrush
leaves the town
and turns into
Fulbrook.

and recently installed extra lighting has helped to make this a pleasant place to park, even on dark nights. From here, there are fine views of the church tower; a large population of waterfowl swim in the stream beside the car park, or sleep on the picnic tables. Ducks and drakes of the most competitive variety will suddenly appear at the prospect of food, to which they will react volubly. The millstream bridge is possibly on the site of another ancient ford in the river.

This bridge links with Tiverton Villa where Keith Davies, for nine years Mayor of Burford, opens his plantsman's gardens to the public and sells plants for charity, which he also does weekly at the Tolsey. The Villa is a twin-gabled house that a local man, George Rose, built by the millstream in 1889 for Keith's great-great-grandfather; it is the only Victorian residence in the town. Noteworthy are its front portico and pillars, and decorated bargeboards. The adjacent Guildenford has some lovely cottage gardens, packed in season with colour and perfume.

The Baptist Chapel was built in Witney Street in 1700. The Black Boy Inn once stood where the magnificent Great House is now, built in Italian style, almost at the close of the seventeenth century. The castellated parapet is forever a reminder that it was designed by Dr John Castle, who furnished his tomb in the churchyard with a similar arrangement. It is also one of the properties in Burford that may have been built by Christopher Kempster. At one time, it was occupied by friends of the diarist and novelist Fanny Burney. In the town museum is a doll's house that has been partly modelled on The Great House, and peopled and furnished in the styles of 1820.

The Royal Oak pub is on the site of the White Hart, through which, in 1642 during the English Civil War, a group of Parliamentarian soldiers fled after a minor skirmish with Royalist troops who then followed in hot pursuit. The Royal Oak has more than one thousand beer mugs and jugs hanging from the beams in its bars. The Angel, formerly the Masons' Arms, is believed to date from the sixteenth century, although the front is probably of the eighteenth. At that time, stagecoaches left from here for London.

High Street is the main shopping street. Here are antiques shops, gift shops, art galleries, fashion retailers and clothing boutiques, furnishings and interiors, health and beauty, craft shops, book shop, teashops and restaurants – all mixed in with the shops needed for day-to-day living. Burford has a justified reputation for specialist shopping, and, because the town caters for tourists, even the ordinary retailers often stock lines that are just that little bit different. It is a good place to look for that special present. High Street is particularly attractive during the dark evenings, when the window displays are lit up, and some of the premises are very old and very interesting.

The Old Bull Hotel was built in 1658, and the brick façade, with stone dressings, was put up early in the eighteenth century. The parapet is panelled; flat pilasters run through the two upper storeys; the quoins are of brick; and

Tiverton Villa, the only Victorian residence in the town, built 1888-9 by George Rose.

Huffkins, the famous bakery and restaurant.

The Priory, as rebuilt by Sir Lawrence Tanfield after 1548.

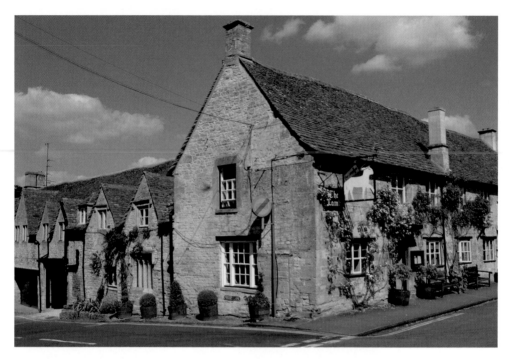

The Lamb Inn, Sheep Street, was built in the fifteenth century as a lodging house for wool merchants.

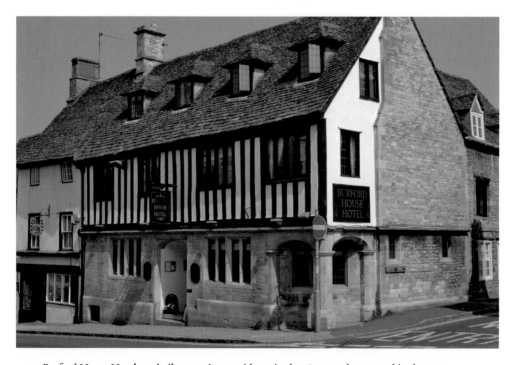

Burford House Hotel was built as a private residence in the 1600s, and converted in the 1930s.

The Bay Tree, Sheep Street, formerly the large town house of Sir Lawrence Tanfield, MP for Woodstock and Chief Baron of James I's exchequer.

the windows have keystones and aprons. The ground floor is ashlar. Inside, is the 'market room' where market business was transacted until 1873.

London House is now a dealership for sporting antiques and memorabilia. Built in the fifteenth century, this timber-framed building has a stone undercroft in two sections, divided by a wide, pointed arch; it is known as 'the crypt'. Other parts have groined vaulting; in one area, this springs from a central octagonal pillar and moulded corbels. The front elevation is three storeys, jettied, and features blocked-up timber windows with pointed, cusped lights. Close by is a three-gabled house, now occupied by the Cotswold butcher's group of Jesse Smith and W. J. Castle. It was built in the fifteenth century, and the oriel windows were added in the sixteenth. It is timber-framed, was once another of Burford's inns, and is full of interesting late medieval details. The Highway has been a hotel since 1926, and was recently refurbished. This building, a former ironmonger's and candlestick maker's, was built c. 1480. It is half-timbered, has a late fifteenth-century doorway, and a jettied upper floor.

The Hill is a favourite spot for photographers to take a shot of the sweep of High Street, framed by the leafy limes, and taking in the hills on the other side of the Windrush valley. The lime trees were planted in 1870, and the war memorial was put up in 1920. The Hill is almost entirely residential, except for

galleries and retailers of furnishings on the west side where it becomes High Street, and a restaurant and some independent traders on the east side. There are some nice seventeenth-century cottages and houses that will reward those who choose to venture to the top. Many of these have Georgian doorways and decorative architectural features.

Hill House is a fourteenth-century hall house, with additional accommodation from the sixteenth century. To the front, beside the fifteenth-century doorway, is a six-light mullioned window, and, at the rear, there is a mullioned and transomed two-light window that has been dated *c.* 1320, and which has flowing tracery. Across the road is The Gabled House. The oldest deeds extant for this double-gabled house are dated 'the fourth year of the reign of Henry VI', and recent carbon dating gives the year 1438 for its beams, which is probably when some internal remodelling took place. The gables have finials, the square-headed windows are mullioned on each level, and the central doorway has a four-centred arch. Note too, the sixteenth-century house next door; it has a little single-light pointed window of that date, set deep in the wall, with a square hood, and a fanlight of three arched lights with a square hood moulding above the depressed arch of the ancient doorway. The Dragon Inn is an award-winning Chinese restaurant, in a sixteenth-century building that was once The Rampant Cat public house, and which has a nineteenth-century frontage. Some of the woodwork is medieval, and the building was a coaching inn during the seventeenth and eighteenth centuries. The archway in its nineteenth-century frontage is now guarded by two white Chinese lions.

The old courthouse or Tolsey, which was built *c.* 1500, is a half-timbered structure with two bay windows above a series of pillars, and is double-gabled. The present clock dates from the mid nineteenth century. Wool merchants once struck bargains here; it was the place where traders paid the fees that enabled them to operate in the town's markets and fairs; and it has been a reading room and a courtroom. The town's horse-drawn, hand-pumped fire engine was kept behind the locked doors between the two left-hand pillars. The ground floor was enclosed from *c.* 1800 to 1956, at which date the building was restored; commodity sales now take place amidst the pillars. WI produce, home baking, plants, cut flowers, wet fish, artworks and books each have their selling days. The town's history is packed into two of its upper rooms that comprise the Burford Museum. The displays include the market charter of 1090, civic regalia, and the town's seals and maces; friendly societies' archives; country clothing, artefacts and traditional tools; and a mid-sixteenth-century iron-bound chest; bells from the Burford foundry; and other metalware and historic memorabilia. There is also a frieze showing all the old houses in Burford, drawn in 1939 by a young architect.

Sheep Street was once on the main route between London and Cirencester, and you can still sit on the wide greens on which the creatures were once penned.

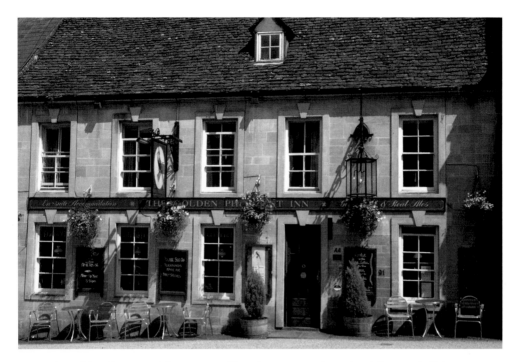

The Golden Pheasant, High Street, is a fifteenth-century wool merchant's house, rebuilt in 1700 when it became a coaching inn.

On one side, is a mixture of small, gabled houses, cottages, and larger, stone town houses, built between the fifteenth and eighteenth centuries. Several of the doorways are misshapen, and some have decorative motifs in the spandrels. There are timbered overhangs, and wavy roofs whose tiles are moss- and lichen-encrusted. A number of these were once inns, in a town that still had more than sixty of them at the end of the nineteenth century. Cobbled pathways separate the dwellings from the wide verges, mature trees are a feature of the streetscape, and the residents pay to keep it all up together. When sheep markets were held here, the animals were penned on the grassy banks. This is a street of gables, mullioned windows with square hoods, the occasional timber-framed frontage, some old overhangs, stone doorways and Tudor archways.

The Greyhound is a large building on the north side, with an obvious former carriage entrance; it was once the Greyhound Inn, and was, almost continuously from 1949 until early this century, the home of *The Countryman* magazine. The writer John Maynard Keynes lived for brief periods in 1909 and 1910 in the Little House or Calendars, a fifteenth-century property that he rented in Sheep Street, and which is distinguished by its timber-faced, overhung upper storey. At Calendars too, lived the Revd Dr. Vivian Green, who was variously chaplain, senior tutor, sub-rector and rector of Lincoln College, Oxford. Many

The Cotswold Gateway, a nineteenth-century rebuild of an eighteenth-century property that was once a school boarding house and which has been a hotel since 1928.

of his characteristics were assigned to the fictitious spy George Smiley, created by the reverend's former pupil, David Cornwall – writing as John le Carré.

The Lamb Inn, the oldest hostelry in Burford, was built in the fifteenth century as lodgings for wool merchants. By the 1700s, it was an established inn. At one time, shepherds looking for employment presented themselves in the street below, and farmers in need of their services appraised them from the window of an upstairs room. The ghost of a First World War soldier is said to occasionally walk through this room. Cottage-like and rambling on Sheep Street, where it incorporated the weavers' cottages after *c.* 1720, its Priory Lane front has five gables and a square-headed, fifteenth-century window with four cinquefoil-headed lights. The courtyard is stunning, and there is a traditional-style walled country garden with lawns and ornamental borders. It is one of two hotels that dominate the south side of the street; both are partly made out of former cottages that now have tumbling roofs and are variously clothed in rambling roses, creeper and wisteria.

The town's Tourist Information Centre is in the former Garne & Sons brewery front office, where some 40,000 people visit each year. The archway is nineteenth-century, but the premises were built *c.* 1750 and thought to have been the malthouse for the Lamb Inn; the brewery opened in 1798 and kept going until 1969 – by which time it belonged to Wadworths.

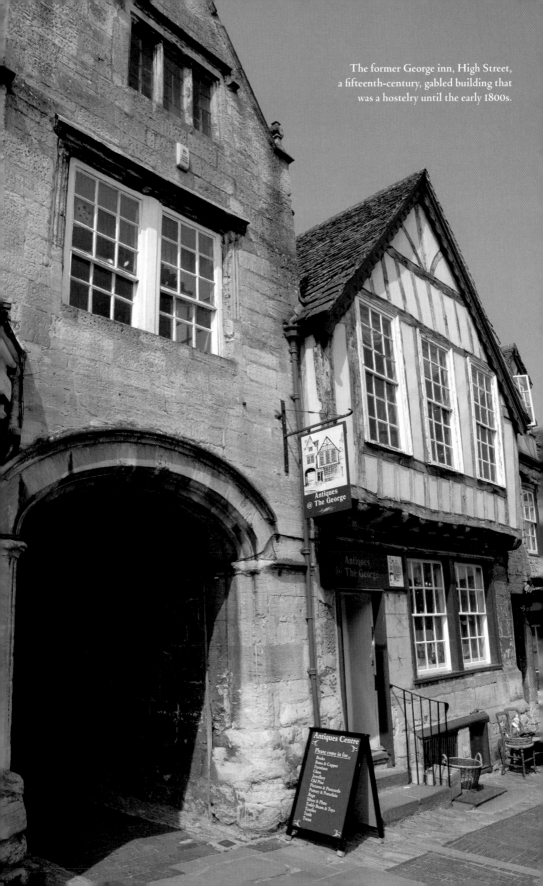

The former George inn, High Street, a fifteenth-century, gabled building that was a hostelry until the early 1800s.

The Bay Tree Hotel is a five-gabled town house built in the late eighteenth century for Sir Lawrence Tanfield – MP for Woodstock, Chief Baron of the Exchequer to James I – and his wife: two people who were much disliked in Burford. Tanfield became Lord of the Manor in 1617. The property has belonged to the Cotswold Inns and Hotels group since 1998. Inside, there are original, well-worn steps and flagstones, two original stone chimneypieces, and a high gallery. At the rear, is a stone terrace, and a secluded walled garden that was allegedly laid out by Lady Tanfield. The front of the hotel in April and May positively drips with spectacular and aged wisteria. There is a legend that the troublesome spirit of the much-disliked Lady Tanfield took to launching itself about the skies over Burford in a fiery chariot and screeching doom and destruction. Local clergymen eventually corked up the apparition in a bottle, which was deposited in the Windrush beneath the first arch of Burford's bridge. It is said that the whole dreadful scenario will be resumed, should this stretch of the river ever dry up.

In the High Street is also the oldest chemist's shop in the country; it has been in business since 1734 when it was opened by apothecary Nicholas Willett in the former premises of the Crown Inn. It has been Reavley's since 1918. Inside are walls lined with Victorian chemists' shop rounds, old medicine bottles, and 163 drawers in two banks from c. 1850, which have fading labels, such as opium and antim crum. In the sixteenth century, the site of the Red Lion Bookshop was the house and business premises of a fish merchant, and it was once another of Burford's inns. So too, was The George, now a multi-dealership antiques business. This tilting, timber-framed building with an upper-floor overhang was erected late in the fifteenth century, and was closed down as an inn when bought by the Bull Hotel in the early 1800s. One of the windows has the date 1666 scratched on it. Samuel Pepys was there; so was Charles I, and Charles II was there with Nell Gwyn. The front of Huffkins, the well-known bakery and teashop next door, was added in the late eighteenth century. Separating the two eating areas is a fourteenth-century stone arch with shoulder lintel. Huffkins has been voted amongst the top fifty tea and coffee houses in England.

Burford House, built in the early 1600s on the corner with Witney Street, was a private residence until the twentieth century, then, variously, a drapery store and a furniture store. It has a close-studded, timber-framed upper floor, and a ground floor of Cotswold stone. The building was converted in the 1930s and became a hotel called The Corner House. In the fifteenth century, a wool merchant may have lived in what is now the Golden Pheasant Inn. The rebuilding of 1700 gave it a fine ashlar façade, of five bays with strong keystones to the square-headed windows. As The Golden Ball, it was another of the town's coaching inns. Internally, there are thick stone walls, flagstones in the bar, and oak beams. The Methodist Chapel is one of High Street's landmark buildings. Formerly a private residence that was built c. 1715 in Baroque style,

the premises were bought and converted by the Wesleyan Methodists in 1849, and were internally remodelled a century later. It is alleged that Christopher Kempster may have had a hand in its design. There are regular sales of antiques, arts and crafts, and memorabilia in the basement.

An inn with a past and, allegedly, an upstairs ghost: The Mermaid is dark, low, flagstoned, thick-walled, and riddled with a wonderfully oppressive sense of nefarious activities of the past. Part of it was once The Three Pigeons, part a butcher's shop with an alley between the two. Note the original mounting block. The Oxford Shirt Company's clothing emporium occupies a single run of half a dozen cottages and one exceptional town house, remodelled internally. The Cotswold Arms on the corner was once called The Mermaid, of which the town has had three, and, for a while, two existed at the same time.

The Old Rectory can be glimpsed from Priory Lane behind its high wall next to the school. It was built *c.* 1700, and is also thought to have been the work of Christopher Kempster. As for The Priory itself, Edmund Harman was granted lands here – on the site of the one-time priory of St John the Evangelist that formerly belonged to the Abbey of Keynsham – by Henry VIII. Harman built himself a mansion there, and this was later rebuilt by Sir Lawrence Tanfield after he acquired the lands in 1584. His grandson, Lucius Carey, Lord Falkland, sold it to William Lenthall, Speaker of the Long Parliament. The house has an imposing front of two wings, and, internally, includes some of the fabric of the original priory. Next to the house is the chapel, built in the second half of the seventeenth century. Between 1948 and 2008, The Priory was the home of a community of Benedictine monks and nuns. It was not open to the public, except as a retreat, but concerts and other local events were sometimes held in the grounds. These are particularly attractive at snowdrop time, and whilst the building was in the hands of the Benedictines, Burford's residents often enjoyed walking around the gardens. The house is now a private residence. Falkland Hall, on the corner of Priory Lane and High Street, was built for clothier Edmund Sylvester in 1558, it was bought in 1906 by the newly founded Burford Recreation Society, and bought from them in 1920 as part of the town's memorial to the Great War. During the twentieth century, it has been variously an institute, a public hall, the venue for a travelling cinema, a place of dancing and other entertainments, and an antiques sales room. The lion carved in the first-floor oriel window was unveiled in 2000 by HRH The Prince of Wales to celebrate the millennium. The premises are partly occupied by Burford's very comprehensive kitchen shop. The Bear Inn was built adjacent to the Falkland Hall in the seventeenth century; it is now a prettily planted courtyard called Bear Court, beside some of the town's art galleries. Opposite, there is a run of independent traders, including Bygones, which has been selling collectables and memorabilia for more than twenty years; and Mrs Bumble's, which is an extraordinarily extensive delicatessen and food shop.

The oldest deeds extant for this house on The Hill are dated 'the fourth year of the reign of Henry VI', and its beams have been carbon-dated to 1438.

The buildings around the approach to the church are a particularly interesting group. First the church itself. St John the Baptist was built in 1175, and has since grown aisle by aisle, chapel by chapel, remodelling by remodelling, and is now officially one of the top twenty churches in the country for historic interest. There are often guides here who are happy to explain the complexities that history has wrought on the fabric, and it is a fascinating journey. The Earl of Essex, Cromwell's commander-in-chief, put up part of his army in the church in 1643, and in 1644 some fifteen thousand troops were in the town. You can still read the inscription that Anthony Sedley 'prisner' scratched into the font in 1649, and learn about the 340 Levellers that Cromwell locked up here, and who are remembered in an annual pageant in the town. William Morris founded the Society for the Preservation of Ancient Buildings after seeing restoration, of which he disapproved, being undertaken at St John's. The churchyard has a number of fine bale tombs. Numerous cultural activities take place in the church.

Nearby is the grammar school, founded in 1571 by Simon Wisdom, who held lands and properties around the town and endowed it with the resulting rents. It was rebuilt in 1868, incorporating some of the original fabric, and added to in the latter years of the nineteenth century. The topographical writer Reginald Arkell (1872-1959) – poet, biographer, musical playwright and comic novelist – was a pupil here. The upper floor was once the town hall.

There are almshouses alongside Church Green, which is a pleasant place to sit and contemplate them, the church, and the old grammar school building. Eight almshouses were built in 1457 by Henry Bishop, steward to Richard Neville, Earl of Warwick – 'Warwick the King Maker' – who was sometime Lord of the Manor. These were remodelled in 1828. Adjacent, are four more almshouses, built in 1726 by Dr John Castle. Adjacent is the Warwick Hall. Built as a school for infants and girls in 1863, on the site of a former merchant's house, this became a church meeting house in 1914 and was leased to the town council in the 1980s as a public meeting hall. Craft, memorabilia, or produce sales are regularly held here, and there is an occasional flea market.

Just outside the town are the Cotswold Wildlife Park and Gardens, and the home lover, gardener and plant hunter's paradise that is The Burford Garden Company. Both are major tourist attractions. There are two inns where the A40 and the A361 join at the entrance to Burford, on the road that runs above the Windrush. Both were established to take advantage of passing trade when these roads were being developed. Burford Lodge Hotel, Oxford Road, was built c. 1814 as the first private residence on a diversion of the London road that had previously run through the centre of the town. By 1844, it was The Bird's Nest public house, and then became The Oxford in 1864. After another period as a private house, during which a writer of hymns lived there, it became, c. 1930, the High View Private Hotel run by a family of musicians and naturists. The Cotswold Gateway, Cheltenham Road, was built early in the eighteenth century, and was formerly called The Bird in Hand. It is a linked, double building of five bays and three storeys, and used to have a wide carriage entrance and, until the 1940s, a large portico. Winston Churchill once lunched there with one of the Mitford girls. The bar has long been popular with aircrews from Brize Norton, and the hotel has featured twice in books by Dick Francis, and in one Morse tale by Colin Dexter.

Viewed from the A40, the Windrush runs a silver ribbon amidst fine views over the wide flood plain, and then the B4047. For the most part, the Windrush is a friendly, shallow river; it is clear, generally benign, cheerful and inviting throughout its thirty miles or so. Occasionally, however, it shows that it can flood quite severely, as one might witness from the Witney road after a spell of exceptionally wet weather.

Otherwise, you can again take a scenic route from the centre of Burford, burying yourself for a while in leafy lanes, hamlets and villages such as Fulbrook, Widford, Swinbrook, Asthall, Worsham, Little Minster, and Minster Lovell. There, you will find pretty little villages, interesting old churches, and historic inns – such as The Swan on the bridge at Swinbrook, and The Maytime at Asthall – with stories to tell. By the time the Windrush emerges beside the former mill building and the Old Swan at Minster Lovell, it has worked itself into something of a frenzy.

Mrs Bumbles, a destination delicatessen in the Cotswolds.

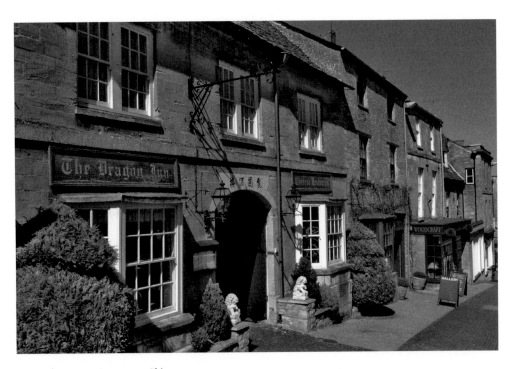

The Dragon Inn, now a Chinese restaurant.

Fulbrook

As it leaves Burford, the Windrush runs swiftly past Ladyham – the five-bay house in Fulbrook wherein, between 1904 and 1911, lived the novelist Compton Mackenzie (1883-1972), and which was the 'Wychford' of his story *Guy and Pauline*. He and his brother-in-law Christopher Stone (1882-1965) created the house from two run-down, gabled, Elizabethan cottages. Compton Mackenzie was the originator of *The Gramophone* magazine in 1923, and Christopher Stone, who in 1927 became the first disc jockey on the BBC, was its London editor. In his poem 'Burford', published in his 1909 collection *Lusus*, Stone wrote: *But dimpling round its timid foes, the lightly laughing Windrush flows*. It is odd to think that what is now a substantial river at this point might once have been considered to be a 'foul or dirty brook': the *fulebroc* that gave the place its name.

When it was fully operational as an independent village, Fulbrook had a Wesleyan Methodist chapel that was built in 1861, and a school that was built in 1864. Today, the main road curves here on its way between Burford and Charlbury, and drivers, pleased to have shaken off the slow descent along the former's main street to the traffic lights at Burford Bridge, tend to take Fulbrook at an indecently brisk speed. Much of the little village is hidden by large, mature trees; the church is at the end of a lane that runs between an old farm and Pytts House and barn; and the only real point of reference is the memorial cross. Mercifully few of Fulbrook's men fell, but their names are here written in full.

There is an ancient yew tree in the churchyard, about eighteen feet in girth, which is said to be one thousand years old, and a fourteenth-century stone tomb-chest. The church of St James the Great is a Norman Transitional building that has retained its round-headed chancel arch, north arcade, south doorway, and font from the early thirteenth century. The five-bay north arcade is of plain semi-circular arches springing from hefty, squat pillars with trumpet-scalloped capitals. The fabric was remodelled and the church enlarged later in the thirteenth century, providing an Early English south porch and nave extension. The church was repaired and re-roofed in 1827; in 1892, the tower and nave were restored

The Norman transitional church of St James the Great.

to the design of Gloucester architects Walker & Son, paid for by parishioners; at the same time, London architects Christian & Purdy oversaw the restoration of the chancel at the expense of the Ecclesiastical Commissioners and Eton College. The arched opening to the shallow porch has shafts and bell capitals; inside, there is a roll moulding with billet above the Norman doorway, all encapsulated within a late thirteenth-century hood comprising three arch orders on jamb shafts, also with bell capitals. There is a votive cross in its fabric.

The west window is a thirteenth-century trefoiled lancet; another window in the south wall of the nave is of similar date; the east window is also Early English and contains a stained glass memorial to a benefactor of the church who died in 1884. The lower stage of the tower is also Early English, and its upper stage is Perpendicular – the period in which the clerestory and the square-headed windows were added. The tower includes a sundial. The combination of low tower and a north aisle only is common in the area, but here it gives the building a particularly lopsided, unfinished appearance from the west, which adds rustic charm. In 1952, J. B. S. Comper's war memorial to Fulbrook's fallen in both wars was built, of Cotswold stone and slate, into a north aisle recess. The north transept, and the windows therein, are Decorated. The chancel arch has fine decorative mouldings, with shafts and bell capitals. A memorial brass to Edmond Rous is dated 1633. There are other memorials in the sanctuary and chancel to seventeenth-century members of the Jordan and Thorpe families. The interior has traces of wall painting, in connection with the chancel arch, the north transept, and around the capitals and above the first pillar in the nave. The wooden roof bosses include heads with foliation, and a green man poking out his tongue, close to the chancel arch. The font is a plain, cylindrical Norman bowl.

The war memorial cross at the centre of the village.

Widford

South-east of Burford, the Windrush settles down as a single watercourse, running towards low-lying Widford through flat flood plains that are frequently submerged. The river comes to meet the back road from Burford, then loops tantalisingly away. A footpath follows its course, running parallel with the road between Burford and Swinbrook, crossing the river at the pretty little Widford bridge which is almost engulfed in trees, and gives access to the place. Ancient Widford, a place of dwellings, a manor house built in the sixteenth century, and at least one mill arranged about the Windrush, is thought to have been abandoned in the fourteenth century following an outbreak of the Black Death. From about 1700, the manor was owned by the Fettiplace family, whom we shall also meet at Swinbrook and Asthall.

Until the mid 1800s, the forest of Wychwood protected the site of the lost village; now the landscape is more open, and evidence of the old settlement is primarily an area of undulations in the ground around the church. One of the old buildings remains, most probably the site of the corn mill, on the south wall of which there is a square sundial.

Widford Water is a lake on the northern side of the Windrush. There are pleasant walks on either side along the riverbank. Towards Swinbrook, the route is open; back to Burford, it is immediately clothed in trees. Until now, with the exception of Bourton-on-the-Water where the river runs straight through the town, all of the settlements have been to the west or south of the Windrush. Widford is on the north bank, and thereafter this trend continues. The name of the place is said to derive either from *withig ford* meaning the ford by the willows, or more simply to mean 'wide ford'. Until the Parliamentary Boundaries Act of 1832 transferred Widford to Oxfordshire, the parish was administratively within Gloucestershire; its position was consolidated in the Counties (Detached Parts) Act, 1844.

The church of St Oswald is thought to have been built by the monks of St Oswald's Priory in Gloucester, on the site of a Roman villa. It is in a field to the east of the place, but this was not so when it was part of the village.

The isolated, but easily accessible, church of St Oswald.

It is an unspoilt gem: chancel and nave are under one roof with, externally, a two-tier thirteenth-century bellcote at the intersection, the support for a bell dated 1777. The west window is square-headed; the east window has reticulated tracery; most other windows are single-light, trefoil-headed lancets built in deep splays of the thirteenth-century fabric. Inside is a thirteenth-century tub font; there are some fourteenth-century wall paintings in the nave, and one of St Christopher in the chancel. The chancel includes two niches, a piscina and an aumbry. There is a fifteenth-century pulpit; a flat Jacobean communion rail; attractive little runs of high box pews from the early 1800s; and two commandment boards dated 1815 on the east wall of the nave.

The church was closed in 1860, except for burials. Occasionally, tessellated fragments came to light in the churchyard, which were taken to be evidence of former Roman occupation of the site. In 1904, the Society for the Protection of Ancient Buildings part-financed restoration of what had become a disused and decaying building, when well-preserved fragments of mosaic were discovered beneath the floor at the north-west and south-west angles of the chancel. The church can only be reached on foot, but walkers can continue along the footpath into Swinbrook.

Swinbrook

But for its church of St Mary the Virgin, Swinbrook – the ancient 'swine ford' – commands little attention in guidebooks, yet it is an intensely attractive village of seventeenth- and eighteenth-century farmhouses and cottages set at all angles. The village school became the post office. A bridge of two flat arches crosses the Windrush and the millstream, beside a single row of adjacent buildings in which there is still the mill house, although it is now a private dwelling. Next door, is the little cottage to which Unity Mitford came home from Germany to recuperate and live with her mother. Beside this, all the mill workings are still in situ, and next is the fifteenth-century former corn mill that is now The Swan. There are good views from the sides of the adjacent hills, and pretty walks beside the river – particularly through the adjacent fields to Burford. In springtime, its roadsides are packed with daffodils, and the summertime idyll is completed by a poplar-lined, riverside cricket pitch with a pavilion, and the sound of leather on willow. The Windrush often seeps onto the pitch in the winter. A little brook, which begins nearly two miles due north of the village, close to an ancient burial mound, passes close to the tree-lined little village green before joining the Windrush just before the Swan.

The Swan is a fine old roadside pub restaurant, built in the seventeenth century and recently saved from closure. It is almost all that remains of the Mitford estate at Swinbrook, and in 2007 it underwent a programme of renovation and rebuilding, financed by the owner, the former Deborah Mitford, the Dowager Duchess of Devonshire, then aged eighty-six. It is in a beautiful position beside the bridge; stone-built with small doorways and pretty dormer windows, clad with wisteria and creeper, and beautifully appointed within. Its barns have been converted into bedrooms as part of the renaissance, and much of the artwork on the walls depicts the Mitford family.

It was to Swinbrook that the Mitfords came in 1926, having sold Asthall Manor. The family was headed by David Bertram Ogilvy Freeman-Mitford, 2nd Baron Redesdale – formerly of Batsford near Moreton-in-Marsh – and his wife Sydney, née Bowles. Here they brought up their famous children

The River Windrush passes beneath the village bridge, opposite The Swan.

Small brooks run through the village on their way towards the Windrush.

Thomas (1909-45), and the notorious and talented 'Mitford Girls' – Nancy (1904-73), Pamela (1907-94), Diana (1910-2003), Unity (1914-48), Jessica (1917-96) and Deborah (*b.* 1920). Nancy Mitford, Pamela, Diana and Unity are all buried in Swinbrook churchyard; their parents and brother each have memorials within.

However, it was the landowning Fettiplace family, one of whom married a Portuguese princess, who for 300 years held the manor. Of their substantial family house, either built or remodelled at the end of the fifteenth century, probably by Anthony Fettiplace (1460-1510), there is no trace. Of its likely builder, there is a brass in the church. The house was built on rising ground, sheltered by trees, and surrounded by terraced gardens and fishponds. Descriptions of the interior suggest that here was effectively a baronial hall, much decorated with colourful heraldry associated with the Fettiplaces and the families to whom they were attached, and the whole place lit by large windows. The last Fettiplace expired in 1805. According to legend, Swinbrook Manor was then let to a tenant. The man proved to be a wanted highwayman, and his butler was the leader of a gang that comprised himself and several other of the manor servants. Following the apprehension and subsequent execution of the men for highway robbery, the house fell into ruin and was pulled down except for the coach house and stables, which were converted to residences. However, there are still the remains of the Italian-style terraced gardens that the family built into the hillside.

In St Mary's churchyard, there are many sombre eighteenth-century headstones, with carved tops and shoulders; skulls and winged angels; scrolls, flowers and fruit. There is also a fair number of roll-top tombs with sculpted ends, bale tombs, table tombs, and tea caddy-type tombs. Much of the decorative work is well done, and is still reasonably sharp. The church has a Norman Transitional interior, encased in a Decorated fabric that was punctuated by Perpendicular windows and onto which was added a Perpendicular clerestory, and, in 1822, an afterthought of a tower. The north arcade and the chancel arch preceded the south arcade in the thirteenth century, but by relatively few years. Scalloped capitals, stiff leaf foliage, and a whole range of minor decorative motifs of the age make this a joy of a church to read.

The Fettiplaces' striking Tudor and Stuart wall tomb monuments of 1613 and 1686 – the latter attributed to William Byrd (1624-*c.* 1690), an Oxford sculptor – elaborate the north and south walls of the chancel. These splendid likenesses in stone and marble depict the late medieval Fettiplaces, posed on their elbows. They lie beneath highly decorated and enriched pediments within classically designed monuments that are encrusted with family heraldry: one above the other on shelves close to the altar, separated by the old altar rail. Three of the effigies are dated 1504, 1562, and 1613; the dress of the others suggests the times of Charles I, Charles II, and William III. This family owned

The Swan.

land hereabouts from the start of the sixteenth century until early in the nineteenth; they were considerable benefactors in the village, and, in 1716, endowed a school there. They are illuminated by light through the fifteenth-century east window, where the crisp tracery is all the better defined for having no stained glass to obscure the view of the surrounding countryside. In fact, St Mary's lost its old glass in 1940, when a German mine exploded nearby. The church is also notable for the engaging medieval misericords – said to come from Burford – in the choir stalls.

Swinbrook is where, in 1568, Hugh Curwen died, the then Bishop of Oxford and formerly the first Protestant Bishop of Meath; Archbishop of Dublin and Chancellor of Ireland. Swinbrook Regatta – a Swinbrook to Asthall family raft race – takes place on the river in June.

Asthall

This is another attractive riverside village, of which fine views are to be had from the bridge which was built in 1834. Pollarded willows line the course of the Windrush here, a reminder of how important willow once was for all manner of things about the farm, and as a saleable commodity to such craftsmen as hurdle makers and thatchers. Old Asthall was once called *Esthale*, and it runs more or less between the Maytime Inn and the church. Along the way, are many old cottages, a manor house, some beautiful restorations, and some very appealing and sympathetic conversions – such as those of stables, barns and former coach house near the church.

St Nicholas's, on its eminence, is Norman Transitional, with a three-bay nave arcade of *c.* 1160 and an Early English chancel. The church has large Norman pillars, and an exceptional chancel arch of the period, with beakhead mouldings. The fourteenth-century transept was converted to a chantry chapel; the altar, of the same date, has a rare integral piscina; there is a fourteenth-century stone effigy of a female in a wimple, veil and flowing robes; some murals done in 1892; and there are a number of bale tombs in the churchyard.

The Maytime Inn is set prettily on the village crossroads with its tiny tree-clustered green – a number of old properties now included in a hostelry whose fabric may well have existed since the fifteenth century. It was very badly affected when the river flooded in 2007.

Asthall is a place of legend and mystery, where a Roman road, Akeman Street, cut through the village on its way between Bicester and Bath, and the evidence of a large Roman settlement is all about. The old road once crossed the river near Asthall Bridge. To the south, there is the tree-covered Saxon burial mound of Asthall Barrow. This was excavated in 1923, when it disclosed some seventh-century pottery and a cremation burial. Worsham Bottom, to the south-east, was said to be where, in the days of horse transport, an evil-looking sprite leapt out, putting fear into animals and travellers alike.

The village was always Elizabethan manor house, church and cottages. The former was built, *c.* 1620, on a site that is thought to have been occupied since

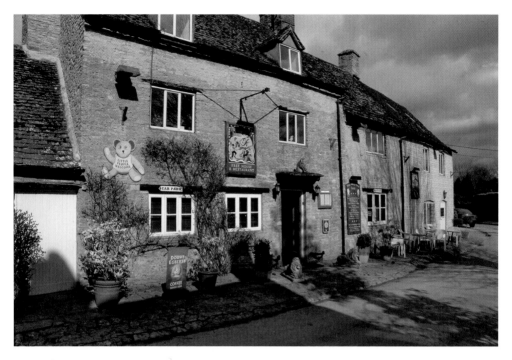

The Maytime Inn.

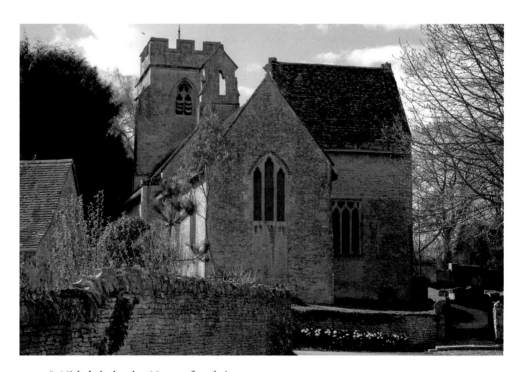

St Nicholas's church, a Norman foundation.

the late thirteenth century. It lies near the west end of the church, and there is a magnificent view of it from the churchyard. The house is much-gabled, and has been considerably added to over the centuries, and is notable for its embattled bay windows. Sir Edmund Fettiplace, whose family are represented so eccentrically in Swinbrook church, bought the manor house in 1688, and it remained in his family until 1810 when it was acquired by John Freeman Mitford (1748-1830), who had been created 1st Baron Redesdale in 1802.

This family had been associated with Batsford Park, near Moreton-in-Marsh, since the 1600s, and it was there that the 1st Baron died. He was succeeded as 2nd Baron Redesdale by his son, John Thomas Freeman-Mitford (1805-1886) who was also created 1st Earl Redesdale. When he died, his estates, including the property at Asthall, were bequeathed to Algernon Bertram Freeman-Mitford (1827-1916), although the titles became extinct. However, the baronetcy was revived in 1902, and he became 1st Baron Redesdale (2nd creation). His son, David Bertram Ogilvy Freeman-Mitford (1878-1958), became 2nd Baron Redesdale, who, with his wife Sydney (née Bowles) was the father of the famous Mitford girls. David inherited Asthall from Algernon in 1916 and, three years later, relocated the family there from Batsford Park. They were to stay until 1926, when David moved the family into his newly built Swinbrook House.

The house they came to at Asthall in 1916 was allegedly haunted, and during the First World War it was a convalescent home for wounded soldiers. It would be the 'Alconleigh' of Nancy Mitford's novel *In Pursuit of Love*; it is also described in Jessica Mitford's *Hons and Rebels*. Deborah Mitford was born there in 1920. It was in the Hardcastle family from 1926 until the late 1990s, and in 1999, the renowned garden designers and builders Isabel and Julian Bannerman were retained to work on the gardens and the grounds. This house is now renowned for its very fine gardens, the modern sculpted gatepost finials by artist and sculptor Anthony Turner, and the art exhibitions that are held in the grounds.

The Windrush between Widford and Asthall.

Minster Lovell

The A40 between Burford and Witney runs above the course of the Windrush valley, with panoramic views as the river snakes through its flood plain into Minster Lovell. If you have chosen this quick route between Burford and Witney, you might reward yourself with a detour onto the B4047, where Minster Lovell lies on either side. To the south, is the predominantly modern Minster; to the north is Little Minster and one of the most attractive villages associated with the Windrush. Between the village and Witney, the river passes beneath a three-arch, fifteenth-century bridge.

The name of Minster Lovell is derived from a small Benedictine priory that was established here in the twelfth century when the place was more simply called *Minstre*, and that of the great landowning Lovell family, whose name was added in the late 1200s. The river hits the village, at its most picturesque point, in something of a rush, before calming down where it once formed part of the moat around Minster Lovell Hall. The village bursts upon the senses at the sixty-acre old Mill Conference Centre and the 600-year-old, gloriously timber-framed and wisteria-hung Old Swan Inn: as attractive a collection of cottage-style Cotswold buildings as you will find anywhere in commerce and trade. Rhubarb wine was traditionally served at the Old Swan during the village feast. Between inn and conference centre, is what remains of the medieval village cross. The inn once had a brewhouse, which is now the restaurant. The mill, successor to one of three hereabouts at Domesday, can also still be seen.

Thereafter, old Minster Lovell ascends its hill in a straggle of chocolate box thatched dwellings, some of which sit behind a grass-lined little rivulet. Each stone-built cottage lies behind a tiny footbridge, and colourful planting is seemingly anchored to its walls. There are residential delights like the Old Bakehouse with its projecting bread oven, and the former post office, the Old Post House. There is a village cricket ground. Ultimately, it all leads to St Kenelm's church, and, by means of a churchyard path, to the ruins of the Hall.

The river seems almost to pause at Minster Lovell Hall, tucking itself into some very quiet and secret place in the landscape, before heading off across

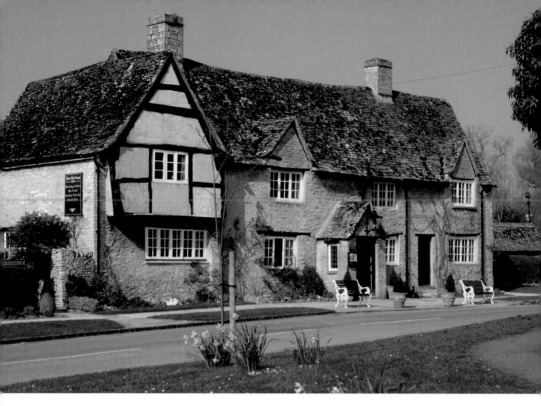

The Old Swan has developed from a timber-framed building that was there in the fifteenth century.

the meadows. It runs behind the substantial ruins of a fifteenth-century house, and was once part of its moat. These ruins, which would be gaunt in any other landscape, are here made homely by the proximity of the church and the river. There is an unimaginable quietness about the place. The house was built around three sides of a courtyard, and survived until the mid eighteenth century when its fabric was plundered to make farm buildings. What remains is impressive and rewarding, particularly as you will walk past the Perpendicular church to get to the house and a nearby fifteenth-century circular dovecote. House and dovecote are in the care of English Heritage.

The church was built by William, Lord Lovell on what are believed to have been Anglo-Saxon foundations during the first half of the fifteenth century. It is dedicated to the eighth-century, martyred son of Kenwulf, King of Mercia, who was killed by his sister, and is buried at Winchcombe. It has a vaulted central tower, a reredos made in Caen stone and erected in 1876, and William's own fifteenth-century alabaster tomb with the effigy of himself dressed as a knight. Masons' marks can still be seen on the pillars within, and there are mass dials on the outside of the building. The pond, at a curve in the Windrush beside the church, is said to have been associated with a Benedictine foundation that is thought to have been adjacent in the Norman period, although there are no material remains of it.

Immediately to the south-east of the church lie the dramatic remains of the Lovell family's mansion, of which the more substantial sections are from the north side of what was originally a square of buildings. It is approached by an ancient, cobbled path; only a fraction of the building may have survived, but this is significant. So too, was Minster Lovell's part in the Wars of the Roses.

It is said that Francis, Viscount Lovell, fought at Bosworth Field with Richard III in 1485, and, being on the defeated side, escaped to Flanders. After two years in exile – and with Henry VII now on the throne – he returned to fight on the side of the Earl of Lincoln, John de la Pole, in support of Lambert Simnel, the pretender. Lincoln had been proclaimed by Richard III as his successor, so his support for Simnel went only as far as furthering his own aspirations to topple Henry VII and gain the crown. Lovell pinned his colours to the pretender's cause simply to avenge the death of his friend, Richard III. In the event, Lincoln was killed at the Battle of Stoke in 1487, and so might also have been Francis, Viscount Lovell.

Indeed, that was at first thought to have been the case, or that he had been drowned trying to escape by swimming the River Trent, or that he had holed up in a cave. However, it was reported in 1737 that when building work was being carried out at the Hall in 1708, a skeleton was discovered seated at a table in an underground vault, whereupon were writing materials and a book. Close by was a cap that was adjudged to have been his. This was supposed to

St Kenelm's church, and the ruins of the fourteenth-century hall that was demolished in the late 1700s.

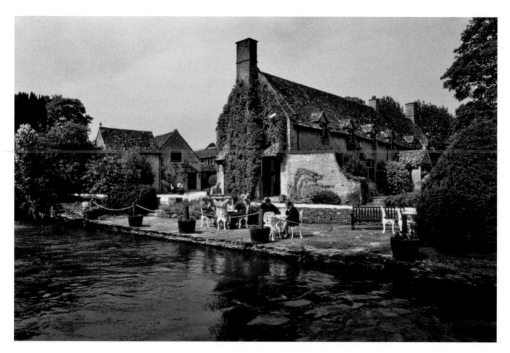

The River Windrush runs beside the former mill, now a conference centre.

have been the remains of this Francis, who had died of starvation in the locked room following the death of the only servant who knew of his whereabouts, and who kept the key. It is said that the whole tableau turned to dust upon the admission of air, and no likely chamber has subsequently been located. It is nonetheless an intriguing story.

The writer John Buchan made use of this tale, Minster Lovell and the surrounding area in his novel *The Blanket of the Dark*, published in 1931. It tells the story of 'Peter Pentecost', educated at Osney Abbey, who is said to be the son and heir of Edward, Duke of Buckingham and thereby the rightful king of England. 'He came in secret to his house' says the hero of Francis, Viscount Lovell, 'and what befell him after that is known only to God'. And of the place itself, 'I do not venture near Minster Lovell except in holy company'.

Francis, Viscount Lovell, was also one of the dramatis personae in William Colyngbourne's fifteenth-century satirical rhyme: 'The cat, the rat and Lovell the dog doe rule all England under a hog'. Lovell was lampooned as 'the dog' – some say because there was a wolf-dog on his crest, others that he was considered to be 'the king's spaniel'. The cat was Sir William Catesby, and the rat was Sir Richard Ratcliffe. It was not just a merry play on names and heraldry; Richard III was a much-disliked king, and these were three powerful and influential men of no greater popular repute.

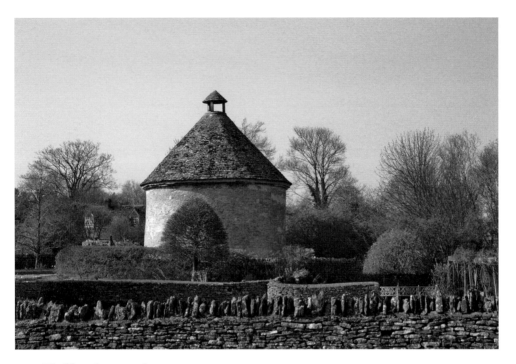

The fifteenth-century dovecote.

The other story attributed to the Hall took place one Christmas time, when a Lovell and his young bride were celebrating their marriage. During the festivities, when fed up with dancing, she betook herself to hide, expecting her husband to easily find her. However, he did not; she had climbed into an oak chest which locked as she closed the lid, thereby entrapping her. It was opened many years later, when the skeleton that was discovered dressed in wedding finery was judged to be that of the missing bride. In 1602, the manor was bought by Sir Edward Coke, and the family remained in ownership, if not in occupancy, for just over two hundred years. A programme of planned demolition, whilst other parts of the building were allowed to decay through under-use, began in the mid eighteenth century. Later attempts to restore the place came to nothing, and in 1935, the ruins passed into the care of the Ministry of Works. This is a delightful spot.

Close by the ruins and the church is a large circular dovecote, built *c.* 1431, and now hemmed in by a farmyard. It is open at the top. The dovecote is sometimes open to the public, many of whom will have to bend considerably to get through the doorway. Once inside, though, it is reasonably light and the tiers of some 700 nesting boxes are a triumph of uniformity. The nearby river continues to loop towards Witney, past the sites of some former blanket mills.

Crawley

One of the largest of the loops takes the Windrush very close to Crawley, a knot of a place, settled into its comforting hollow. Little brooks, which link curves in the Windrush, run beside the roadway. It is a hamlet that straggles along several threads of ingress and egress. These approach roads are lined by steeply banked hedgerows, and visitors unfamiliar with their layout will wonder at the maze of little junctions. Approaching from the south, the tree-lined course of the river leads towards a settlement that is enmeshed in leafiness amidst flat, open fields. The waterway passes the site of a former long barrow, where human remains were exhumed, and progresses towards the hamlet beneath a three-arch bridge that was remodelled in 1833. Beyond this, the Windrush runs through wide meadows and open fields in farming country, and then dives towards Witney, its course marked by a trail of trees and other vegetation. To the north-east, the land rises in sight of Hailey, a village with which, historically, Crawley has been conjoined. Until the twentieth century, the place was described as Hailey-cum-Crawley. Hereabouts too, there are several watery ditches that in some way connect with each other, and with the river.

Many of the buildings in Crawley are constructed of coursed limestone rubble, occasionally with bricks as dressings or by way of brief ornamentation. Most have stone slate or tiled roofs. The place seems to have developed from the mid seventeenth-century, such as at Uphill farm with its square-headed, mullioned windows, through to the late eighteenth-century Manor Farm, and on to the occasional architect-designed nineteenth-century residence. The former atmospherically named Dodd's Row, which had a terrace of ancient cottages, was swept away in the 1970s to make space for the houses on what is now known as The Fordway. Eventually, all roads lead to a little triangular green with, in its centre, the war memorial of a village cross that was erected in the 1920s. Crawley was always almost entirely composed of farms whose lands came together more or less where the clutch of buildings is now arranged prettily about this, the village's focal point.

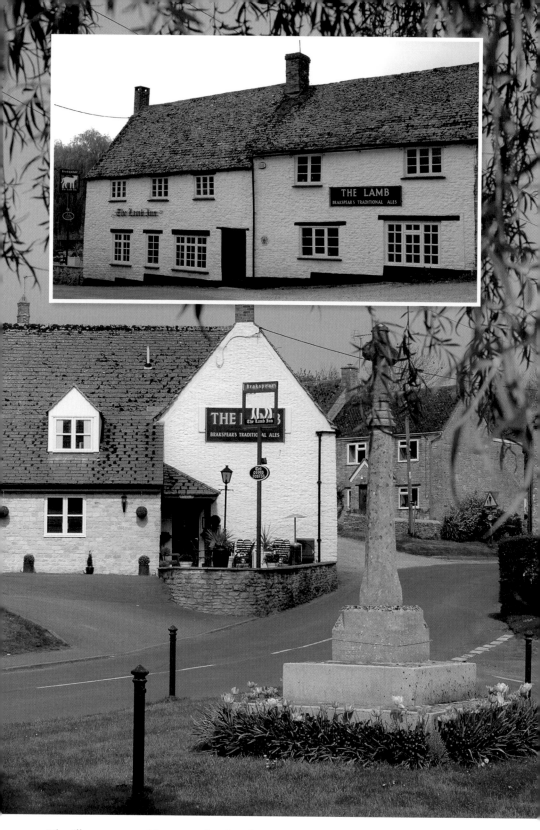

The village war memorial cross, on the triangular green, was erected in the 1920s.
Inset: The Lamb Inn was built in the seventeenth century and extended in 1791.

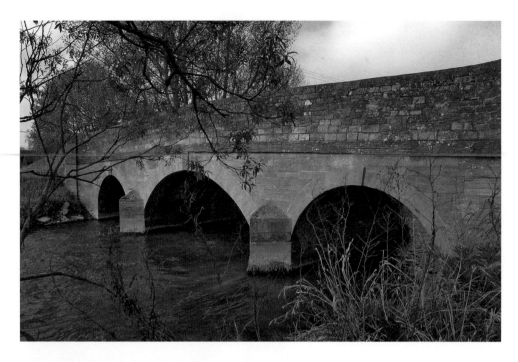

Above: The village bridge over the Windrush.

Left: Several watery ditches converge on the Windrush near the village bridge.

Nearby, amidst a scattering of houses, cottages, and farm buildings, is the Lamb Inn on Steep Hill. This seventeenth-century building, with a date stone denoting an extension of 1791, still has its original beams. It was once the village shop. What is now its car park once held the village hall, the venue for social and leisure activities for generations of people in Crawley. The other hostelry, now The Crawley Inn but previously the New Inn, is believed to have been built in 1783, either as a farmhouse or to accommodate agricultural workers. In the early 1800s, a cottage was put up adjacent, and almost immediately a bake-house was added, and this became the village bakery. The latter was demolished in the late twentieth century, but the rest of the complex comprises the inn as it is today in Foxburrow Lane.

St Peter's chapel was built on a rise at Crawley in 1837, at a cost of £250, and consecrated ten years later. Its founder and financier was the evangelical Revd Charles Jerram (1770-1853), who had been rector of Witney since 1834. What he built at Crawley was effectively a single-cell meeting house, with an undivided interior, given visual ecclesiastical credence only by the lancet windows and the little bellcote on one gable end. Jerram funded, or part-funded, a number of building projects locally that also included schools; a schoolroom was attached to the chapel at Crawley. He was also a prime mover and part-financier of Holy Trinity church at Wood Green, Witney, which was designed by Benjamin Ferry and opened in 1849.

Jerram's chapel at Crawley was a chapel of ease for the church of St John the Baptist at nearby Hailey. The latter had been built in 1761, and in 1838, Revd George Crabb Rolfe, who had been Jerram's curate at Witney, was presented to it. This church was pulled down in 1868, except, it is recorded, for 'a small portion of the west end, mantled with ivy and left to mark the site'. Its replacement of 1868-9, in early French gothic style, was by vicar Rolfe's architect son Clapton Crabb Rolfe (1845-1907) who utilised the stones of the old church. The chapel at Crawley was closed in 1984 and converted to residential.

There may have been a corn mill here on the Windrush for more than a thousand years. It became a fulling and carding mill and, in the mid 1880s, part of the Witney blanket-making industry, which continued into the 1970s. During this decade, Crawley Mill was converted to a light-industrial complex. This will always be associated in the minds of film buffs as the unlikely, remote spot where one of the iconic characters of the silver screen was created and built. This was R2D2, made there for *The Empire Strikes Back* and *Return of the Jedi* in the Star Wars series. In the 1970s, the White Horse Toy Company made rocking horses at Crawley Mill. George Lucas, the creator of Star Wars, was so impressed by one of these that he thought the company might be able to make special effects characters. In 1978, John Jostins graduated with a First in Fine Arts from Lanchester Polytechnic, Coventry, where he had studied

The village war memorial cross.

sculpture, specialising in interactive electronics. His then girlfriend knew the girlfriend of someone at White Horse; the result was that, in 1979, Jostins went to work on the R2D2 project with a small team of four-six people.

He developed and made eight R2D2s in the early months of 1979. Three were remote controlled; three were made for use and abuse in the films and went backwards and forwards for repair and refurbishment; and two were built to house the dwarf actor Kenny Baker, who played the part in all of the films in the Star Wars series. It was at Crawley that Kenny had his fittings, and where adjustments were made to accommodate him inside the R2D2 casing. After his Star Wars involvement, John Jostins worked at Crawley Mill on special effects for *Superman II*, *Dr Who*, and *Blackadder*, and left the site in 1986.

Some of the limestone mill buildings are still at Crawley Mill, crossing the millstream, as are two of the old circular chimney stacks. Of New Mill, another one-time blanket mill on the Windrush between the hamlet and Witney, there remains but one old mill building on a site that has become a modern office development.

Witney

The Windrush again splits into two waterways almost as soon as it meets Witney. Here was *Witta's island*, where the river was variously forded for hundreds of years before a stone bridge with three arches was built across it in 1822. The place was successively developed from early in the eleventh century.

Emma, daughter of the Duke of Normandy, widow of both Ethelred II and Canute, lived in later life at Winchester. Before she fell out with her son, Edward 'the Confessor', over her alleged support of a Scandinavian claim to his throne, she granted an estate on her lands at Witney to the Bishops of her adopted town. Edward, niggled by his mother's apparent allegiance to Magnus of Norway and suspicious that of her children she preferred Harthacanute – whom she had begat with the Dane rather than Edward's own father – swooped on her at Winchester and claimed her lands. Meanwhile, the Bishops of Winchester pressed on with developing the settlement at Witney.

They set about building a palace, and a wedge-shaped market area, a little to the south-east of the former Anglo-Saxon settlement. By 1278, a weekly market was being held, and there were two annual fairs. The town's fortune came from sheep; the surrounding farms provided the wool, and the river drove the water wheels. Meanwhile, Witney walked relatively lightly in the footsteps of the nation's politics and history. Charles I, having just escaped from imprisonment in Oxford, stayed in the town for three nights in 1644; five years later, Cromwell marched through this pro-Parliament place with the blood of the Burford Levellers on his hands. The site of the original market is now Church Green, which provides a magnificent setting for St Mary's and for the many historic buildings that line its tree-cloistered perimeter. Then the route of present-day High Street went in, and typically long, narrow burgage plots, fronted by little timber-framed dwellings with thatched roofs, flanked all of the roadways. Building material came from the encompassing Forest of Wychwood.

Historically, the Windrush played an important part in Witney's cloth making and blanket industry. The river gave Witney the waterpower it needed for its weaving, quite possibly from Roman times, and the last mill in the town

to make blankets kept going until 2002. The converted Early family's gabled premises alongside Mill Street, and their factory buildings with their retained chimney, on the approach road from Minster Lovell, are a constant reminder of what Witney was once all about. There are reminders too, within the town. None is more evocative than the terrace of narrow, two-storey, millworkers' dwellings with attic dormers in Gloucester Place. They would have housed many of the hundreds of looms that were known to have been around the town in the industry's heyday.

In 1830, William Cobbett wrote that just a few years previously 'there had been above thirty blanket-manufacturers' in the place, adding 'twenty-five of these have been swallowed up by the five that now have all the manufacture in their hands'. During the 1800s, the blanket-making monopoly that Witney had for so long enjoyed was being eroded by mills in other towns that were making much cheaper, and, according to Witney, inferior blankets using recently developed machinery. By 1850, the Early family had monopolised the trade; nine of them were then recorded as being principals in the manufacture of Witney blankets. Ethel Carleton Williams, in her 1935 book *Companion into Oxfordshire* remarked: 'A visit to Witney without seeing a blanket factory would be like watching a performance of Hamlet without the Prince of Denmark.' She continued: 'Blankets are the lifeblood of Witney, and it is one of the romances of Oxfordshire that this little town, far from the coalfields and great industrial centres, should for centuries have retained its trade and developed its manufactures without any apparent advantages.' In Bridge Street, there is a double-gabled sometime warehouse, where the wool was sorted.

The farms surrounding the town provided the wool, and the river drove the water wheels. In his survey of 1720-31, *Magna Britannia*, Reverend Thomas Cox said that the town's success was due to 'the nitrous water of the Windrush' which gave 'quality and whiteness to the blankets, as well as the particular spinning technique that had been developed by the workers'. The waterway also facilitated the town's brewing industry, of which the Wychwood Brewery, maker of the Hobgoblin brand, is the twenty-first-century survivor. It has existed in one guise or another since John Clinch began brewing on Church Green *c.* 1840. Clinch's kept going for more than 120 years, and then there was a lull until the 1980s when brewing began again. The present brewery, just off Church Green, is on the site of his original Eagle malting house. In 2004, the premises had a £1 million refurbishment, brought over much of the Brakspear brewing plant from Henley-on-Thames, and began to brew the Brakspear beers at Witney. Here, they give tours of the building, and 'a tutored tasting' of their products.

During the First World War, servicemen from North America and refugees from Belgium were accommodated in Witney. As the Second World War raged, Spitfires and Hurricanes were repaired at De Haviland's nearby airfield.

In the 1950s, this area became Witney's post-war centre for light engineering. It provided alternative employment just ahead of the 1960s amalgamation and rationalisation of blanket-making interests that fundamentally presaged the industry's decline.

When Witney decided to reinvent itself in the 1980s, the aim was to programme a retail and services renaissance. The architects had the foresight to put the town centre first; they developed within it, rather than create out-of-town shopping centres that might have seen off Witney's viability. Former mill and other town centre brownfield sites were remodelled into low-density, residential developments, and the town expanded peripherally. There are also smaller pockets of courtyard shopping to be explored, where independent and specialist retailers cluster. The result is excellent shopping and excellent eating, mixed in with historic buildings, sympathetic new-builds, all the retail you would expect of a modern working town, and everything you might look for by way of specialist independents with an eye for the tourist trade. Witney has a world-famous teddy bear shop adjoined by a small, but packed, teddy bear museum, and the town has a second-hand bookshop, which is equally renowned for its catalogue of titles on bell ringing, folk music and dance.

Today, Witney is effectively still a hybrid town, and is still in transition. Hybrid, because it is at the same time a Cotswold town and an Oxfordshire town; yet it is not wholly an Oxfordshire Cotswolds town in the manner of, for example, Burford. It is a wool town, but it straggles in a way that other wool towns do not, and it is hybrid in the sense that convenience architecture as well as a degree of retrospective-style new build have been added over the past few decades, nodule-like, onto the old town. This integrated approach created an unusual style of hybrid for the Cotswolds, but invigorated the town centre economy and concentrated all retail into a relatively small area. Witney's latest commercial programme is the mixed Marriott's Close retail and commercial development.

It has one main street in three parts: Bridge Street, High Street and Market Square. Corn Street, where the settlement began and which runs off High Street, is so busy in a retail sense that, in any other Cotswold town, it might be the main street by itself. There are also the modern shopping developments such as the Marriott's Close development, the Woolgate Shopping Centre, and the more intimate Langdale Court, Waterloo Walk, and Wesley Walk. The Woolgate opened in 1988, designed in a style that is typical of a Cotswold market town, and built with a Cotswold stone finish beneath pitched slate roofs that have weathered and mellowed over the years.

The West Oxfordshire District Council's large, award-winning Woolgate Shopping Centre car park, off Witan Way, might almost be considered a tourist attraction. It is so leafy and well kept that it has been described as 'a park with cars in it'. It is effectively a controlled, municipal woodland with spaces for

The thirteenth-century spire is possibly the best of its kind in the county.

The John Holloway almshouses, in St Mary's churchyard, were established in 1723 and rebuilt in 1868 by William Wilkinson.

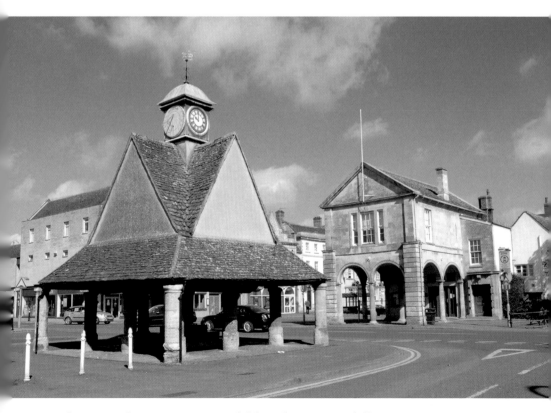

The seventeenth-century Buttercross and eighteenth-century town hall.

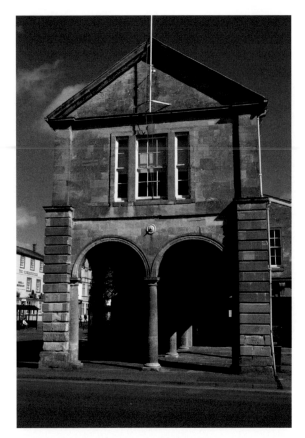

Left: The eighteenth-century town hall with its open piazza at street level.

Below: The Marlborough Hotel, a former Georgian coaching inn in the town centre.

An old-fashioned ironmonger's premises.

750 cars and it won the Car Park of the Year Award in 1988, and, in 2003, the Thames Valley Police Safe Car Park Award.

A good starting point for visitors is the museum in Gloucester Court Mews. This was opened in 1996 in a one-time smithy, the former home of Malachi Bartlett, builder, who lived there until the 1870s. His work is often met with about the town, and his gauging rod for testing depths that could not be seen by the eye – as well as several of his tools – are in the museum. They are all embossed with his name. There, the exhibits are presented more or less chronologically, beginning with the archaeology of the area from the Roman period, backed up by the geology. Upstairs, an arts and crafts gallery has changing exhibitions.

Everywhere you look in Witney, there are one-time coaching inns whose Georgian or Victorian façades hide older interiors of great character, and which today serve good beer and fine food. These reflect Witney's importance as a market town, and its strategic location for travellers. Of these, mention must be made of The Angel, with its attractive low stone frontage overlooking Church Green. This former alehouse, called The Greyhound in the seventeenth century, was sold in the mid 1800s when both seller and buyer were members of the blanket-making Early family. International cuisine is noticeable amongst the traditional and contemporary restaurants of Witney.

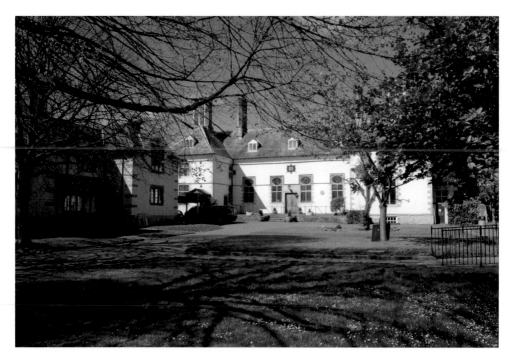

The grammar school which was established in his native town in 1662 by Henry Box, a London grocer.

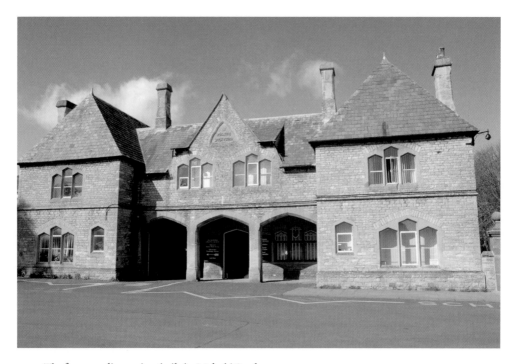

The former police station, built by Malachi Bartlett.

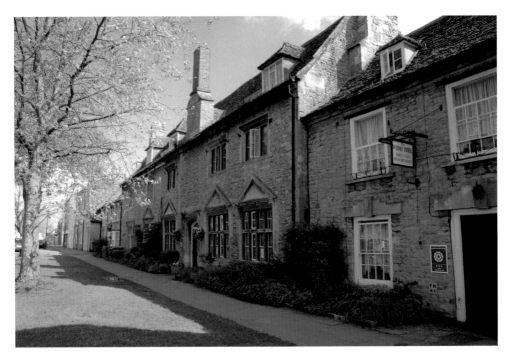

Houses beside Church Green.

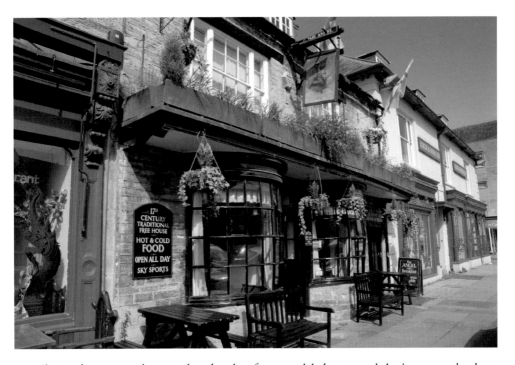

The Angel, a seventeenth-century hostelry where farmers and dealers met to do business on market days.

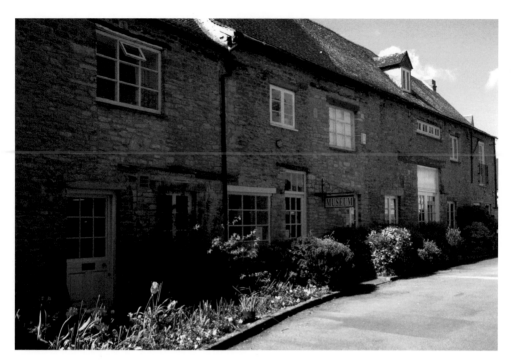

The town's museum is in builder Malachi Bartlett's former home, where he lived until the 1870s.

So much of interest in Witney is around Church Green. There, the church provides a backdrop to the large, rectangular, and well-manicured open space that is lined by mature lime trees and has a war memorial cross at the town end. Visit Witney around lunchtime on a fine, warm day in spring or summer, and you will find that Church Green is as packed with people as if it were a beach. It is a fine place for pupils of the nearby school to relax in, and at other times, it is the focus for events and celebrations such as May Day celebrations, and other spectator sports.

Close to the church, beneath a tarpaulin roof, are the excavated remains of a medieval house that was rebuilt into a bishop's summer palace. William Gifford, Bishop of Winchester, built the house in the second decade of the twelfth century; his successor, the turncoat bishop Henry de Blois, converted and enlarged it – fortifying the complex of secular and religious buildings with clay and stone. There must have been much intrigue here, for Henry, brother of King Stephen, was temporarily estranged from his monarch in favour of Matilda's claim. It happened when de Blois, who was annoyed that Stephen had not made him Archbishop of Canterbury, decided that he could no longer condone the king's violence towards members of the clergy. The buildings were all but demolished in the eighteenth century; and the Oxford Archaeological

Group revealed what was left beneath the grassy mound in 1984. It is a small site, railed off and canopied, but there is a useful interpretation of the walls and footings still to be seen there.

Beside the former bishop's palace are Holloway's almshouses. In 1723, John Holloway built a terrace of six almshouses in the churchyard, to be lived in by six widows of blanket workers. In 1868, William Wilkinson, of Oxford, rebuilt them in nineteenth-century neo-Gothic. Much of their charm devolves on their location and the romantic style of the architecture: little gables in pairs and singles with pointed finials, square-mullioned windows beneath, inset with pointed hoods, three hooded porches on brackets, and heavy chimneys. Another bequest by Witney-born worthy John Holloway, who had achieved success in London's haberdashery trade, added a free school in 1723 for educating, clothing and apprenticing sons of journeymen weavers. The school later took in the sons of anyone who worked in the Witney blanket industry, who later went on to become apprenticed to it.

There are another half-dozen early nineteenth-century almshouses in Newland, at the other end of the town. These were built in plain Tudor style to house 'six aged unmarried women', and the inscription states that they were 'built and endowed by William Townsend, a native of this town and haberdasher of Holloway, London'.

A fine terrace of former weavers' premises in Gloucester Street.

William Townsend's Tudor-style almshouses of 1821.

At the southern end of Church Green, stands the cruciform St Mary the Virgin: a Norman and Early English church on a Saxon site. The exterior is imposing and it offers the prospect of chapels and transepts to investigate. The tower is thirteenth-century, the spire soars to 150 feet, and together they comprise what is arguably the finest thirteenth-century steeple in Oxfordshire. The two sections are anchored together by large corner pinnacles. Much of the interior is Early English and fourteenth-century work. The rebuilt arch in the porch is a Norman survival, and there is another doorway that has decorative motifs of the same period. Elsewhere, the Early English work includes the thirteenth-century nave arcade, the tower arches, and some nice lancet windows. The gem of the place is its seven-light Decorated window with flowing tracery. The interior is less than satisfactory, having been restored in the late 1860s by the severe ecclesiologist G.E. Street, in a way that removed much of the atmosphere.

Just west of the church is the old rectory, otherwise known as Trelawney House after the heraldic arms of Revd Sir Jonathan Trelawney, Bishop of Winchester 1707-21 that were put up in a cartouche over the door. This is a square, stone-built mansion of two storeys and five bays, built 1721-23 for Revd Robert Friend who was rector here, 1711-39. The house has a plain, straight parapet and an attractive hipped roof with dormers. During the mid 1970s, it was restored and converted for the use of the Henry Box School, in whose occupancy it remains.

Above left: Blanket Weavers' Hall, built in 1721 for the Witney Company of Weavers.
Above right: Wychwood Brewery, where beer has been brewed since *c.* 1841.
Below: The world-famous teddy bear shop.

To the east of the church, local builder Malachi Bartlett erected a William Wilkinson-designed, Tudor-inspired police station in 1860. It is an interesting piece of Gothic vernacular: a central section with three arches on columns at ground level, and a sharp gable above. The main windows are groups of three stepped lights, each with arched heads. Close by, is the grammar school that was established in 1662 by Henry Box, a native of Witney who had been financially successful as a London grocer. It was intended for thirty boys who were born in the parish. There is a memorial to Henry in St Mary's, and, after his death, the school was transferred to the Grocers' Company in 1674. It went comprehensive almost exactly three centuries after its formation, and is still fronted by the Tudor buildings.

Also on Church Green is the Tudor 'bread and beef' terrace – so called after the contribution from their rents that went towards helping the poor. The Green has sixteenth- and seventeenth-century buildings on the east side, and larger houses, put up in the eighteenth and nineteenth centuries, to the west. These include the old rectory of 1723. Noteworthy is the late seventeenth-century-fronted Hermitage that stands out with its mullioned windows and ground-floor pediments, and the slightly older Wychwoods. Both have sixteenth-century cores, and pretty dormers. These contrast with Staple Hall, a large double-gabled lodging house for wool merchants and cloth merchants, built in 1668 on the corner of Bridge Street, and allegedly on the site of a fourteenth-century warehouse. Like so many of Witney's buildings whose fabric still bears the evidence of carriageways, it was once a coaching inn.

The symbol of Witney, however, is the steeply cross-gabled sixteenth-century Butter Cross. For centuries, it protected all manner of perishable goods offered for sale at the town's markets. The building comprises four excessively pitched cross-gables with an overhang on all sides, carried by thirteen stumpy stone pillars. The central pillar, on stone steps, is thought to be the remains of a preaching cross that once included the statue of the Virgin Mary, and the building may have been erected to protect that, rather than the agricultural use to which it was put. What is left of the cross, on three worn and shiny steps, now also helps to hold up the roof. The open timber roof, with its big crossbeams, braces and ancient timbers, is a joy. Once, its gables were each decorated with carved bargeboards, and in-filled with diagonal timberwork. A clock turret with cupola tops the building; Witney and London clothier William Blake of Cogges gave the timepiece to the town in 1663.

Across the way, stands the old combined town hall and pitched market loggia, put up at the same time as the Butter Cross. This is a two-storey building with one long room, latterly used as a council chamber and lecture hall, above the classical-style piazza. At street level, the building is open on three of its sides by means of round-headed arches on slender columns. It was built in the eighteenth century, and farmers stacked their corn here, which

they sold to those who approved the samples that they showed in the local inns on market days.

The pseudo-Classical Corn Exchange of 1863 is one of the most conservative of Witney's several buildings in Victorian Baroque. This was about three decades before the financial devastation to which the British corn industry would be subjected following cheap imports from the prairies of the New World. The Corn Exchange is a pile of architectural eccentricities with quoins, and a little scroll-shouldered gable with paired piers and finials that work as a final flourish. In the central section of the façade, only the first-floor window has a segmental pediment; beneath it, huge brackets with swags of flowers support the canopy over the entrance. Everything at ground-floor level is rusticated. The Corn Exchange doubles as a public hall for films and live performances.

An historic building that links Witney's blanket industry with its brewing business is the former Blanket Weavers' Hall in High Street, now a private house. It was built in 1721 as a visible presence for the then decade-old Witney Company of Weavers. Pedimented, with flat-arched openings, depressed arches, sharp keystones, quoins and ball finials; it is neatly conservative Baroque, and includes the Company's arms and the name of Robert Collier, who was their Master at the time. Horses and carts once clattered through its central carriageway, taking their cargo to be weighed, measured, and approved for sale. When the Early family bought the property in 1842, they set up The Blanket Hall Brewery. Forty-eight years later, this was sold to Clinch's: by then the town's biggest brewing concern.

The Wood Green area of Witney is where many of the town's more affluent citizens, including some of the mill owners, settled away from the noise of trade and commerce. They established themselves at Wood Green in fine, architect-designed Georgian houses that can still be seen today. This was the 'Thrush Green' of the novels by Dora Jessie Saint who lived for a while in Witney during the twentieth century, and who wrote as 'Miss Read'. Not everyone of note went to Wood Green, of course; the five-bay, two-storey Post Office building in High Street, with its Venetian window, was a fine mid-eighteenth-century residential mansion. Close by, the five-bay, three-storey house with keystones, string courses, columns and pediments is as grand an example of its type as one might expect hereabouts.

In 2005, Weaver's Bridge was opened at Witney, linking a new housing development with Witan Way. In the great floods of 2007, the old town bridge was closed and large sections of the town were badly affected. Witney was cut in half by the water, Bridge Street was closed, more than 1,700 residential and business properties were flooded, and many people had to be evacuated. These are perhaps the inevitable consequences of a settlement built so close to the flood plain of a river that has the ability to turn Langel Common, the Witan Way car park and several town centre streets into a huge lake.

The memorial cross beside Church Green.

Now, the course of the Windrush alongside the town is the focus of the Witney Country Park, off Witan Way, which, since 1988, has been developed and maintained as an extensive nature reserve. Volunteers developed the land hereabouts as the Witney Lakes and Meadows Country Park, and conservation area. It comprises thirty hectares of land, owned and managed by Witney Town Council, and is a place of contemplation and stress relief for its townspeople. The Windrush Path, a route from the centre of Witney and also nearby Cogges, has been developed to run through a hay meadow and a wet meadow, grazed by cattle, between the two branches of the Windrush, close to Witney Lake. The lake was an old, deep gravel pit that was flooded in the mid 1980s and now includes a protected nature reserve. The aim of the Lower Windrush Valley Project is to join this walkway with the Thames Path. The A415 follows the course of the river's dual progress towards Standlake, and then the road rushes ahead to where the waterway slips into the Thames at New Bridge.

Opposite: **Manor Farm, Cogges.**

Cogges

This hamlet is removed from Witney only by a gentle stroll alongside the Common, the Witney Country Park, and across the River Windrush. The river separates to the north of Langel Common, and thence proceeds on a winding course towards Witney Lake, south of the A40. This whole area, between the town and Cogges, is a nature reserve. The town council bought the land in 1988 and undertook a series of land development projects and wildlife habitat management programmes. The freshwater lake was made from a former gravel pit; there are woodland areas, a hay meadow, and a wet meadow, all of which have innumerable indigenous and visiting species of wildlife.

Manor Farm, on the opposite bank of the Windrush to Witney, claims to include the fabric of the oldest domestic survival hereabouts – the hall and kitchen of a house that was there in the mid thirteenth century. The rest of the building is mostly of the sixteenth and seventeenth centuries, and those parts of the house that are open display Victorian rural life. Where the farm is now, there was a medieval village with a moated manor house, of which there is

now little evidence on the ground. Manor Farm Museum, in adjacent barns and outbuildings, houses agricultural displays, including farm vehicles, tools and machinery. There are traditional breeds of animals to be seen, a walled kitchen garden, working exhibits, and a programme of events. The Windrush runs through the museum's grounds.

Just along the road is the little village church of St Mary, which dates from the eleventh century. Such of it as existed early in the twelfth century was part of lands and residential property hereabouts that were privately gifted to the Benedictine abbey of Fécamp. This enabled the abbey, in 1103, to establish a satellite priory at Cogges, which appears always to have been small and not otherwise satisfactorily endowed. The priory appointed chaplains who had lodgings within the priory buildings, and the church was probably used equally by monks and parishioners. In 1441, after a period in the possession of the Crown, the priory was granted to Eton College, which thereafter enjoyed revenues of it and was instrumental in the appointment of its incumbents. Part of the priory, or at least of its thirteenth-century fabric, remained within what was to become the vicarage, which was also added to in the sixteenth century and again in the nineteenth.

The church was enlarged in the thirteenth century and remodelled in the fourteenth when the tower was built. The part-octagonal, north-west corner tower with a lantern and a conical cap is an oddity. Otherwise, the building consists of a thirteenth-century, part-rebuilt chancel; eleventh-century nave; twelfth-century south aisle; and a fourteenth-century north aisle and north chapel. The entrance is beneath a round-headed doorway with hood moulding, and the font bowl is a plain Norman tub on a fourteenth-century base. The rather grand chapel has a fourteenth-century tomb chest – decorated with foiled circles, symbols of the Evangelists, and shields – bearing the effigy of a female. This is supposed to be a member of the Grey family of Rotherfield Grey, of which family Walter de Grey, Archbishop of York 1215-55, is probably the best known.

Below Witney lies the lower Windrush valley, an area that has been altered by extensive mineral extraction for sand and gravel since the mid twentieth century. By the new millennium, this work had created upwards of fifty lakes, several of which are stocked with carp, and operated by a private fishing company. Most of these lakes lie within the two branches of the Windrush, between Witney and Standlake; some have individual lakeside footpaths, and within them may be small islands, bird hides, and areas that are designated nature reserves. Visitors can see a wide range of waterfowl, wading birds, and aquatic plants. Since 2001, this whole area has also been part of the remit of the Lower Windrush Valley Project, an organisation working in partnership with all stakeholders to improve its landscape, biodiversity and public access.

The Lower Windrush Valley Project has also developed The Windrush Path, a link for walkers between Witney and the Thames Path National Trail to the south.

Ducklington

The first village on the Windrush after Witney Lake lies on the western bank of the river. The rare snakeshead fritillary grows here in a ten-acre meadow, and much is made of this fact on one April day each year. The best-known attributes of this village are its pond and village green, surrounded by attractive cottages with little dormer windows, and its association with traditional country dancing. Ducklington Morris was established in 1980, reviving a pastime that had been in abeyance here for a century. It was tied in with the ancient 'peeling horn ceremony', which devolved on hunting rights in Wychwood Forest. The Windrush path can be accessed by public footpath, crossing the river to the north of the church.

St Bartholemew's church is mainly Norman Transitional and Early English work, with some fifteenth-century rebuilding, and attractive dormer windows. It is worth visiting for the fine decorative motifs of each period, flamboyant window tracery, and the seventeenth-century, oak-panelled reredos that was given by Revd Thomas Farley, vicar 1836-70. The village hall is a one-time tithe barn; the old schoolroom and master's house was put up in Victorian Gothic in 1858; and the rectory originated in the fifteenth century. The one-time bar of The Bell Inn is now the thatched restaurant, and the present bar was formerly a brewhouse. There are other thatched cottages by the side of the church. On the northern branch of the Windrush, between Ducklington and Hardwick, is the large Gill Mill Quarry where gravel and aggregates are dug. Here, in the second century, there was a Roman settlement; in recent years, Roman roads have come to light and a number of Roman artefacts have been discovered. The owners of the expanding quarry site are involved in restoration of areas as they are worked, and in nature conservation and countryside initiatives in the locality – including the nature trails and walkways. There is no public access to the quarry, but public footpaths and bridleways connect with the Windrush Path and run north and west of Hardwick between and beyond the two arms of the river. Ducklington Mill, now a light-industry business park, lies adjacent to the southern arm of the Windrush.

The A415 now passes Cokethorpe Park, and the independent Cokethorpe School, which was founded in 1957 and is centred on the eighteenth-century country house, built in the Queen Anne style. Attractive, gabled roadside lodges guard the way into the parkland that was once entirely surrounded by ancient woodlands, of which small areas remain. Fish House, a little folly-shaped castellated building, was erected in 1723 as a pump room, providing Windrush water to Cokethorpe Park.

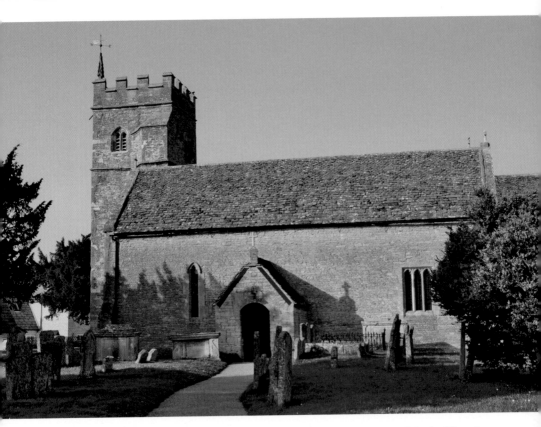

St Bartholemew's church is mainly twelfth- and thirteenth-century work, rebuilt in the fifteenth.

Opposite: **Craftsmen working at Manor Farm Museum, Cogges.**

Hardwick

A little downstream, also on the Windrush Path, is the tiny hamlet of Hardwick, made up of small stone-built cottages. The place appears to have just escaped the gravel-worked lakes that press hard upon it by hopping across the river. Here, beside the Windrush, there was once a mill, as the stone-built mill house, outbuildings and mill cottage attest. Two of the nearby lakes formed from the gravel extraction are owned and operated by the West Oxfordshire Sailing Club and, between the hamlet and Standlake, there is a 180-acre holiday home and campsite complex. The series of lakes, into which the hamlet appears embedded, are examples of old gravel pits that have been restored and are much appreciated by fishermen. Public footpaths, crossing both arms of the Windrush, link Hardwick with nearby Gill Mill, and northwards with the village of South Leigh.

Stanton Harcourt

Those who follow the Windrush by car or on foot will not come to Stanton Harcourt as a matter of course, although minor roads approach it from Witney, Hardwick and Standlake. The way from Witney is accompanied by a patchwork of rivulets and brooks that eventually trickle into the northern arm of the Windrush; the other two routes cross both arms of the river and thread through the flooded gravel pits that characterise the landscape hereabouts. The lakes reluctantly give way to fields, and then to the wooded areas that cushion Stanton Harcourt in the landscape. One of these lakes, south-west of the village, obliterated much of the RAF airfield that was operational here for six years from 1940, when the area was largely concerned with gunnery training and training for night flights. Winston Churchill flew from Stanton Harcourt airfield for Casablanca in 1943, and aeroplanes charged with raiding the German battleship *Scharnhorst* – which was sunk in the same year – also took off from here. Hangars and other former military buildings remain, now partly used to house agricultural vehicles, and otherwise as office accommodation and industrial units.

That aside, this is a particularly appealing village with a two-part village green. The cottages are stone-built, and thatched or tiled; and the eighteenth-century stocks were last refurbished in 2008 and given their own thatched roof. There is a combined village shop and post office, and two public houses – The Harcourt Arms and the Fox Inn – both in Main Street. The Harcourt Arms, erected close by the manor house in the eighteenth century, is stone-built with brick dressings, and brick-built extensions. It has its old beams and a large fireplace with a bread oven. Its ghost is that of a Mrs Hall who killed herself upon discovering that her husband had transferred his affections to a former landlady there. Her shade was thought to have been exorcised, but locals will tell you that it was made of sterner stuff and has since reappeared. The Fox is in an early nineteenth-century property that became a pub with its present name in the 1840s. It is still an unspoiled country pub, beloved of the locals.

The small, aisle-less church of St Michael in the centre of the village.

The word *Stanton* comes from various interpretations one might put upon a combination of the word for stone, and *tun* meaning farmstead or even an enclosure of any number of dwellings. Indeed, until well into the 1800s, almost everyone here seemed to be either a farmer or a carpenter and wheelwright; into the twentieth century, even the occupant of the manor house – created in 1868 out of much older buildings – was occupied as a farmer.

The stone part of the place name may refer to an extensive megalithic stone circle, named the Devil's Quoits, which was also a casualty of the wartime airfield. There are now hardly any traces of the circle, and nothing on land that is accessible to the public. Three stones remain, although no longer standing. The circle and accompanying earthworks were said to have been erected to commemorate a Saxon victory in 614 near Bampton when forces under Cynegils and his son Cwichelm killed two thousand of the opposition. Some readers may prefer the explanation that the stones were thrown there by the Devil, who was playing quoits over Wytham Hill with a beggar for the latter's soul. Chastised for doing so on the Sabbath, and for cheating, he flung down the stones in a fit of pique. The site was excavated by the Oxford Archaeological Unit in 1972, 1973, and 1988. In 1995, a Time Team investigated the palaeolithic deposits of the site. Whatever the truth, 'the farm by the stones' is a reasonable explanation of the first part of the place name.

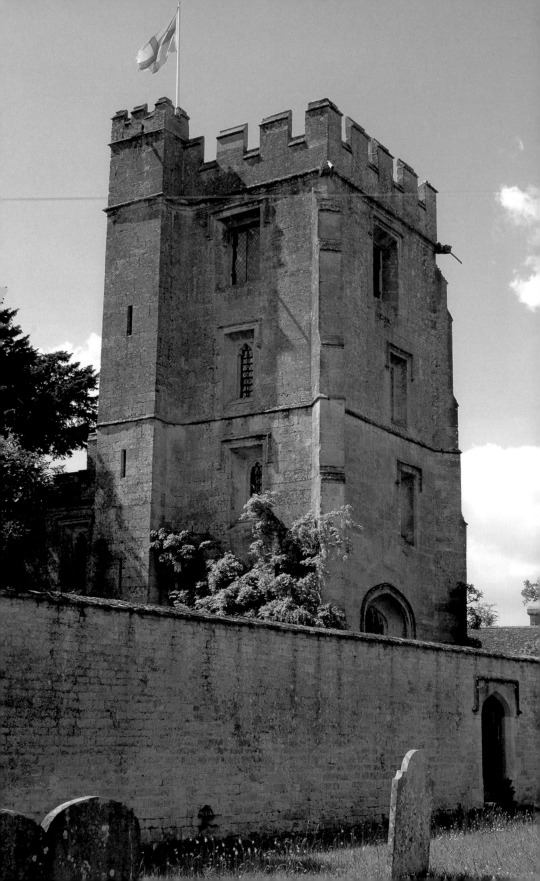

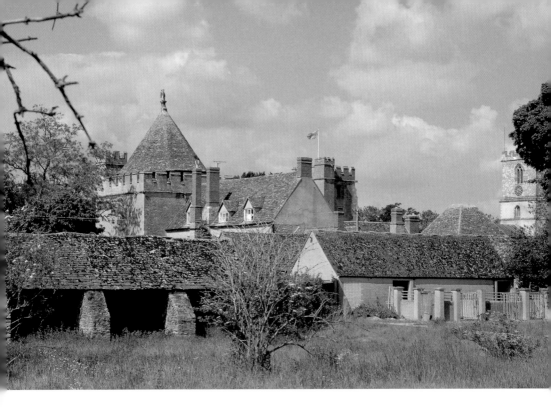

Above: The manor house, Pope's Tower, and the medieval kitchen form a group beside the church.

Right: The medieval kitchen in the manor complex.

Opposite: The tower, of *c.* 1460, includes a chapel with three rooms above – in the topmost of which Alexander Pope stayed, 1717-18, and it is now known as Pope's Tower.

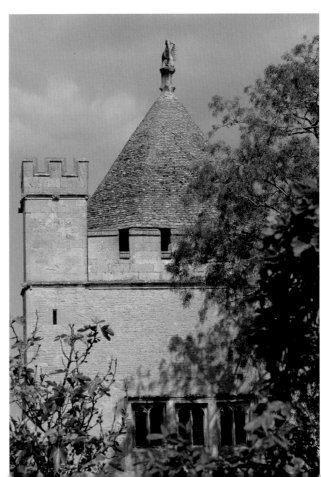

The Fox Inn.

The Harcourt appendage appeared after 1193 when Robert de Harcourt of Bosworth, Leicestershire married Isabel de Camville, heiress to her father Richard's estate at Stanton. A much later, but richly decorated, altar tomb in the church is allegedly associated with her. The Harcourts lived here for six centuries, during which time they distinguished themselves on fields of battle and in the political arena. The mid-twelfth-century cruciform church of St Michael in its pretty setting is one big memorial to their occupancy, and the student of historic costumes will benefit from a tour of their likenesses in the church.

There are Norman features in the nave and the chancel, in the decoration of the doorways, and in the lower parts of the tower. The chancel is Early English with notable lancet windows and a rare chancel screen of c. 1250; the canopied and richly decorated altar tomb is Decorated; and the Harcourt chapel is Perpendicular. Harcourts are here recalled in heraldry, sculpted in effigy, picked out in portrait busts, immortalised on wall tablets, and described in urgent detail. Their lives are highlighted in the details on tomb chests, or where their likenesses lie in stone or alabaster. The place drips with classical monuments to them, protected by cherubs, encased in urns, overhung by pediments and vaulting; they are enrobed in swags and scrolls, and in all manner of minor decorative motifs of neo-classicism.

Some of the inscriptions were written by Alexander Pope, notably the verses to two lovers who were killed by lightning in a nearby harvest field during one of the poet's stays there. Pope famously occupied a room in what is now known as Pope's Tower, 1717-18, with only the occasional company of his friend John Gay

who was staying at Cokethorpe Park. At the time of Pope's occupancy, the Harcourts' fifteenth-century manor house was falling into disrepair around the solitary genius. After Sir Philip Harcourt died in 1688, his widow relocated to Cokethorpe. The old house was demolished in the 1740s; but there remain a number of legacies. One is the inscription Pope wrote on a piece of red glass: 'In the year 1718 Alexander Pope finish'd here the fifth volume of Homer' (he was translating the *Iliad* in six volumes). This was relocated to Nuneham Courtney, which estate Robert Harcourt of Cokethorpe bought in 1710. Another reminder is the chapel with its three-stage tower wherein the uppermost room – which, unusually for something that has the appearance of a church tower, has the most windows – was Pope's study. The third important survival is the kitchen, and there was a Tudor gatehouse, which has been incorporated into the later manor.

The chapel, dating from the 1460s, is thought to have originally been on the north side of a quadrangle of buildings, together with the great hall and butteries of the manor house. It has a three-stage crenellated tower with a square stair turret rising above it at the south-west angle. What was essentially a domestic chapel is at ground level, divided by a Perpendicular arch into a small nave and chancel, with three chambers above, one on top of the other. The windows of this building are square-headed with either one light or two, cinquefoiled, beneath square hood mouldings with plain or decorative label stops. Gargoyles extend beneath the parapet. Inside the chapel, there is a groined roof with bosses, and a Perpendicular east window faces the parish church. The tower was supposedly where an Alice Harcourt was murdered, apparently by the chaplain at the time, and from where her ghost was laid in the nearby pond, which already had an occupying spirit. Both are able to haunt the vicinity only when the pond dries out.

The late fourteenth-century kitchen really is a remarkable building, which is thought to have been on the west side of the original complex. Pevsner described it as 'one of the most complete medieval domestic kitchens in England, and certainly the most spectacular'. It often invites comparison with the much larger example at Glastonbury Abbey, which is octagonal and has four chimneys, although here it is just over twenty-five feet square. It is battlemented and has a corner stair turret. Smoke escaped from an open fireplace through louvres in the roof, which is otherwise covered by an octagonal pointed cap. Above this, is a griffin supporting a weather vane. The windows are similar to those in the chapel and Pope's Tower; four doors lead off – one into the stair turret; there are ovens and recesses in an interior wall; and a timber-vaulted roof above.

For more than twenty years, until fairly recently, this important complex was opened to the public on certain days; sadly, this is no longer the case. (A century ago, it cost 3*d* for a ticket, available from a cottage close to the church, which granted admittance.)

Above: **The Harcourt Arms.**

Left: Village stocks, close to
The Harcourt Arms.

Standlake

Standlake artist and community activist, the late Ariana Windle, who lived in the village at Cheswell Cottage, designed mosaic sculptures and inspired those made from recycled material by villagers. These, which may be seen about the place, have given Standlake a modern reputation for its art. Ariana died in 2004, and one of her memorials is the two-mile-long Lower Windrush Valley Mosaic Trail, between Standlake and Newbridge. This is distinguished by its mosaic wildlife way markers, designed by the local Art Underfoot initiative. The trail runs on two sides of an imaginary square to the west of the river.

Here is a wandering village, which Henry VIII once settled on Anne of Cleves. It is said to derive its name from 'stone stream', the 'stone' part referring to the Devil's Quoit henge monument (see Stanton Harcourt, after which that village is also named). A footpath runs almost north, connecting Standlake with Stanton Harcourt some two miles distant, beyond both arms of the river, and through the flooded gravel pits and quarries that characterise the area, and near the site of the monolithic stone circle. In the high street at Standlake are the sixteenth-century, gabled inn which has been The Bell for about a century, and The Black Horse, made out of an old cottage in 1673. Opposite, is a chocolate box-style thatched cottage, and the village has its post office and stores. The church of St Giles is distinguished by its octagonal tower of c. 1370 and later spire. The rest of the fabric is mainly Norman, Transitional and Early English. There is a Norman doorway in the north wall, and windows of the same period. In the 1880s, restoration took place, and an amount of new-build in the earlier styles. The Windrush touches the village at the church, just beyond which lies the nineteenth-century former Church Mill, said to have been the last mill on the Windrush in working order. It was last used commercially in the 1950s, apparently to make animal feed, but the mill and its adjacent accommodation had gradually declined throughout the 1900s. Here, there were once two waterwheels; the remaining undershot wheel was refurbished in 1992, powering millstones that ground corn into flour and it was a feature of late twentieth-century annual National Mill Days.

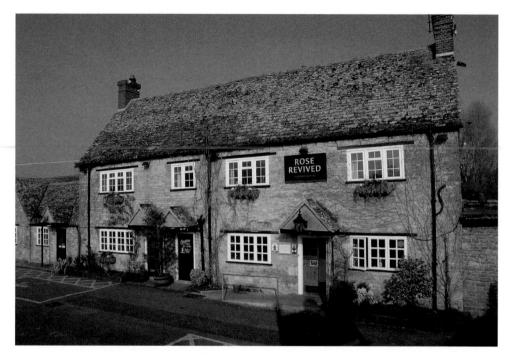

The Rose Revived, named The Rose from 1700s until the start of the twentieth century, and 'revived' following extensive flooding.

Standlake, at its southernmost extremity, becomes Rack End, where fullers' racks were laid out in association with the Gaunt House mill. Gaunt House, a seventeenth-century mansion that was moated with waters from the Windrush, was garrisoned in 1643 for the King during the English Civil War. It was besieged by Fairfax for Parliament, and surrendered in 1645. Later, it was associated with two deans of Christ Church, Oxford – Dr Samuel Fell and his son Dr John Fell, the latter being also Bishop of Oxford in 1676 until his death ten years later. A few yards on from Rack End, the two arms of the Windrush that have run parallel to the road since Witney join together below Broad Bridges. The river has now just over one mile of independent existence left. It uses this to wiggle capriciously through the few wide water meadows over which it will still occasionally assert itself by flooding.

To the south of the village, almost adjacent to the River Thames, lies Standlake Common Nature Reserve, the result of restoration after gravel extraction that took place in the latter 1990s. Here is a twenty-five-hectare site, centred on a large lake with gravel beaches and islands. It includes reed beds, pools, wetlands and muddy areas, with bird hides and places to picnic. The amount of wildlife here, especially species of birds, is considerable.

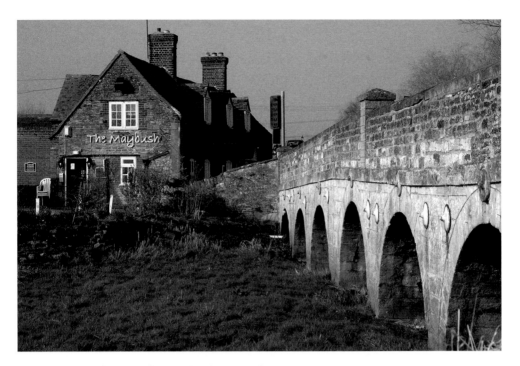

The Maybush, a riverside tavern beside New Bridge.

Hereabouts, the Windrush wanders into the flood plain of the Upper Thames Valley before debouching into the River Thames at the medieval-arched New Bridge, south of Standlake. The area has long been subjected to flooding; a raised causeway of seventeen arches on one side and twenty-eight on the other attested to the difficulties experienced here in the past. According to Fred Thacker's book of 1909, *The Stripling Thames*, the ingress of the Windrush is now lower down the Thames than formerly, because silt built up to form an island at the original point of entry and another had to be cut. Here, two of the bridge's six pointed arches span the Windrush, and the Thames is crossed by four.

The bridge has triangular buttresses or cut waters. It is said that a river crossing was built here in 1250, allegedly by monks who then owned the land hereabouts. The bridge was only 'new' in relation to that at Radcot. Both bridges now existing are likely to have originated in the fourteenth century. There is a story that, being much in need of repair by the fifteenth century, the new bridge was partially rebuilt, using stone from the Taynton quarries, the work being paid for by donations raised over time amongst travellers and guests at an adjacent alehouse. In 1644, the Parliamentarian Sir William Waller was engaged in a skirmish with Royalist forces around the bridge. It was altered in 1801, when cutwaters were added to the flat arches.

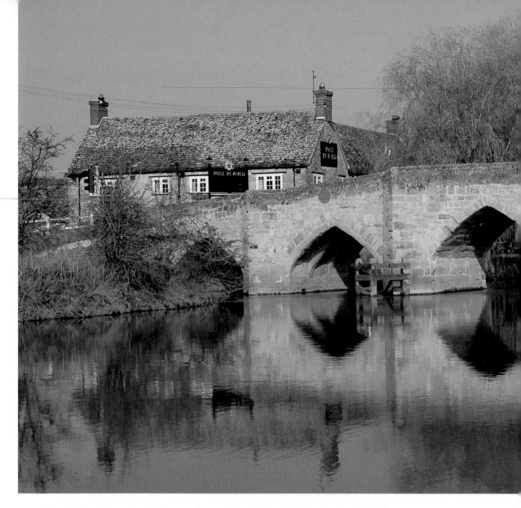

New Bridge, beneath which flows the conjoined River Windrush and River Thames.

On one side of the bridge is The Maybush, a long, low riverside tavern built of rough stone with brick dressings; it has shuttered windows, dormers, and an orange-tiled roof. There is a riverside terrace and gardens. On the other side of the bridge is The Rose Revived, now remodelled as a contemporary hotel restaurant. By the mid 1750s, this was just 'The Rose', a small cottage alehouse with pretty dormer windows that stood abutting a larger dwelling, hard against the roadside, where steps led down to a mooring on the river. It retained that name until after 1903, when it was badly affected by flooding and became a residential property. Both buildings were incorporated in the 1930s as The Rose Revived, which advertised teas and luncheons beside the river.

Opposite: The village pond, church, and former school at Ducklington.

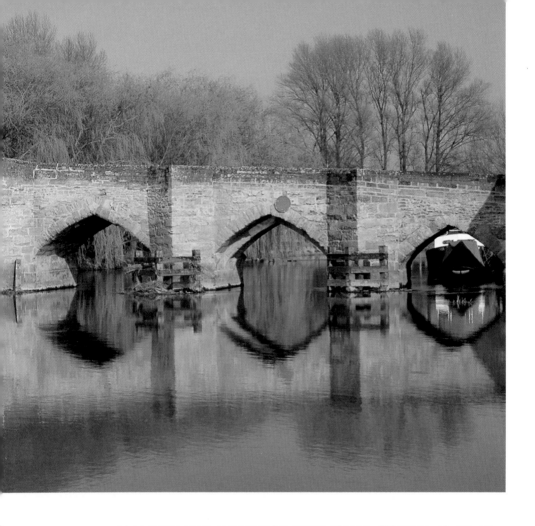

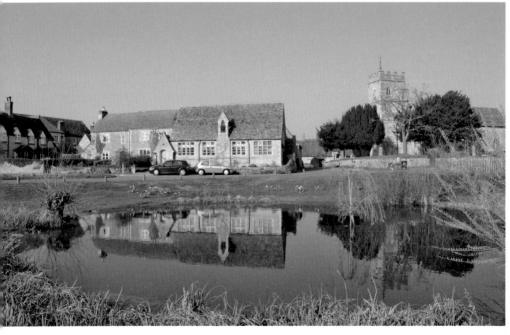

About the Author

Mark Child is a historian, and architectural and topographical writer. His books include *Discovering Church Architecture*; *Discovering Churchyards*; *The County Guide to Wiltshire*; *English Church Architecture: A Visual Guide*; and *Churches and Churchyards*. He has edited a publication on archaeology and ancient history, written three books about historic boats, and two – *Aspects of Swindon History* and *Swindon An Illustrated History* – on his home town. He is well known for his articles over many years on towns and villages for Archant Life magazines, particularly *Cotswold Life*.

Where the incoming Windrush, on the right, meets the Thames on the left.